THE
ABCs
OF
Victorian Antiques

THE
ABCs
OF
Victorian Antiques

By Dan D'Imperio

Illustrated by Edgar Blakeney

DODD, MEAD & COMPANY · NEW YORK

For Margaret Finley

ISBN: 0-396-06925-8
Library of Congress Catalog Card Number: 73-21163
Printed in the United States of America

INTRODUCTION

Victorian antiques, whether acquired by inheritance or by personal selection, represent an unequaled collecting challenge. Victorian interiors were miniature museums, filled with beautiful and amusing objects from around the world. The resulting wealth of antiques from this era is a revelation and a cause for celebration. Both museums and private collectors now vie for outstanding examples of rapidly vanishing Victoriana.

To make learning about these antiques as easy as ABC, here are concise descriptions of hundreds of items from the treasure trove of the period, with special collector's tips and, at the end of each entry, convenient value guides. Together, these should enable anyone to recognize and evaluate a Victorian antique with the assurance of an expert. You will learn the methods used by professionals to differentiate between the authentic antique and the fake, and by using the value guides you can tell at a glance how much your antiques and family heirlooms are really worth. The value guides can be applied to all your antique transactions with confidence; the prices quoted have been thoroughly researched and are based on a nationwide survey of antique values.

The sources for Victorian antiques range from your grandmother's attic to the next estate auction sale. Antique shops and shows abound with fascinating examples, and flea markets are fine places to find worthwhile surprises. With the aid of this guide, you should uncover some excellent values. Happy hunting.

A

ABC PLATES

Learning the letters of the alphabet was as easy as ABC for the child of the nineteenth century who was given an alphabet plate. The borders of the plates were decorated with the letters of the alphabet and the centers featured animals, maxims, famous people, and Aesop's Fables. The plates were usually glass, pottery or porcelain, and an overactive child might be presented with one of pewter or tin. The majority of alphabet plates originated in England and when the country of origin appears on the underside of the plate, this denotes a date of production after 1891. They were teaching aids for children learning to read, and rare examples exist with the raised alphabet letters in Braille or sign language for a blind or deaf child. *Tip:* The earlier plates have raised alphabet letters, while the later versions have printed letters. ABC Plate values: Plate, 5", $20; Plate, 7", $24; Plate 8", $28.

ACORN CLOCK

A distinctive small shelf clock, designed by American clockmaker Jonathan Clarke Brown. A clock label on the interior reading "The Forrestville Manufacturing Co., Bristol, Connecticut" indicates you have uncovered an authentic acorn clock. The naturalistic acorn-shaped top case is the distinguishing feature, often further embellished with acorn finials on the side brackets. A painted glass panel, known as the tablet, houses the pendulum on the lower portion of the clock. The tablet may bear a reverse painting, or be decorated in a manner that permits viewing the motion of the pendulum. The acorn-shaped case was copied by other clockmakers, all examples being classified as scarce and rare. Acorn Clock values: Clock, "Forrestville Manufacturing Co." label, $3,000.

ACTRESS GLASS

The faces and names of leading theatrical figures were immortalized on pattern-glass tableware of the 1880s. A total of twenty-six different pieces were issued in this pattern, and actresses saw their faces staring back at them from goblets, spooners, and pickle jars. Introduced in 1879, the early pieces displayed both the name and face, but as an actress lost her fame, often her name was removed from the glass. This pattern has been a favorite collectible with those in the theatrical profession. *Tip:* Reproductions are complete with the name and the face as the earlier glass is the type most often reissued. Actress Glass values: Bread Tray, $50; Covered Cheese Dish, $80; Footed Small Sauce Dish, $15; Spooner, $45; Walter Pitcher, $75.

ADAMS ROSE PATTERN

This perennial favorite dates from the 1820s. The illustrious firm of Adams and Sons was actively engaged in the production of this pattern until the 1850s. The early wares were bright and brilliant, picturing red roses and green leaves on a white background. All production ceased on this pattern during the mid-Victorian period, but the firm issued a variant later in the century. The wares produced earlier are referred to as Early Adams Rose. The later production was decidedly inferior in color and quality. This so-called Late Adams Rose was dull and murky, lacking the brilliance of the earlier wares. The earlier pieces are easy to recognize as they are clearer and sharper than the later version. Early Adams Rose values: Cup and Saucer, $75; Creamer, $80; Sugar Bowl, $100; Teapot, $140. Late Adams Rose values: Plate, 10", $40; Sugar Bowl, $65; Teapot, $90.

ADVERTISING CARDS

Leaf through an old Victorian scrapbook and you'll find page after page of colorful trade or advertising cards. The cards were distributed by firms and local business establishments to promote a product or service. They are often removed from the scrapbooks, and budget-minded collectors enjoy the wide range of subject material. Soap, thread, stove, pharmaceutical and remedy categories are popular, as are those issued in a series format. *Tip:* The firm of Currier and Ives issued approximately one hundred subjects in trade cards. They are marked with the

name of the firm. Advertising Card values: Good condition with copy intact, $1 each; Currier and Ives cards, $25 to $30 each depending on subject rarity.

AGATA GLASS

The New England Glass Company of Massachusetts developed this art glass that was produced for a limited time during the year 1887. Joseph Locke discovered the method for producing this glass. Agata has a glossy surface and was given a special treatment resulting in a mottled effect with spots or blotches of a different color. The glass is actually a variation of the highly prized Peachblow glass, and it was produced in very limited quantity. The desirable mottled effect was formed from mineral or metallic stains. Agata values: Bowl, 5″, $950; Celery, $950; Milk Pitcher, $1,250; Toothpick Holder, $600; Tumbler, $750; Vase, $850.

AHRENFELDT

Porcelains from the renowned Charles Ahrenfeldt factory of Limoges, France, were imported to the United States in quantity during the 1890s. American wholesale agents found an immediate market for this fine-quality, handsomely decorated china. A second factory was soon opened by the firm to meet the ever increasing demand for their wares. Varying marks include the name C. Ahrenfeldt and the initials CA, often accompanied by Limoges, France. Ahrenfeldt values: Chocolate Pot, pink roses, $50; Covered Butter Dish, floral decor, $42; Cup and Saucer, pink roses, $20.

ALMANACS

A kitchen indispensable, the trusty almanac was consulted with daily regularity well into the nineteenth century. They antedate newspapers in America, as the first almanacs were printed in the late 1600s. The almanac provided the reader with a guide to keeping a record of the days and weeks, phases of the moon, weather predictions, and planting times. Combined with such useful information was a liberal sprinkling of amusing commentary, riddles, and plenty of propaganda for worthy causes. A number of almanacs closely resemble religious tracts. *Tip:* Age, condition, and contents determine value, those dating prior to 1850 generally bring higher prices. Almanac values: Ayres Almanac,

1879, $4; Burdock's Blood Bitters and Key to Family Health, 1888, $3; Hostetter's United States Almanac, 1874, $3.50; Presbyterian Almanac, 1843, $7.50.

AMBER JEWELRY

A Victorian lady was certain to have a fine representation of amber jewelry, particularly in the 1880s and 1890s when long amber necklaces became fashionable. This popular mineral, derived from a yellowish fossil resin found on the shores of the Baltic, was primarily used as secondary jewelry. The colors range from light cloudy yellow to a clearer brownish red. *Tip:* The deeper the color, the finer the amber. Amber values: Necklace, eighty amber beads, gold clasp, $100.

AMBERETTE PATTERN

This pressed pattern glass, a favorite of the 1880s and 1890s, was made by several leading American glasshouses. Klondike and the descriptive "English Hobnail Cross" are two other names for this pattern. The cross is formed by two wide bands containing English hobnails, the distinguishing feature of this design. Well known to collectors is the version issued by Dalzwell, Gilmore and Leighton of Ohio, supposedly to honor the Alaskan Gold Rush. The amber bands depict the gold rush, while the panels they form are frosted with a satin finish to represent falling snow. Variations occur in color and overall design, depending on the glass house involved. Amberette values: Creamer, $85; Spooner, $45; Syrup, $75; Tumbler, $48.

AMBERINA

An innovative two-colored glass patented by Joseph Locke of the New England Glass Works in 1883. Blown and blown molded, and finally pressed glass amberina pieces were to become household favorites. Colors shade from a yellow or amber base to a rose or red top, or vice versa. The Mt. Washington Glass Company of New Bedford, Massachusetts, perfected a type of Amberina glass at about the same time. Legal hassles developed between the two companies, and Mt. Washington agreed to market their version under the name "Rose Amber." Experts agree that it is next to impossible to attribute definitely a piece of this two-tone glass to either the Mt. Washington Glass Company or the New England Glass Works, as they are very similar. Table and ornamental

pieces were made in this transparent shaded glass in various patterns including Diamond, Drape, Thumbprint and Swirl. Amberina produced prior to 1900 has the greatest interest to collectors. Amberina values: Diamond Quilted Celery, $230; Inverted Thumbprint Pitcher, 7" high, $275; Melon-shaped Creamer, $190; Punch Cup, $90; Tumbler, $100; Water Bottle, $170.

AMBROTYPE

This photographic improvement arrived on the scene in 1851, and spelled doom for the earlier Daguerreotype. After all, the ambrotype produced a positive photograph on glass by a process whereby the photo film was developed and floated on glass. It's unfortunate that a magic smiling device was not developed at about the same time, as those being photographed look as if they had the local photographer confused with the dentist. Ambrotype values: Woman holding book, case American-eagle design, $16; Small boy with ornate case, $10.

AMERICAN MARINE

The original maker of this maritime delight in table-top dinnerware was Francis Morley & Co., Staffordshire potters from 1845 to 1858. They designed a complete dinner service specifically for the American export market, the design being printed in blue, brown and other colors. American Marine was appropriately named, as ships at sea abound on every piece. Racing boats, steamers, ferry boats and rowboats all vie for attention with choppy seas, billowing sails and detailed harbor scenes. The earliest pieces will have the Morley trademark on the underside; pieces produced after 1859 bear the name Ashworth. American Marine values: Butter Pat, round, $5; Cup and Saucer, blue, $32; Plate, 7" diameter, brown, $16.

AMERICAN POTTERY COMPANY

Active in Jersey City, New Jersey, this firm was a leader in American ceramics around the 1840s. Blue-printed wares resembling imported English pieces were attempted by this prominent factory with notable success. They made dinner services, which have the firm name and pattern name on the underside. Highly respected are their various objects made for the presidential campaign of William Henry Harrison in 1840. Daniel Greatbach brought additional attention to the firm with his bril-

liantly executed hound-handled pitchers, in the Rockingham glaze. A marked specimen from this illustrious company represents an extraordinary antique find. American Pottery Company values: Plate, Canova pattern, $50; Hound Handled Pitcher, $150.

ANIMAL HORN FURNITURE

This organic furniture, known since antiquity, enjoyed a revival in America during the nineteenth century as people moved west. A warm rustic feeling was provided by steer- or buffalo-horn chairs, hat racks, tables and hassocks covered with plush goat or sheepskin upholstery. This exotic furniture, made from natural animal horns, was considered a proper souvenir gift for American Presidents. Abraham Lincoln received an animal horn chair from a Western admirer. Sophisticated collectors find this furniture form offers exciting decorator touches to an interior. Animal Horn values: Buffalo Standing Hat Rack, $350; Hassock, $110; Steer Horn Arm Chair, $220; Wall Hat Rack, $120. Illustration on page 99.

ANIMATED CAP PISTOLS

These cast-iron toys, which the J. E. Stevens firm of Connecticut manufactured, were the absolute rage of the 1880s. They were made in the shapes of numerous figures and animals, and a simple pull of the trigger fired the paper caps and set the subject matter into motion. They are in the same category as cast-iron mechanical banks of the period. The cap pistols will show signs of wear as they suffered from heavy usage. To retain their antique value, both conventional and animated cap pistols should be left in the original worn condition. Painting or restoring will only lessen the value. Cap Pistol values; Monkey on Log, $360; Shoot the Hat, $350.

ANTHONY PORTRAITS

The shop sign read *Mr. Anthony, Photographer,* and famous Americans came from far and wide to be photographed by this gifted gentleman. A portrait session at his studio was the "in" thing during the 1860s, and all the beautiful people of the day paraded proudly into his New York City establishment. Finding an original "Anthony Portrait" would most certainly rate you the antique find-of-the-month award. Anthony Portrait values: Little Girl, holding doll, small size gilt frame, $42.

ANTIMACASSAR

Gentlemen never ventured out of the house before first applying their Macassar hair oil during the 1800s. This little number was a fast-selling grooming aid at leading emporiums across the country. What to do about those terrible greasy stains that soon appeared on every parlor chair? Trust the resourceful lady of the house to solve this perplexing dilemma. Busy fingers were soon knitting and crocheting tidies and doilies by the dozens. These hand-made pieces would protect the furniture against those nasty Macassar hair oil stains, and thus was born the antimacassar. Antimacassar values: Three-piece Crocheted Armchair Set: $18.

APOSTLE POTTERY

The Gothic-revival influence of the early Victorian period brought about the introduction of this pottery. English potters originated the Apostle pitcher in the 1840s, with Apostle figures in relief around the outer surface. American firms responded, and visitors to the New York Crystal Palace Exhibition in 1853 viewed an octagonal water cooler with eight Apostles in niches around the outside. This piece was credited to Daniel Greatbach, who modeled it in flint enamel glaze while working at Bennington, Vermont. A rockingham-glaze cuspidor and numerous other Gothic-related objects in Apostle designs can also be found. Apostle Pottery values: Apostle Cuspidor, $100; Apostle Pitcher, circa 1850, $120.

APOSTLE SPOONS

These are the most sought-after spoons ever produced, the design being centuries old and English in origin. A different Apostle appears at the tip of the handle on each of the twelve spoons in the set. There were numerous versions of the Apostle spoon marketed during the middle nineteenth century. Collector attention has centered on these late examples, as complete sets and as individual spoons. Since numerous collectors aim for complete sets, prices continue to escalate on spoons of nineteenth-century origin. The novice should approach the acquisition of Apostle spoons with utmost care, as they are currently being reproduced. Apostle Spoon values: Small Spoon, circa 1890, $7; Spoon, circa 1850, $30.

APOTHECARY BOTTLES

The nineteenth-century druggist kept various drugs and compounds in colorful bottles. The bottles were often labeled, or had space for a label, and came in a variety of sizes in both clear and colored glass. Bottle buffs prefer an apothecary bottle to be complete with the original ground-glass stopper. Rare examples exist in cut glass. *Tip:* Any apothecary bottle made prior to 1900 will interest a collector. Apothecary Bottle values: 8″ high, $14; 10″ high, $18; 12″ high, $24; 15″ high, $30.

ARGAND LAMP

The first step toward modern lighting was the invention of an oil-burning lamp by Swiss chemist Aimé Argand in 1783. Brighter illumination occurred with his development of the central-draft burner, and an Argand worker is credited with the discovery of the lamp chimney. The fact that a tubular wick, sheltered by a glass chimney, created a brighter light led to its being used on all Argand-type lamps. Argand lamps were made with one or two burners, usually with a standard of bronze or other metal, combining classical and rococo elements. The shades were frequently frosted glass with cut-crystal prisms. Designs varied, depending upon the individual maker and the currently prevailing styles. Argand-type lamps continued to be made into the 1870s with variations. The Astral and Sinmumbra lamps were two later versions, made by Cornelius and Company of Philadelphia and by other leading lamp manufacturers. Argand Lamp values: Bronze, cut and frosted shade, circa 1850, $215. Illustration on page 11.

ART NOUVEAU

A rebellion against the numerous Victorian revival styles began in Europe during the 1870s. Natural forms prevailed in this new international style of art and design. Maidens with flowing hair, entwined vines, and plants with tendrils created a style with a romantic turn of expression. The Art Nouveau influence in America flourished in decorative arts such as metalwork, jewelry, glass, pottery and graphics. This artistic rebellion enjoyed great popularity in America between 1890 and 1910. Art Nouveau values: Brass Statuary, 15″ high, $40; Bronze Tray, 9″ x 6″, $65; Doulton Vase, 8″ high, circa 1900, $60; Hand Mirror, silver plate $24. Illustrations on pages 21, 119.

ARTS AND CRAFTS MOVEMENT

Led by William Morris and his followers, this was an attempt in the latter part of the nineteenth century to return to hand craftsmanship as a method of improving industrial art and design. The movement was well organized in England and fostered a return to handmade items and a revival of cottage crafts. It was less successful in America, although craft centers were organized in various parts of the country for designers, painters and cabinetmakers. The Royercrofters Group of East Aurora, New York, the Rookwood Pottery of Cincinnati, Ohio, and the Art Workers Guild of Providence, Rhode Island, were three important centers in the United States.

ART UNION

Would you like to win a beautiful painting by a talented artist? Simply join the Art Union. The first Art Union on record was conceived by M. Henin in Paris in 1810. Naturally, an American version could not be far behind, and one was established in 1838. Every new member received a subscription to an art journal, plus a fine engraving. Ten short years later membership totaled close to nineteen thousand. Members anxiously awaited the news that their number had been drawn and they were to be given a drawing, painting or piece of sculpture. The lottery concept actually concealed an art crusade, so winners and losers alike became patrons of the arts. Art Union values: Parian Figure, 24" high, Woman with Heron, signed by Copeland, dated 1858, $250.

ASTRAL LAMP

Count Rumford can be credited with this improvement over the early Argand lamps. To eliminate shadows, fluid was held in a reservoir and transmitted by tubular arms to the burners. Shadows had been annoying lamp users ever since Aimé Argand, a Swiss chemist, invented the Argand lamp in 1783. The shadowless Astral lamp was favored during the 1830s, and for many decades thereafter. Astral Lamp values: Brass Lamp dated 1870, 26" high, $260. Illustration on page 11.

ATLANTIC CABLE GLASS

The successful laying of the Atlantic Cable resulted in countless souvenir items being marketed to commemorate the event. The officers

of the steamer that laid the cable were given gold metals designed by Tiffany & Company of New York. The public satisfied its buying urge with trifles such as snuffboxes, pipes, china and glass novelties galore, handkerchiefs, and medals—not gold, of course, just plain old metal medals! The glassmakers responded to the call by issuing pattern glass called Cable during the 1860s. The pattern is simple in design and proved popular and soon a variant appeared, Cable with Ring. All pieces related to the Atlantic Cable are considered highly collectible. Cable Pattern Glass values: Tray, $35; Butter Dish, $70; Egg Cup, $25; Tumbler, $46; Goblet, $40.

ATTERBURY DUCK DISH

The Atterbury Company of Pittsburgh, Pennsylvania, patented this sought-after rarity in 1887. The design was pressed with glass eyes, and realistic feathers added to the appeal. The duck dish was produced in white, black, blue, amethyst, and also in several color combinations. The Atterbury ducks were marked on the base with the patent date. Thomas Atterbury also designed a Bull's Head Mustard Pot and a Rabbit Tureen. *Tip:* The Atterbury duck dish has been reproduced; however, the reproductions do not bear the 1887 patent date. Atterbury Duck Dish values: Amethyst with patent date, $110; Black with patent date, $110; White Glass with patent date, $80.

AUDUBON PRINTS

John James Audubon, the American-born artist, created a magnificent series of water-color bird drawings, published in England from 1827 to 1838. Robert Havell of London issued the English version in eighty installments. An American edition was published during the 1840s. Mr. Audubon was a dedicated ornithologist, with a life-long ambition to picture American birds in their natural habitat. The prints from the original portfolios and volumes, based on Audubon's drawings, are now classified by collectors as "Audubon Prints." There were 435 prints, all hand-colored by Audubon, with the exception of plate 404, which was colored by Lucy Audubon. They make up the most valuable collection of bird prints in existence. Audubon prints are rarely sold individually, and are well beyond the means of the average collector as they are extremely valuable. *Tip:* Countless reproductions are in circulation. They are quickly recognized from the originals upon close examination. The

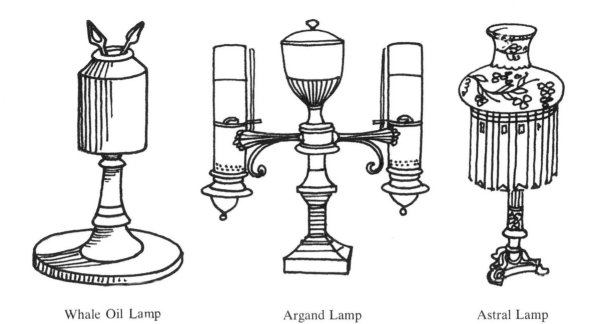

Whale Oil Lamp Argand Lamp Astral Lamp

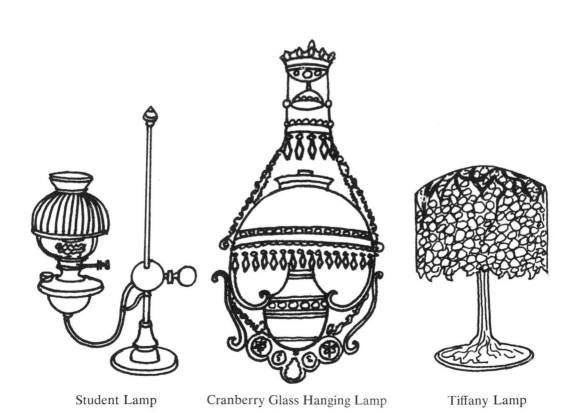

Student Lamp Cranberry Glass Hanging Lamp Tiffany Lamp

reproductions are on thinner paper, and are usually machine-printed. Audubon Print values: Blue-Green Warbler, $750; Sharp Tailed Finch, $800; Song Sparrow, $800; Marsh Hawk, $1,100; Tufted Duck, $1,300.

AUTOGRAPH FAN

Every young lady of the 1860s carried one of these with her to a party or program. She offered her folding paper fan for guests to autograph as they were quite easy to write upon and certainly a perfect opportunity for an unattached gentleman to make a slight overture or proposal in writing. Many a Miss became a Mrs. thanks to a mere autograph being written on a paper fan. Autograph Fan values: circa 1860, good condition, $12; circa 1860, fair condition, $8.

AUTOPERIPETIKOS

Joseph Lyon Company patented a clockwork walking doll with a china head and kid arms in 1862. With a turn of the key the doll would walk, gesture and perform, thanks to her neat little clockwork body. William Goodwin's contribution in 1868 was a walking doll that actually pushed a carriage. Don't walk away from one of these walking dolls—they come along just once in an antiquing lifetime. Autoperipetikos Doll values: Doll, circa 1870, 12″ tall, $360.

B

BABY CARRIAGE

The two-wheel baby carriage of the 1840s, made by Crandall's and other makers, closely resembled a stroller. They were drawn by a front wooden arm; later there was a back bar for pushing. Over the years this type was gradually replaced as patents were granted for improvements. From this humble beginning the baby carriage evolved into a luxurious four-wheeled fancy, having springs, fringed canopy, flowered or velvet upholstered seats and even a parasol. The post-Civil War baby was likely to view the neighborhood happenings from an elaborate reed, rattan or wicker carriage. The same makers produced doll carriages, with the same elegant details. *Tip:* A maker's name will increase the already sizeable worth of a Victorian baby carriage. Baby Carriage values: Stroller

type, circa 1840, $225; Wicker Carriage, elaborate, upholstered seat, parasol, circa 1870, $180.

BAILEY CUT FLOWERS

Harriet Bailey, a Wisconsin artist, exhibited her cut-paper art work at the Philadelphia Centennial in 1876. She excelled in the art of cutting flowers and floral bouquets from paper. Her intricate cutout paper designs were often mounted, framed and sold as pictures. This gifted artist gained national recognition, and her paper cutouts were fondly known as Bailey Cut Flowers. Bailey Cut Paper values: Framed Flower subject, small size, $35.

BALLOON BACK CHAIR

A chair back with a rounded style and pronounced waistline associated with the Rococo Revival patterns was known as a balloon-back chair. Both simple and ornate designs were popular as parlor chairs, sold either singly or in pairs and often as part of a complete parlor set. The more elaborate styles have a more pronounced design, with finger molding. The balloon-back arm chair had upholstered padded arms, while the balloon-back ladies chair was smaller in both design and construction. All pieces mentioned have the balloon back, with waistline effect; black walnut and rosewood were favored woods, circa 1850–1870. Balloon Back Chair values: Armchair, good condition, $340; Lady's Chair finger carved, $285.

BALLROOM CHAIR

A very small gilt side chair, usually with bamboo turnings. Light and fragile, the ballroom chair was often rented for special occasions. They were perfect for balls or receptions, since they were very portable and could be supplied in large quantities. Young ladies, however, preferred to spend the evening whirling around the dance floor rather than perched upon a rented gilt ballroom chair! Ballroom Chair value: good condition, $85; rough condition, $50.

BAMBOO FURNITURE

Oriental imports of bamboo furniture date from the eighteenth century. The Japanese exhibit of bamboo at the Centennial Exposition in 1876 brought about a renewed interest in this furniture. Authentic and

simulated bamboo were imported and produced in the United States to accommodate the bamboo rage of the 1880s and 1890s. A number of American factories achieved a natural bamboo look with bird's-eye maple, turned to resemble bamboo. A complete line of reproductions, based on many of the original designs, has recently been developed and sold. Bamboo Furniture values: Chair, circa 1880, $60; Corner Chair, $75; Sewing Stand, $35; Umbrella Stand, $70. Illustration on page 21.

BAMBOO PATTERN

In 1883 the La Belle Glass Works of Bridgeport, Ohio, issued a unique pattern of pressed glass in a design simulating bamboo. This was perfect timing on the part of this glasshouse, to capitalize on the bamboo rage of the 1880s. Complete tableware settings were made in clear glass, with sticks of bamboo outlining the individual pieces in well-rounded relief. The handles also simulated bamboo on this appropriately-named and easily-recognized pattern. Knobs of covered pieces have high spreading fans and items may be found plain or with engraved decoration. Bamboo Pattern values: Butter Dish, $20; Covered Compote, 8″ high, $30; Creamer, $18; Tumbler, $11.

BANANA DISH

Introduced in the 1850s, the banana dish was a glass or ceramic dish on a stand with open and curled sides. They are usually attributed to the southern regions of the United States, but as the banana gained national recognition, so did the banana dish. The curled sides prevented the bananas from rolling right out of the dish. Banana Dish values: Colorado Pattern, Clear, $45; Colorado Pattern, Green, $70; Snail Pattern, $72; Moon and Star Pattern, $50.

BANDBOX

Ladies and gentlemen of the 1800s kept their hats dust-free by storing them in round or oval boxes of thin wood or pasteboard. They were light and portable and often taken on trips as handy catchalls for hats, cuffs, collars and other bits of finery. They were decorated with colorful papers having patriotic, historical or scenic motifs, scraps of wallpaper being a favorite covering. The inside of the box was lined with newspaper. *Tip:* The newspapers lining a bandbox may aid in dating the box and establishing its origin, and thus prove important in themselves. Band-

box values: Pasteboard Bandbox, circa 1860, good condition, $50; Wooden Box, circa 1850, good condition, $60.

BANJO CLOCK

Now known as the banjo clock, the American wall clock patented in 1802 by Simon Willard featured a longish pendulum housed in a banjo-shaped case. The original design was copied and modified and there are numerous varieties of banjo clocks. The clocks produced by the Willard family are highly prized and considered superior and most pleasing in design. A large quantity of simple banjo clocks was produced by Edward Howard of Boston, Massachusetts, during the 1840s. There has been more widespread faking of banjos than of any other clock ever made. The Willard name may be located on clocks rebuilt and reproduced by other firms. Check a banjo for the maker's paper label as this would be your assurance that the clock is authentic. Banjo Clock values: Brewster & Ingraham, $350; Howard & Davis, $200; Ingraham, $130; Simon Willard, $1,000.

BANKS

The most desirable and sought-after antique banks are the penny mechanical banks. They were originally sold as toys when introduced in the 1860s. Thrifty parents urged their children to save while enjoying the animated banks. Mechanical banks vary in value depending on rarity and condition, rather than age alone. A limited-edition bank from the turn of the century may be more valuable than one issued years earlier. Still banks caught the fancy of collectors when prices soared on mechanical banks. They are frequently in the form of a safe or bank building. A still bank may be wood, tin, cast iron, white metal, glass, pottery or porcelain. Rarity will determine the value. Never repaint an antique bank. *Tip:* The reproductions are brightly painted, while the antique banks will always show some signs of wear as eager children found them fascinating and they were subjected to rough use. Check carefully for signs of use and factory marks as these will guide you in authenticating these sought-after collectibles. Mechanical Bank values: Bull Tossing Boy, $1,100; Jumbo Elephant, $250; Locomotive, $750; Squirrel and Tree Stump, $400; Woodpecker, $600. Still Bank values: Buffalo, $50; Indian Head, $40; Irish Policeman, $45; Statue of Liberty, $40; Turkey, $35. Illustrations on pages 171, 211.

BANQUET LAMP

Great Grandmother always referred to her kerosene lamp as a "banquet lamp." That was prior to the novel *Gone With the Wind,* after which they became known as "Gone With the Wind" lamps. Kerosene lamps replaced all other types of oil lamps when Colonel Edwin L. Drake struck oil in, of all places, Pennsylvania, in 1859. One year later a solid round wick was in use, followed by a device that turned up the wick, and a glass chimney. Banquet lamps were sold by the millions during the 1870s and 1880s, when they retailed for one dollar to ten dollars each. A beautiful shade could be purchased for another dollar or two. Completely original banquet lamps are in great demand. *Tip:* The first kerosene lamp made with a handle for safe carrying did not appear until 1870. Banquet Lamp values: Britannia Metal, Brass-plated 21″ high, $200; Satin Glass, 22″ high, circa 1890, $300; 30″ high, hand-painted shade, original condition, $265.

BAROQUE

Baroque is derived from a Portuguese word meaning an "irregular-shaped pearl." It incorporated a very elaborate style of art and architecture heavily decorated with scrolls, carvings, columns, and other heavy ornamentation. This style reflected the Louis XIV revival forms, favored during the mid-Victorian period.

BASALT

Josiah Wedgwood developed a black basalt stoneware body in the late 1760s. His black basalt was considered to be an improvement over the earlier material for this type of body known as "Egyptian Black." Company catalogues began listing ornamental and utilitarian objects in basalt during the 1770s. Basalt remained in favor for the entire Victorian period, being produced by firms in England and on the Continent. The matte-black basalt body was particularly effective for tea and coffee services, although plaques, medallions, candlesticks, ewers and other handsome pieces were produced. Marked specimens from the Wedgwood firm are coveted, as are those from other leading English potters. Basalt values: Bowl, 8″ diameter, Wedgwood, $95; Creamer, 5″ high, Wedgwood, $65; Teapot, impressed Wedgwood, circa 1850, $120.

BASKET SWIVEL CHAIR

Pre-school youngsters of the 1840s rotated in cleverly constructed Windsor-type chairs mounted on a single iron support. Securely attached to one side of the chair was a sizable basket. The basket was large enough to accommodate books, slates, crayons, pencils and other paraphernalia to prepare a child for future school-day activities. Actually a form of rotating high chair, the swivel mechanism permitted the occupant to observe the movements of other household members with comparative ease. Basket Swivel Chair values: Circa 1850, good condition, $95.

BEADWORK

Godey's Ladies Book and *Peterson's Magazine* often gave beadwork instructions to ladies of the 1860s. Beads were strung, then sewn into various appealing designs on pin cushions, watch cases, wall pockets, lambrequins and pen wipers. Favorite motifs included flowers, birds, leaves and patriotic designs. A leftover scrap of flannel or some other material from a sewing project was often used for beadwork—which just proves what can be accomplished with a few beads, a few scraps, and a few precious drops of ingenuity. Beadwork values: Pin Cushion, 5" x 8", $28; Pen Wiper, floral motif, $12; Wall Pocket; $14; Pin Cushion, large size, patriotic motif, $38. Illustration on page 109.

BEATRICE PATTERN

Wedgwood & Company of Tunstall, England, registered the Beatrice pattern design at the English registry office in 1887 and again in 1890. The transfer-printed pattern features a tree trunk and leaves combined with flowers and ribbon. The combining of natural forms with conventional ones was in evidence on this and other dinnerware from various Staffordshire potters of the late nineteenth century. Beatrice Pattern values: Creamer, $18; Cup and Saucer, $12; Sugar Bowl, $25; Teapot, $38; Tureen, covered, with Under Platter, $75.

BEDSTEPS

Pile several mattresses on top of an already high four-poster bed and the ascent becomes a slight problem. Bedsteps—small wooden steps —were made for the express purpose of easing the climb into bed. They were a necessity during the seventeenth and eighteenth centuries, remain-

ing popular into the middle of the nineteenth century. The more auspicious versions came complete with a cupboard base, ideal for storing a chamber pot inside. Bedstep values: Circa 1850, $120.

BEDWARMERS

In the pre-central-heating days, bedwarmers were absolute necessities. Finely engraved and pierced brass and copper bedwarmers may be found in a number of pleasing designs. The earlier pans had iron handles, replaced on later versions by wooden handles of walnut, applewood, ash or oak. They are currently being imported from abroad. *Tip:* Antique bedwarmers should show signs of smoke marks on the pan, and the wood may be lighter around the tip of the handle. The joints between the handle and pan may be loose from constant use. Bedwarmer values: Brass, pierced design, good condition, circa 1860, $90; rough condition, circa 1870, $48. Illustration on page 41.

BEEHIVE CLOCK

Popular in Connecticut, this small shelf clock was in vogue from 1850 to 1870. The name was derived from the shape of the wooden case rounding to a point at the top, resembling an old-fashioned beehive. It was also known as a "flatiron clock," as it bears a resemblance to an upturned flatiron. A beehive clock with an eight-day movement is desirable, and a limited quantity were produced with a reverse painting on the tablet. Beehive Clock values: Sonora Chime, Mahogany Case, $130; Terry and Andrew Painted Tablet, $135.

BEIDERMIER

A German furniture style in the classical Empire forms, very popular in Europe during the early 1800s. The Beidermier furniture was quite comfortable, heavily cushioned and padded, and was copied in America by furniture makers. It enjoyed its widest influence between 1825 and 1860. The name is derived from a comic character, Papa Beidermier, a famous German newspaper character. Beidermier values: Armchair, circa 1840, $600; Desk of Applewood, circa 1840, $600; Fruitwood Cupboard, circa 1840, $1200.

BELLEEK

McBirney & Armstrong of Fermanagh, Ireland, developed Belleek in 1857. The exceptionally thin iridescent porcelain, with a pearly textured glaze, is as thin as paper. The open basketwork pieces with hand-modeled flowers and foliage are unbelievably lovely pieces. The mother-of-pearl luster effect inspired the famous sea and shell forms. American manufacturers also were engaged in the production of fine Belleek. The Ott & Brewer firm of Trenton, New Jersey, made prized Belleek about 1880. The Knowles, Taylor and Knowles Company of East Liverpool, Ohio, made Belleek and "lotus ware," a porcelain very similar to Belleek. *Tip:* The word "Ireland" on a piece of Irish Belleek first appeared in 1891. Irish Belleek values: Circa 1870–1890, Creamer, $75; Cup and Saucer, $60; Teapot, $100; Vase, 6″ high, $55. American Belleek values: Circa 1885–1900, Set of 6 Open Salts, $30; Plate, 5″, $25; Powder Box, $40; Rose Bowl, $65.

BELLFLOWER

Dating from the 1840s, the bellflower pressed-glass pattern is considered to be one of the earliest produced in the United States. The pattern has an all-over vertical ribbing on which is imposed a bellflower-vine design. The pattern varies slightly, with both single-vine and double-vine pieces available. *Tip:* Reproductions do exist. Bellflower values: Champagne, $40; Covered Compote, 8″ high, $135; Egg Cup, $18; Mug, early, $65.

BELL JAR

A bell-shaped glass dome was a familiar sight in the Victorian Sunday parlor. It protected from dust a favorite piece of ladies handiwork, a lovely bisque figurine, or some variety of stuffed bird. A bell jar with its treasure intact represents a memorable antique discovery. You may have the good fortune to find one with an elaborate display of wax fruit or a magnificent shell-work design. Purchase even the empty bell jar, as it will be only a matter of a few more antiquing trips before you uncover something suitable to place in it for display. Bell Jar values: 11″ high, with base, $34.

BELTER, JOHN HENRY

This cabinetmaker was famous for his finely-crafted Rococo Revival furniture of the early Victorian period. Belter established his own business in New York City, following earlier training in Germany, and remained in business until his death in 1863. He favored rosewood and mahogany and with his patented laminating process was able to design furniture with delicate and lacy carving. Belter kept his laminating process a secret for many years, and did not patent it until 1858. Best known for his chairs, he also made matching tables, sofas, cabinets, secretaries and couches. Belter beds display elaborate carvings and feature serpentine and rounded contours. He was an outstanding craftsman with great pride in the design and durability of his furniture. His work is regarded as the finest and most distinctive of the American Victorian cabinetmakers. Belter Furniture values: Rosewood Armchair, $1,200; Rosewood Side Chair, $850; Carved Rosewood Sofa, $3,100. Illustration on page 21.

BENNETT, EDWIN

This was one of the leading American pottery firms of the Victorian era. It was established in Baltimore, Maryland, in 1846. The Edwin Bennett firm's long list of ceramic accomplishments includes the famous Rockingham-glaze Rebecca-at-the-Well teapot. Pitchers and jugs decorated in the raised-relief English tradition are treasured. They excelled in the production of Victorian majolica, employing colored glazes on outstanding ornamental and utilitarian objects. Majolica was made by this company in the early 1850s, and pieces were usually marked "E. & W. Bennett, Canton Avenue, Baltimore, Md." By the 1870s they added white granite, semi-porcelain and hotel china to their lines. Bennett values: Fish Pitcher, marked, $60; Rebecca-at-the-Well Teapot, marked $85.

BENNINGTON POODLE

America's best-loved animal subject was produced by the Fenton-operated Bennington potteries between about 1849 and 1858. The well-known standing poodle with shaggy mane and basket of fruit in its mouth was made with numerous variations in details, glazes and materials. Minor details are evident when a group of poodles are examined, and

Schoolmaster's Desk

Bamboo Table

Belter Table

Damascus Table

Art Nouveau Table

Louis XVI Revival Sewing Table

they were made with and without a moustache. This was the only dog subject ever made by the renowned potters of Bennington, Vermont. Rockingham and flint enamel-glazed poodles are highly prized, and those of granite ware, yellow ware and parian are quite rare. The characteristic shaggy mane is a Staffordshire-type decoration, known as "Cole Slaw." Bennington Poodle values: Bennington, dated 1849, $975.

BENNINGTON POTTERY

The pottery produced during the nineteenth century in the town of Bennington, Vermont, is referred to as "Bennington pottery." The principal factories were the Norton and Fenton family-owned potteries. The United States Pottery Company dates from the 1850s, and was under the guidance of Christopher W. Fenton. Very few pieces of Bennington bear a factory mark. The absence of such a mark makes it fairly impossible to ascertain that a piece was produced by one of the potteries in the town. Rockingham wares closely associated with the factories were also produced in other areas of the United States, as well as in England. The streaked-enamel Rockingham ware known as "flint enamel" was perfected and patented in 1849. Bennington hound-handled pitchers and cow creamers have been extensively reproduced for many years. Parian, stoneware, yellow ware, Staffordshire-type vases and numerous other items came from this center. Bennington pottery minus a factory mark should be referred to as Bennington-type pottery. Bennington values: Coachman's Bottle, with factory mark dated 1849, $300; Cuspidor, unmarked, circa 1870, 8″ diameter, $45; Pudding Mold, unmarked, $40; Toby Jug with factory mark, circa 1850, $300; Washbowl Set, 2-piece, $175.

BENTWOOD

Michael Thonet (1796–1871) conducted experiments on laminating and shaping wood by steam. This resulted in his developing, about 1850, a method whereby birchwood could be bent into very fancy shapes. The curves were reminiscent of the rococo style and became known as Bentwood. Bentwood was produced in Austria and exported in great quantities to the United States. A do-it-yourself project, Bentwood was shipped unassembled and was easily put together with screws. American furniture makers made some Bentwood, but could not compete with the

fine-quality imported pieces. Bentwood values: Armchair, $120; Child's Chair, $75; High Chair, $90.

BERLIN WORK

Needlework designs have been created for centuries by skilled women the world over. In the early 1800s enterprising Berlin print-sellers started to produce patterns which at first were hand-painted on paper or engraved. A bit later, the designs were colored on canvas, and when the wool-stitched patterns were completed, they were called Berlin Work. Bookmarks, mottos, traveling bags, eyeglass cases, and pin cushions were a part of the needlework rage. Relegated to the attic years ago, Berlin work is enjoying a revival and once again mottos are beginning to appear over every doorway. Berlin Work values: Eyeglass Case, $15; Mottos, circa 1860–1890, $20; Stag Picture, 24" x 36", $50; Traveling Bag, good condition, $45.

BERRY BOWLS

Beautiful glass berry bowls, in handsome silver-plated frames, began replacing epergnes as centerpieces by the 1890s. Ruffled- and crimped-edged bowls in a rainbow of colors employed various glass techniques and were irresistible when filled with fruit or flowers. A number of berry bowls have been separated over the years from their metal framework, and a berry bowl complete with frame is a real find. Major glasshouses in the United States made the glass bowls in both clear and colored pressed-glass patterns, including Satin Glass, Amberina, Burmese, Mary Gregory Glass, and other types of late Victorian art glass. The ornate bowls rested in complementary silver-plated frames, with handles rising majestically over the center of the bowl. Berry bowls were favorite wedding gifts around the turn of the century and are known to collectors as Bride's Baskets. Berry Bowl values: Satin Glass, pink diamond-quilted pattern, silver-plated stand, $240; Satin Glass, red bowl, with stand, $150.

BETTY LAMP

This primitive lighting device, used in country and frontier areas well into the nineteenth century, was made of various metals, usually tin, iron or pewter, and had a shallow reservoir for grease and a floating wick. They were round, oval or triangular, with a groove or slot at one

end. The wick extended a bit from this side so as to be easily lighted. There were gradual improvements in the Betty lamp. It was designed as a hanging lamp, often hung from the back of chairs, and as a standing lamp. The closely-related Phoebe lamp had a cup beneath the wick to catch the oil drippings. Betty and Phoebe lamps were in use until the American Civil War. Betty Lamp values: Iron Lid and Hook, circa 1850, $48; Iron, circa 1840, $36. Illustration on page 41.

BIBLE BOXES

The Bible box was brought to the shores of America with the early settlers. It was usually a deep rectangular box with a hinged lid, decorated with carving or paneling. The Pennsylvania Dutch often painted their Bible boxes. They were considered to be as important as any piece of furniture, and the family name could be found painted or carved on the lid. *Tip:* The Bible box was never made with a lock. Bible box values: Circa 1850, carved with hinged lid, $80; Painted Bible Box, circa 1860, good condition, original paint, $100.

BIRD CAGES

Small birds fluttering and chirping about in attractive bird cages became fashionable in England and France during the eighteenth century. By the middle of the nineteenth century, bird cages graced parlor and sitting rooms everywhere. Gothic-style bird cages were impressive in size, some large enough to accommodate a small aviary. Houses, palaces, castles and Chinese pagoda-shaped bird cages vied with those of dome or steeple form for attention. Some reached monumental proportions depending upon the skill of the craftsman. Brass, wicker, wire and wood cages frequently had water and seed boxes of porcelain or silver. Special cages were constructed for housing squirrels and parrots. All Victorian cages are in the "scarce" category. Bird-Cage values: Brass Bird Cage, small, circa 1880, $38; Chinese Pagoda, Oriental Design, Porcelain Feeder, circa 1880, $75; Gothic-style Bird Cage, large, circa 1850, $200.

BISQUE

The term "biscuit" or "bisque" is applied to pottery or porcelain in a once-fired but unglazed state. A craze for bisque swept through both England and the United States between 1850 and 1900. Bisque of the

eighteenth century was undecorated, but imperfections were apparent and a bit of coloring quickly concealed any imperfections. Decorated bisque was in vogue, and appealing figurines retailed for only $2.50 a pair in 1888. The numbers on the base of bisque refer to a factory style number; very few pieces bear a factory mark. Bisque was heavily produced in many countries during the 1800s and recent reproductions have flooded the market. Bisque is very fragile and perfect pieces made prior to 1900 have the highest market value. The country of origin on the base of a piece would indicate a production date after 1891. Bisque values: Girl with Basket, 10″ high, $30; Madonna, 9″ high, $35; Nodding Lady, 7″ high, $70; Piano Baby figurine, 10″ long, $125. Illustration on page 181.

BITTERS BOTTLES

The label on a bitters bottle would often proclaim that just one small spoonful would result in a miracle "cure all." A wide and varied range of bitters were made between 1850 and 1900. The contents were a mixture of herbs, roots, barks, and spices blended with liberal amounts of alcohol. Bottle buffs prefer the odd or unusual shaped bottles, with the word "bitters" on the glass, or one complete with paper label. A bitters bottle completely intact, with contents, plus label and outside box explaining its curative powers, is a collector's find. Prices vary depending on shape, color and rarity. Bitters values: Burdock Blood Bitters, $28; Halls Bitters, amber ¾ quart, $80; Old Dr. Warren's Quaker Bitters, $60; Royal Pepsin, with label and stopper, $70; Tippicanoe, deep amber, $72; Wallace Tonic, square amber, $65.

BLACKBERRY PATTERN

Hobbs, Brockunier of Wheeling, West Virginia, patented the blackberry pattern of pressed glass in 1870. They made complete tableware settings in clear glass and "hot cast porcelain" known today as milk glass. Blackberries, leaves and stems form the design, and the covered pieces have knobs or finials of blackberry fruit; handles on selected items are also in the blackberry shape. The firm continued making the pattern into the 1890s. Pick your blackberry pieces with utmost care as this pattern has been extensively reproduced. Authentic antique pieces are in demand with the milk-white version bringing slightly higher prices than the clear glass items. Blackberry values: Bowl, round covered, clear,

$15; milk glass, $30. Salt, footed, clear, $16; milk glass $31; Tumbler, clear, $12; milk glass, $25.

BLOCKS

Children of the Victorian era were provided with sensational assortments of interesting and educational blocks. A leading American toymaker of the period, the Crandall family, developed nested blocks which were quickly copied by other firms. They also advertised a wide variety of blocks, including Masquerade Blocks, Chinese Blocks, Building Blocks, Sectional Blocks, First Reader Blocks and Noah's Dominoes. Any set of blocks marked with the name Crandall is a worthwhile acquisition. Other important American toymakers who issued blocks were Morton Converse, S. L. Hill, McLoughlin Brothers and Milton Bradley. These firms competed with the European makers, the competition resulting in some extraordinary sets of blocks. Complete sets are rare; even finding an incomplete set of alphabet blocks means you've uncovered sufficient letters to spell out the word "money." Block values: Alphabet Blocks, set of eight nested, circa 1860, $70; Colored Lithographed Animal Set, circa 1880, $50; McLoughlin Brothers, Nested Blocks, circa 1870, $75.

BOHEMIAN GLASS

Elaborately engraved glass imported from Bohemia, Germany and Austria appealed to the Victorian taste. The glass had one or more layers of colored glass cut or engraved away in fancy patterns, so the underlying colors were revealed. As many as four layers of glass were applied, and the finished piece was quite magnificent when cut. Overlay is a name often given to this glass with one layer over the other, and often it is called "cased glass." American glasshouses produced some Bohemian glass in the same elaborate manner as the exquisite imported pieces. Bohemian Glass values: Bell, Deer and Castle Motif, $50; Compote Ruby, $45; Vase, 5″ high, Deer and Pinetree Motif, $40; Wine glass, 5″ high, $18; Wine Decanter, 10″ high, $40. Illustration on page 201.

BONE DISH

A small crescent-shaped bone dish was a standard Victorian table accessory for the deposit of fish or chicken bones. A fancy bone dish was

placed in front of each diner, and it was often a part of a dinner set. An ornate bone dish was often in the actual shape of a fish. Diners in the finer restaurants often received a souvenir bone dish as a little remembrance, after paying a hefty dinner bill, no doubt. The fad faded around the turn of the century, and nowadays collectors have discovered these bone dishes make interesting candy or nut dishes. Bone Dish values: Flow Blue, $10; Haviland, circa 1880–1900, $10; Ironstone, plain white, $8; Tea Leaf Ironstone, $10.

BOOKCASES

The bookcase became a standard item in the Victorian home, as the century saw a noted increase in the number of books published. The early period bookcase was often a simple make-shift design. This was replaced later in the century with elaborately handsome Gothic, Renaissance and Eastlake-style bookcases. Local cabinetmakers offered a wide choice of both open- and closed-front bookcases, which were generally custom made. Rosewood, mahogany, black walnut and various soft woods stained to resemble black walnut were used. Bookcase values: Eastlake, circa 1880, $340; Gothic style, circa 1840–1860, $400; Late Oak, circa 1890, $290.

BOOK FLASK

A pottery flask which was produced in both the brown Rockingham and flint-enamel glaze was made at Bennington, Vermont, in the mid-1800s. These novelty flasks were made in three sizes and some had titles impressed into the book shape. Dated specimens exist from 1849. Book flasks continued to be made during the 1850s and some of even later production have been noted. The flask was intended to hold rum or liquor; when filled with hot sand or hot water, it doubled as a hand warmer. Book Flask values: Book Flask (Departed Spirits), $78.

BOOKMARKS

Handcrafted bookmarks of the 1800s, crocheted, embroidered, hand-painted or employing woven or ribbon techniques, are all collectible. They rival the manufactured types of silver, silver plate, silk or lithographed paper for collectors' attention. The delicately embossed silver bookmarks, often combined with a paper cutter, had butterfly, fleur-de-lis, eagle and heart-shaped handles. Colorful paper and card-

board bookmarks of the 1870s were lithographed by the Louis Prang Company of Massachusetts and by Raphael Tuck of England. Especially choice are the silk bookmarks of Thomas Stevens, Coventry, England, known as Stevensgraphs. B. B. Tilt, an American firm, made silk bookmarks that resemble the Stevens pieces. These are usually marked with the firm name. Advertising, souvenir and commemorative bookmarks may pop from the pages of an old family volume. Bookmark values: Paper Advertising Bookmark, Mellon's Food, $1.50; Sampler Type, circa 1880, $7; Stevensgraph, Royal Mail Coach, $85; Stevensgraph, The Old Armchair, $75. Illustration on page 131.

BOOTJACKS

Boot wearers continued to rely on the prying power of the bootjack throughout the Victorian era. Despite the variety of shapes, all were equipped with "arms" to grasp the heel of the boot and pry it loose from the wearer's foot. Cast iron, wood and metal bootjacks in lyre, bug, pistol and lacy forms were enduringly popular. One bootjack of a lady in a reclining position has been nicknamed "Naughty Nellie," the darling of all bootjacks! Brass examples are rarer. Resist the urge to paint a bootjack as they are more saleable left in the original condition. Bootjack values: Beetle, cast iron, $14; Naughty Nellie, bronze, $26; Naughty Nellie, cast iron, $16; Tree of Life pattern, cast iron, $17.

BOOTSCRAPER

A stately town or country home may still have a bootscraper from the 1800s intact outside the front door. Those of Victorian vintage usually were set into a small slab of marble, although others may be secured to bricks or masonry, the standard form being two spikes with an iron arc between. The arc portion may have an intricate pattern of cast iron. Another type of bootscraper had a single spiked end protruding from the house masonry. Many a bootscraper has fallen victim to a rising skyscraper. Bootscraper values: Cast iron, sculptured ends, $18; scroll center and ends, 7" x 5", $20. Illustration on page 71.

BOOZ BOTTLE

Mr. E. G. Booz of Philadelphia, Pennsylvania, used a log-cabin-shaped bottle for his log cabin whiskey during the mid-nineteenth century. There were three original Booz bottles designed for this gentleman.

They have been joined over the years by numerous imitations and copies. The reproductions sometimes baffle even the experts. The bottle was made to represent the birthplace of William Henry Harrison, who campaigned in 1840 with the slogan "log cabin and hard cider." Booz Bottle values: E. G. Booz Cabin, amber, early, $325.

BOSTON ROCKER

This most popular of all American rocking chairs was often made by factories specializing in Hitchcock-type chairs. The Boston rocker is easily recognized by its tall spindle back, curved arms and a broad top rail usually ornamented with stenciled designs. The seat varies from oval to rectangular, with a boldly rolled front, upcurved at the rear. A number of rockers were constructed of maple with seats of pine, and were often painted or grained to resemble rosewood. The rocker was made in a smaller size without arms as a lady's rocker. Introduced about 1835, it was mass-produced by furniture factories later in the century. Boston Rocker values: Refinished, $160; rough condition, $90; Lady's Rocker, without arms, $130. Illustration on page 31.

BRADLEY GAMES

Parlor games spelled happy hours for Victorian children. Milton Bradley issued "The Checkered Game of Life" in 1860. This initial effort met with such success that the still active firm continued introducing new and exciting parlor games, many based on current events. Between 1860 and 1900 the Bradley name became associated with indoor games, and their catalogues gave detailed information about their products. Sliced maps of the United States and puzzles like the "Smashed Up Locomotive" proved popular. They advertised "Croqueterie," a game based on croquet, in the 1860s. A neglected toy chest may yield a Bradley crayon set, an optical toy, a set of blocks or a paper doll house. To a collector, Bradley is the name of the game. Bradley Game values: Building Blocks, original box, circa 1880, $30; Tiddly Winks, circa 1890, $8; Twilight Express, $48.

BRASS BEDSTEAD

Brass beds ranged from fancy types ornamented with many knobs and finials to plainer tubular varieties. American and European factories were busy meeting the demand for these bedsteads during the late nine-

teenth and early twentieth century. They vied in the marketplace with the equally popular cast-iron beds produced during the same time. They are still in demand and may be found in numerous sizes. The more ornate examples fetch the highest prices. Brass Bed values: Burnished Fancy Double Bed, $700; Plain Double Bed, $400; Plain Single, $240; Ornate Single, $450.

BRASS FURNITURE

The London Crystal Palace Exhibition of 1851 afforded visitors an opportunity to glimpse the exciting new innovative brass furnishings. A new technique led to the development of furniture forms manufactured from drawn brass tubing, and embellished with cast brass ornaments, sparking a brass fad that lasted until the end of the period. Brass accessories provided even the darkest room with a bold new look. Drawing rooms, parlors, bedrooms, and hallways were soon brightened with brass beds, candelabra, rocking chairs, chandeliers, cribs and hat racks. *Tip:* One or more coats of paint may be hiding the true beauty of a brass treasure from the Victorian era. The paint can easily be removed and the brass polished to original condition. Brass Furniture values: Coal Box, circa 1870, $80; Standing Hat Rack, $75; Umbrella Stand, Lion's Head Handles, $35.

BRAZIL PATTERN

This cream-colored semi-porcelain dinnerware pattern was exported to the United States during the 1880s by the English potters G. W. Turner. They obviously had an awareness of the public's restless urge for romantic faraway places, so prevalent during the 1880s and 1890s. "Brazil" featured a profusion of tropical foliage, plantation leaves, moths, and added detail that varied depending on the size of the piece. Basketwork rims gave this brown, printed pattern further distinction. The pattern name, Brazil, appears within the factory trademark, a shield, along with the firm name and location on the underside of this dinner service, providing positive identification. Brazil Pattern values: Cup and Saucer, $10; Plate, $5; Platter, medium size, $20.

BREAD TRAYS

The bread platter, or service plate, was a familiar sight on a table of the 1800s. A tray was frequently a part of a pressed-glass pattern set

Chest of Drawers

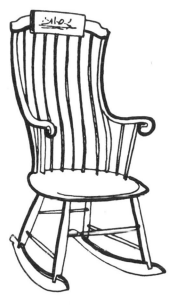

Hitchcock Chair

Boston Rocker

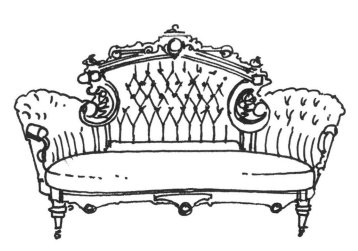

Renaissance Revival Chair

Renaissance Revival Sofa

in a well-known pattern of the day. Commemorative trays were in demand and eagles and flags were favorite motifs for 1876, the Centennial Exposition year. Garfield, Washington, Cleveland and McKinley were often subjects on bread platters, but Ulysses S. Grant was the most honored President. The Model Flint Glass Company issued the Last Supper tray around 1890, while the Liberty Bell platter was made in 1875. A number of bread trays have been reproduced. Bread Tray values: Centennial Pattern, $70; Frosted Lion Pattern, $45; Last Supper, $30; Three Graces, $30; Wheat and Barley, $25.

BREWSTER AND BALDWIN PRINTS

Two active American carriage makers of the nineteenth century, Brewster and Baldwin, presented their agents and customers with handsome prints. The prints pictured famous horses of the period. The two firms issued a number of selected prints, and subjects included Lady Suffolk, George M. Patchen, Ethan Allen, Flora Temple and Princess. The Baldwin firm issued a print, "Celebrated Flyers of the Trotting Turf," that is highly regarded. Brewster and Baldwin Print values: Ethan Allen Print, $130.

BRISTOL GLASS

This opaque blown-glass was heavily imported from the Bristol district of England during the eighteenth and nineteenth centuries. The name Bristol is given to this type of glass regardless of the country of origin. Bohemian Bristol is recognized by its bright enamel coloring, while the French pieces are often decorated with gold. The Bristol of the Victorian era was more ornate with ruffled or crimped edges. Bristol Glass values: Cologne Bottles, 10″ high, pair $50; Egg, 7″, gold decor, $18; Ewer, 8″ high, $40; Vase, 12″ high, enameled decor, pair $90.

BRITANNIA WARE

A name applied to an alloy closely associated with pewter, whose percentage of copper, tin, antimony and other metals always varies slightly depending upon the manufacturer. Britannia is a bit more silver in appearance than pewter. The discovery that Britannia metal could be successfully electroplated resulted in its becoming a household favorite of the mid-nineteenth century. A number of pieces bear factory marks which can be quickly identified. Britannia values: Basket, 10″ x 10″,

circa 1860, resilvered, $45; Butter Dish, ornate, resilvered, $30; Spoon-holder, resilvered, $18.

BRITISH ROYAL ARMS

English potters incorporated the British Royal Arms into their printed or impressed marks during the nineteenth century. A study of the mark can provide a key to dating ceramics. Prior to the accession of Queen Victoria in 1837 there was a small inescutcheon, or extra shield, in the center of the quartered shield. Between 1801 and 1814, this extra shield had a cap over the top, replaced between 1814 and 1837 by a crown. All the arms engraved after 1837 have only the simple quartered shield. American potters also copied the arms mark, necessitating a careful examination.

BRONTE MIRRORS

The A. P. C. Bronte Company of Cincinnati, Ohio, distributed thousands of mirrors to their Midwest customers between 1850 and 1870. A wide variety of mirrors encompassing fashionable styles of the day found favor with Victorian homemakers. A lithographed label picturing the Bronte factory makes positive identification possible. Bronte Mirror values: Oval Mirror, good condition, $84; Rectangular Mirror, medium size, $70.

BRONZE CLOCKS

French bronze mantel clocks became fashionable in the mid 1800s, causing concern among American clockmakers. In an effort to compete with the quantity of imported French clocks, American makers introduced bronze clocks about 1870. Oriental, Egyptian and Grecian forms were the source of inspiration to American clockmakers, and many cases were made in rococo designs. Clock cases of bronze topped with cupids, figures, animals and vases were further ornamented with marble and ormulu trim. A number of novelty shelf clocks were also made by enterprising concerns. Toward the latter part of the century, bronze top and side pieces could be purchased separately, to further embellish a favorite timepiece. Bronze Clock values: Bronze Clock, Marble Trim, 34″ tall, circa 1850, $250; Bronze Clock Under Dome, 10″ x 12″, $160; Ormulu and Bronze Mantel Clock, circa 1870, $165; Waterbury Bronze Clock, hour and half-hour strike, repeater movement, $90.

BROWNIES

Palmer Cox captured the imagination of the nation when his first Brownie book appeared in 1883. The Brownies became legendary after thirteen books revealed how they liked to do good deeds and never expected any thanks. They were soon pictured on china and glass and in magazines. They were also made as dolls, and Cox patented twelve of his Brownie characters to be printed and stuffed as rag dolls. The Brownie rag dolls have been reprinted recently, so please do yourself a favor and be certain not to confuse them with the originals. Brownie values: Cup and Saucer, child's, $18; Paper Dolls, set of four, $15; Demitasse Spoons, $8; Platter, $38; Wood Bank, $25.

BRU DOLLS

A French dollmaker, M. Bru, captivated children and adults alike during the 1800s with his beautifully detailed French fashion dolls. All the clothing that a fashionable lady of the day would wear was reproduced for these dolls. Early Bru dolls had bisque heads and kid bodies. The later versions had jointed wooden bodies. The shoulder head with the swivel neck was a Bru specialty. *Tip*: A clearly incised *BRU* appeared on the left shoulder of authentic Bru French fashion dolls. Reproductions currently being imported carry exactly the same mark. Examine the doll head closely as eyes and wigs differ slightly and the glaze is brighter on the new imports. Antique Bru dolls have exquisite features and defy comparison. Bru doll values: 24″ high, bisque head, incised mark, kid body, dressed, $750.

BUCKMAN TOYS

This New York City-based firm made a line of steam toys operated by small boilers during the 1860s that captivated the younger set. The toys were capable of dispensing a stream of water and retailed for the then fancy price of from five to fifteen dollars. The steam fire engine was able to dispense a stream of water twenty feet into the air. The model side-wheel steamboat also caused a mild sensation. Buckman steam toys rank as among the finest ever produced in America. Gather up a bit of steam and proceed on an antiquing trip to find one of these treasures. Buckman Toy values: Steam Engine, stationary, $60.

BULL'S EYE PATTERN

American glasshouses were right on target when they introduced this pressed-glass pattern around the mid-1800s. Large bull's-eye circles dominate the bold design, often known as Lawrence. A number of important firms made this pattern or a variant between 1850 and 1900, the majority of pieces being of fine-quality, clear and brilliant glass. Further acceptance was afforded the bull's-eye pattern when it became a souvenir item in the 1890s. Factories found it suitable for engraving when issued in ruby stained glass. Bull's-eye variants are easily spotted due to their descriptive names: Bull's Eye and Fan, Bull's Eye and Star, Bull's Eye and Diamond Point, Bull's Eye and Fleur de Lis, and Bull's Eye with Drape. Bull's Eye values: Celery Dish, $37; Cordial, $14; Cruet, $25; Tumbler, $28.

BUNKER HILL BOTTLE

This handsome fifteen-inch-high bottle in the form of the Bunker Hill Monument, a bottle collector's triumph, dates from the 1870s. Bunker Hill Bottle value: Green, $68.

BURMESE GLASS

Frederick Shirley of the Mt. Washington Glass Company of New Bedford, Massachusetts, patented this shaded opaque glass in 1885. Burmese shades from soft yellow to flesh or salmon pink, and while some pieces have a glazed or glossy surface, most have a satin finish. The coloring shades in such a gradual way that it is difficult to determine where one color ends and another starts. A license was granted to Thomas Webb & Sons, of England, to produce Burmese abroad. The Webb glass became known as Queen's Burmese Ware. *Tip:* The pontil mark on Burmese was often concealed by a berry-shaped piece of glass. This can aid in the positive identification of an authentic piece. Burmese Glass values: Bowl, 5", $370; Rose Bowl Miniature, $220; Toothpick Holder, $260; Vase, 5", floral decor, $380; Tumbler, acid finish, $285.

BUTTER MOLDS

Hand-carved butter molds of the early 1800s are now classified as folk sculpture. Later in the century the majority of molds were turned on a lathe. Frequently associated with the Pennsylvania German area, they were prevalent in other dairy regions across the country. The shapes

vary from round to rectangular, and the designs are numerous and include eagle, pineapple, cow, sheaf of wheat, tulip, heart, acorn, swan, dove and hen motifs. Those having the farmer's initials carved into the base provide an unexpected surprise even to one who regularly peers into the base of a butter mold searching for an unusual design. The one-pound brick of butter was stamped with a rectangular trough print, while the butter pat received its imprint from a small round mold. Butter Mold values: Cow design, $12; Flowers and Leaves, $11; Sheaf of Wheat, $10.

BUTTER PATS

A small disk was placed in front of each person at a table to hold a pat of butter. They were often a part of a dinnerware set, and porcelain and earthenware examples can be found. Delicate floral patterns, flow blue, ironstone, both plain white and tea leaf, are but a few of the endless varieties spotted at shops and shows. Small butter pats appeal to those with small collecting budgets. The butter-pat vogue ended around the turn of the century. Butter Pat values: Haviland, circa 1880, $4; Meakin Ironstone, $3; Majolica Leaf Shape, $6; Onion Pattern, $4; Tea Leaf Ironstone, $4.

BUTTONS

The button collector may wish to specialize in a particular category, as the field is wide and varied. Brass buttons covered with a thin wash of gilt were in vogue between 1830 and 1850, the so-called Golden Age of gilt buttons. Hard-rubber buttons, attributed to Nelson Goodyear, proved to be extremely popular, with over five hundred patterns issued between 1850 and 1860. Jenny Lind and Hungarian patriot Louis Kosmuth are two of the many notables with special buttons made in their honor. Cloth, china, pearl, enameled and hand-painted buttons are just a few of those that can be found in a neglected trinket box. Uniform buttons, civilian or Civil War types, are noteworthy. Glass buttons employing the latest glass techniques, and small jet buttons, the rage of the 1870s, await the button buff. Kate Greenaway and small hand-crocheted buttons, along with picture buttons, led the button parade in the 1880s and 1890s. Finding a bag of Victorian buttons could prove to be a bonanza. Button values: Brass Button, St. George and the Dragon, $14; Hard-Rubber Goodyear, 1851, basketweave design, $6; Kate Greenaway Children, Brass, $14; Silver Button, Prancing Horse, $10.

C

CABINET ORGAN

The organ was an essential piece of furniture in the late Victorian period. Family life centered about the family cabinet organ, also known as an American organ. The majestic tones emanating from the organ were produced by the vibration of the various shaped and sized reeds. The maker's name, usually found above the keyboard, will provide you with sufficient information to establish the age and origin of a parlor organ. Despite their rather massive proportions, they are in demand, particularly those that have not been trimmed down in size over the years. Those displaying Eastlake-style details are truly architectural musical achievements, in the grandest manner. Cabinet Organ values: Estey, 88 keys, working condition, $750.

CAMEO GLASS

This type of glass resembles an actual cameo, made in layers and cut or carved away, leaving a raised design. Run your fingers over the design; it will be rough and irregular. Cameo glass was produced in England, France and other European countries around the 1870s. A very limited amount of cameo glass was produced in the United States. Art Nouveau designs are found on French cameo glass by Gallé and the Daum Brothers, among others. Connoisseurs of fine glass appreciate the artistry and special techniques required to make true cameo glass. *Tip:* Gallé glass was always signed with the maker's name. He worked between 1879 and 1905. Each piece of glass made after his death in 1905 will bear his name accompanied by a star. Cameo Glass values: Bottle, 6″ high, signed Gallé, $175; Bowl, 5″ in diameter, signed Gallé, $350; Inkwell, 4″ Daum Nancy, $225; Pitcher, 8″ signed Gallé, $375; Vase, 8″ high, Daum Nancy, $485.

CAMEO JEWELRY

Napoleon gave his beloved Josephine eighty-two magnificent antique cameos. A fashion trend was thereby established which far ex-

ceeded the supply of antique cameos, resulting in both shell and stone cameos being worn for the duration of the Victorian era. Guests at the wedding of Queen Victoria and Prince Albert in 1840 were given cameo rings having a likeness of the Queen as a remembrance. There are two types of cameos: the gem cameo, where the design is cut in relief on a stone such as onyx, sardonyx or agate; and the shell cameo. The shell cameo, made for the masses, is of Italian origin, the artists there reached a high degree of perfection in the art of cameo cutting. Cameo Jewelry values: Shell Cameo Brooch, set in fourteen-carat gold with seed pearls, $135; Man's Carved Onyx Cameo-Ring, eighteen-carat gold, heavy, $195.

CAMPAIGN ITEMS

Beginning with the political campaign of William Henry Harrison for President in 1840, souvenir items have been issued to promote political candidates. Buttons, stickpins, posters, banners, and tokens are a few of the many campaign articles. Handkerchiefs of linen, cotton or silk are lasting mementos. The campaign collector's mania does not end with the successful candidates only, as souvenir pieces pertaining to the "losers" are also in demand. Campaign Item values: Cane, McKinley, $39; Handkerchief, Harrison, 1888, $22; Hat, Blaine and Logan, 1884, $52; Token, Grant, 1872, $45.

CANDLESTICKS

The candlestick was being replaced in the middle 1800s by the oil lamp, and later in the century by electricity. The candlestick became less functional and more ornamental in the transition. The shape of the candlestick changed with the style of the moment, borrowing from Gothic, Rococo, Classical and other revival forms. Ormulu candelabra were influenced early in the period by the French. They incorporated typical motifs, and there were many "Bouillottes" or shaded candelabra. The new candle innovation was the spring candlestick. The candle set into the tubular holder pressed on a spring which slowly pushed the candle upward as it burned. Candlestick values: Candelabra, brass, 14″ high, three-branch type, circa 1870, $87; Candle Holder, saucer type, brass, $36; Candelabra, silverplated, five-branch, 15″ high, $65; Candlesticks, brass, beehive type with pushups 9″ high, $62.

CANE FURNITURE

One of the foremost industries in New York City during the nineteenth century was the production of the popular cane (wicker or rattan) furniture. The cane, the sturdy stem and tendril of a climbing palm, was imported from the East Indies and created handsome furniture. White oak and hickory usually provided the frame around which the cane was woven. Cane furniture was almost entirely handcrafted. Wicker and rattan pieces may often be purchased at a country auction for a price far less than the current market value in a metropolitan area. Cane Furniture values: Doll Carriage, circa 1890, original finish, $70; Wicker Bassinet, $40; Wicker Rocker, $80.

CANEWARE

The tan-colored, unglazed, dry-body caneware was developed by Josiah Wedgwood in the latter part of the eighteenth century. By the 1840s numerous other English potters were making effective caneware objects with relief decoration, or molded designs, often highlighted with enamel work. Serving-jugs of caneware were favored by many potters, and the first ovenproof dinnerware of the 1850s was of ironstone caneware. The number of pieces modeled in the form of bamboo shoots has given rise to the term "Bamboo Ware" in reference to caneware. Caneware values: Pie Dish, game motif, $84; Teapot, caneware relief designs, $90.

CANNON-BALL BED

Popular during the early Victorian period, 1840–1850, this bed featured four turned posts, all topped with a ball finial. The ball finial top was quickly nicknamed "cannon ball," thus cannon-ball bed. Country cabinetmakers favored the design, which was made with a headboard; rather than a matching footboard there was merely a blanket rail at the foot of the bed. Cannon-Ball Bed values: Curly Maple, circa 1850, $225; Softwood refinished, circa 1850, $215.

CANTON WARE

Exported in large quantities to the United States since the 1780s, blue-and-white Chinese ware was decorated by families who resided in or near the city of Canton. Canton is referred to as "China-trade porce-

lain," and was exported to Europe and America on clipper ships. Any nineteenth-century piece of Canton will find a ready buyer. The bulk of the ware is unmarked. Canton produced prior to 1890 has the greatest value to a collector. A limited quantity of it was decorated in brown and is called Canton Bistre. *Tip:* True Canton never pictured any figures on the bridge in the Willow design. Canton values: Ginger Jar, 6½" high, $70; Plate, 7½" diameter, $35; Teapot, strap handle, 4" high, $80; Hot Water Plate, $70; Tray, fish shape, 10" x 11", $85.

CARNELIAN JEWELRY

This brownish-red stone was considered by Victorians to possess protective qualities and guard the wearer against danger. Napoleon never ventured into battle without his carnelian. If a person was wounded, all bleeding would immediately stop by placing a carnelian near the spot. You're a non-believer? Take a carnelian with you anyway—your great-grandmother wouldn't want it any other way. Carnelian values: Necklace, 18" long, circa 1860, gold clasp, $28.

CARPET BALLS

These heavy pottery balls were used with the popular parlor game of Carpet Bowls. The game enjoyed widespread popularity during the first part of the 1800s. A complete set comprised six balls, decorated with plaids, stripes, floral designs, or striping similar to marbles. One white ball completed the set and was often self-colored by the participant. The balls were made in Scotland and the Staffordshire district of England, and were of brown stoneware or white earthenware colored with the design. Carpet Ball values: Striped, baseball size, good condition, $32.

CARRARA

Named for the Italian marble Carrara, this clear, sharp blue-printed dinner service on durable ironstone dates from the 1850s. The designer incorporated statuary consisting of this marble as the central theme. A formal garden is the subject matter, complete with a large statuary group of a woman, girl, and greyhound, along with innumerable other statues, urns, castles, trees and water. The pattern name and maker's mark, *John Holland of Tunstall, England,* appear on the underside; often included

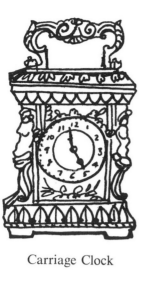

Carriage Clock

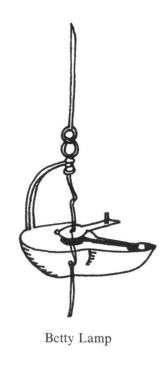

Betty Lamp

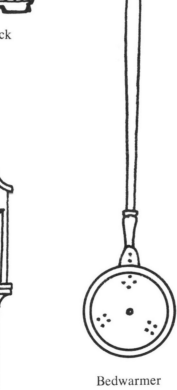

Bedwarmer

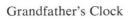

Grandfather's Clock

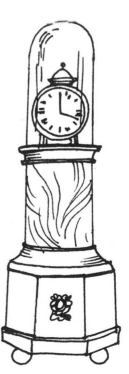

Lighthouse Clock

is the English registry mark. Carrara values: Cup and Saucer, $18; Plate, $11; Teapot, $45.

CARRIAGE CLOCKS

Portable clocks achieved new pinnacles of popularity in the latter part of the 1800s. They were usually French in origin, known as *pendules de voyage*. Two prominent French makers were H. Dacot and A. Droucourt, both active in the last quarter of the nineteenth century. A familiar type of small traveling clock is the style fitted with a brass mounting and topped with an ornate handle. There were cases of gilt, silver and rosewood, with mechanisms differing with each maker. *Tip:* Antique clocks should always be repaired by professional clockmakers using authentic replacement parts. Carriage Clock values: Carriage Clock, ormulu, circa 1870, working condition, $160; Carriage Clock, nickel over brass, running, circa 1880, $110; Carriage Clock, Waterbury, 1891, alarm working, $68. Illustration on page 41.

CARROUSEL FIGURES

A figure of an animal or human, once associated with a nineteenth-century carrousel, is a prized acquisition. The earliest ones are known to date from the 1840s; however, most carrousel figures are from the 1870s. Carrousel figures, whether giraffe, zebra or flying angel, should always be left in their original condition. Giving these valued objects a fresh coat of paint may brighten your decor, but lessens their antique value considerably. The word "carrousel" is derived from "carry us all." Carrousel Figure values: Camel, $850; Horse, good condition, $650; Lion, $800; Ostrich, $850.

CARTLIDGE, CHARLES

A partnership between Henry Q. Ferguson and Charles Cartlidge resulted in the formation of a pottery located at Greenpoint, New York, in 1848. The rococo revival influence prevails in the decoration and shapes of the Cartlidge porcelains of the 1850s. Many of the designs were similar to the eighteenth-century porcelains, employing gilt and polychrome decoration, with light naturalistic relief elements. Their biscuit busts, modeled by Josiah Jones, of Daniel Webster, Archbishop Hughes, Zachary Taylor and others enabled the firm to enjoy an excellent reputation. The factory remained active until 1856; the works continued

under the name Union Porcelain. Cartlidge Porcelain values: Cup and Saucer, floral with gilt decor, $60; Plate, floral motif, $42.

CASHMERE PATTERN

The flow blue patterns of the early Victorian period are so blurred as to be practically indistinguishable. Such a design is Cashmere of the 1850s from the Frances Morley firm of Shelton, England. The oriental design printed in cobalt blue on a white ironstone base must be held to a light before the trees, flowers, shrubbery and animal subjects are discernable. The flowing away from the design was intentional, and the cobalt so concentrated that even the reverse sides of individual pieces were permeated with the color. The firm's trademark is printed in dark cobalt color on the underside. The bidding may reach new heights when the auctioneer holds up a piece of flow blue Cashmere. Cashmere values: Bowl, $30; Plate 7″ diameter, $18; Sauce, $14; Sugar Bowl, $52.

CAST-IRON FURNITURE

Catalogues of the 1870s pictured numerous pieces of iron furniture suitable for both house and garden. Iron plant stands, mirrors, hall racks, tables, chairs, towel racks and washstands were offered for interior decorating. The indoor furniture was painted black with gilding, or often in colors resembling wood. The cast-iron bed was a particular favorite and was widely distributed during the late Victorian period. Gothic or rococo iron settees, benches and tables with matching chairs were produced for gardens. The iron furniture makers also listed many fancy wire pieces, as they discovered wire could be twisted into imaginative shapes, perfect for outdoor use. Robert Wood of Philadelphia issued a complete catalog of impressive cast-iron furniture designs as early as 1840. By 1860 there were numerous local foundries making furniture similar to the Wood designs. The pieces were in parts held together by iron bolts, and thus could be mass produced. Popular patterns of the day included grape, fern and scroll and lily of the valley. *Tip:* The grape pattern cast-iron furniture has been reproduced. Aluminum alloy is often substituted in place of iron. Antique pieces will frequently have welding patches, as the brittle iron often needed repair. Examine pieces carefully for such damage, as they should be priced a bit lower to allow for this repair work. Cast-Iron Furniture values: Bed, fancy, $260; Fern Pattern Settee, $275; Lily of the Valley Armchair, $215; Garden Pedestal Table, 28″

high by 32″ in diameter, $200; Oval Mirror Frame, patent 1862, $90. Illustrations on pages 61, 71.

CASTOR SETS

The castor set was a standard tabletop accessory of the 1800s. The frames of pewter, porcelain, pottery, britannia, silver or silver plate were made to accommodate from two to six bottles. The frames became more elaborate as the century progressed and the upper portion holding the bottles often rotated. The bottles were of clear, colored and opaque glass, in many designs and patterns including Daisy and Button, Fine Rib, Beaded Dewdrop and Thumbprint. Bottles of satin, cranberry, ruby and engraved glass, among others, could be purchased separately to replace broken ones. The bottles were often made to match the frames. *Tip:* Examine the bottles to ascertain if they are all original, rather than being new replacements. Castor Set values: Two Bottles, cranberry, silver-plated frame, $52; Four Bottles, amber, Daisy and Button pattern glass, silverplated frame, $96; Six Bottles, ruby glass, silverplated frame, $125.

CATSKILL MOSS PATTERN

William Ridgway imported this important dinner service to America through his import agent Charles Cartlidge in the 1840s. American homemakers stocked their cupboards with this pattern in blue with dark blue, or gray with black printed on a fine durable ironstone body. Views of New York, New Hampshire, Massachusetts, Washington, D.C., and other areas depicted scenes from everyday American life. The sprigs of moss on the deep rim borders gave the pattern the name Catskill Moss. American views on English wares are fondly known to a horde of faithful collectors as Old Blue or Historical Blue. The English potters are thought to have relied upon paintings and prints for their American views. Catskill Moss values: Cup and Saucer, light blue, $75; Plate, 9½″ diameter, $40.

CELLULOID

John Wesley Hyatt perfected celluloid, the first commercial plastic, in 1868. Collar boxes, bookmarks, dresser sets, and needle cases of celluloid were sold during the late nineteenth century. Plastic or not, celluloid rates as a genuine antique. Celluloid values: Bookmark, $4; Box, 4″ x 6″, $9; Doll, 19″ tall, $70; Needle Case, $10.

CHAISE LONGUE

Empress Eugénie brought about the revival of the chaise longue in France during the 1860s. This direct descendant of the Jacobean day bed also staged a comeback in England and America within the next decade. Designed for maximum reclining comfort, the cushioned chaise longue has a curved support for the reclining body, permitting the legs to be outstretched on the cane or upholstered seat. This was a boudoir piece, as Victorian morals deemed it unthinkable for a lady to be seen with her feet up. A later version of this piece was the popular fainting couch. Chaise Longue values: Circa 1870, good condition, $500. Illustration on page 51.

CHALKWARE

Plaster of Paris ornaments, painted in bright garish colors to attract willing buyers, were generally made into busts and classical figures. Italian immigrant "folk artists" made and sold chalkware statuary during the nineteenth century. Peddlers and street vendors sold numerous chalkware pieces to the masses who could not afford the more costly porcelains. Wealthy Victorians considered chalkware cheap, vulgar and gaudy. Antique pieces today may be considered by some to be vulgar and gaudy, but they are rarely cheap anymore. *Tip:* Chalkware was never a Pennsylvania folk art. Chalkware values: Cat, $70; Dog, 11" high, $65; Figurines, 12" high, pair, $90; Stag, 16" x 18", $80.

CHASE STOCKINETTE DOLL

Introduced about 1891, this beloved American rag doll was the creation of Martha Chase of Pawtucket, Rhode Island. The business developed from Mrs. Chase's fascination with rag dolls and began as a home project. Public response was most enthusiastic and Chase dolls were soon captivating little girls the country over. The faces on the Chase dolls resemble real children and the dolls are clearly marked with a label. The label reads "The Chase Stockinette Doll, Made of Stockinette and Cloth, Stuffed with Cotton, Made by hand, Painted by hand." Chase Stockinette Doll values: 16" tall, $42; 22" tall, $60.

CHELSEA GRAPE

In this pattern small grape clusters in raised relief form the design on a white soft-paste porcelain body. The grapes were given a coloring

of blue, lavender or purple luster. The fine quality white body was ideal for this type of sparse decoration. The name Chelsea is misleading, as the majority of Chelsea Grape related wares are thought to have originated at the Coalport factory during the 1800s, not the famous Chelsea firm active in the late eighteenth century. Grandmother's Ware is an acceptable name for this pattern, since every grandmother had some Chelsea Grape stored in the family cupboard during the 1840s and earlier. Chelsea Grape Pattern values: Butter Pat, $4.50; Cup and Saucer, $42; Plate, 9½″ diameter, $39; Sugar Bowl, $83.

CHEST OF DRAWERS

Available with or without an attached mirror, the chest of drawers has long been considered a standard piece of bedroom furniture. During the 1840s and 1850s a chest of drawers surmounted by a stationary or tilting mirror was referred to as a bureau. Chests of the early Victorian period were the work of cabinetmakers and had hand-cut dovetails on the drawers, roughly smoothed backboards and a similar finish on undersides of drawer bottoms. Such handwork will be in evidence on the chests of finer quality, combined with machine work. The chest of drawers varied with prevailing furniture styles, and may have Gothic, Rococo, Renaissance and Eastlake influences, providing a clue to age. Less plentiful are the chests of drawers with spool-turned details. This piece was always a part of a complete bedroom set, even on the inexpensive cottage types, which were frequently painted. Wood or marble tops usually overhang the carcase up to one inch on front and sides and all were fitted with casters. Chest of Drawers values: Pine Chest, Cottage-type, circa 1870, $230; Walnut, six drawers, refinished, circa 1860, $335; Walnut, marble top, four drawers, circa 1870, $330. Illustrations on pages 31, 83.

CHEVAL GLASS

Improvements in the manufacturing of plate glass by the late eighteenth century resulted in the development of the cheval glass. By the middle of the 1800s dressing-room and bedroom furnishings were being rearranged to accommodate this large full-length mirror. The mirror was mounted between two upright supports or in a wooden frame, upon a mechanism enabling it to tilt or swing. Most were equipped with casters making them more maneuverable. Rosewood and mahogany woods were

favored for the cheval glass of the Victorian years. Cheval Glass values: Rosewood, good condition, circa 1850, $500.

CHIFFONIER

A term popularized in America during the late 1800s for a tall narrow chest of drawers or bureau. The word was derived from the French *chiffonier,* meaning ragpicker; in French cabinetwork the word referred to a tall chest of drawers ideal for storing sewing and needlework paraphernalia. The American version was often made with an attached mirror. Chiffonier values: Rosewood, refinished, circa 1870, $375.

CHILDREN'S MUGS

Staffordshire potters kept a steady flow of children's mugs heading in the direction of the United States between 1840 and 1900. Mugs of ironstone, pottery, porcelain, lusterware, creamware, Mocha ware, and other ceramic creations were hand-painted or transfer-printed with pretty pictures. There were animals, alphabet letters, scenes, inscriptions, Franklin's maxims, month mugs, rhymes, portraits, and by the 1880s Kate Greenaway children, pictured on children's mugs. The Game Series, showing children playing marbles, leap frog or skipping rope, was a sure winner. A gift mug personally inscribed with the name of the recipient provided a personal touch. The earlier hand-painted mugs bring higher prices than the later transfer-printed types, with subject matter and makers' marks also contributing to desirability. Children's Mugs values: A Trifle for Eliza, pink transfer name and border, $42; Kate Greenaway Mug, circa 1890, $38; Mary, 2½" high, blue and white Staffordshire, $33.

CHINA CLOSET

The china closet became increasingly popular during the latter part of the 1800s, gradually replacing the open cupboard as a display piece. This was actually an improvement over the earlier what-not shelves, providing an enclosed place for the safekeeping of the family's choicest china and glass. The china closet was a cased piece on short legs with front and sides of glass, and wooden shelves and back. In some pieces a mirrored back enabled the viewer to be impressed by the double impact of the family treasures. A number of china closets came from the factories

at Grand Rapids. China Closet values: Bow Front, four shelves, mirrored back, circa 1890, oak, $230.

CHINA DOGS

These rarely marked mantelpiece ornaments or Staffordshire chimney ornaments of earthenware were made by a number of English potters. Spaniels, greyhounds, Welsh sheep dogs and French poodles were favored subjects. Pre-1850 dogs were modeled on a rocky base; after this date the dogs were placed on a plinth or stand. They had their greatest popularity and production period between 1880 and 1900. Glass eyes were an added feature, denoting a later date of production, often into the twentieth century. The nineteenth century figures have a tendency to form a fine network of lines, and this glaze crackling makes it possible to identify them from the new reproductions. *Tip:* "Made in England" on the base of a piece indicates it was made during the early twentieth century. China Dog values: Afghan Hounds, 13" high, white with gilt, pair, $85; Poodles, 13" high, black and white, pair, $90; Spaniels, 8½" high, circa 1870, $110; Spaniels, 13" high, circa 1870, pair, $160.

CHINA PAINTING

The craze among fashionable Victorian ladies for painting on china reached such proportions that china manufacturers around the world were busy supplying undecorated pieces or blanks. Fine porcelains were imported from France and England, and American manufacturers were flooded with requests for undecorated wares. The art of china painting was first popular in England and on the Continent and by the 1880s ladies across the United States were attending classes and forming clubs. Exhibitions were worldwide and the art world acclaimed this medium, accepting it as a branch of the decorative arts. Signed and dated examples, bearing the mark of a noted manufacturer, are sought after by those who appreciate the china-painting efforts of the Victorian era. Hand-painted China values: Plate, 8" diameter, floral decor, $18; Pitcher, 12" high, $55; Punch Bowl, large, Haviland mark, $150; Trinket Box, roses, $19.

CIGAR STORE INDIANS

A familiar sight on display in front of the local tobacco establishment of the 1800s was a cigar store Indian chief or maiden. The brightly-

painted figures would frequently have one arm extended for displaying wooden cigars. Other tobacconists preferred a full-size wooden figure of Sir Walter Raleigh, Mr. Pickwick, or even a Scottish Highlander. The cigar store Indians rank as the real favorites in the fine American tradition of unusual shop figures. They are best left in their original condition, if their antique value is to be retained. Cigar Store Indian values: Chief, 7' high, $5,000; Squaw, small, $3,000; Maiden, 6' tall, $4,200.

CIRCULAR SOFA

A favorite place for small talk, the circular sofa, or *causeuse,* was extensively used in drawing rooms, hotel lobbies and other public places during the nineteenth century. The upholstered back had a molded edge suitable for a palm, or other exotic foliage plant. The circular upholstered seat had a molded seat rail, and was frequently trimmed with deep fringe. The Turkish influence was in evidence on later circular sofas, circa 1870–1890. They are in demand, as there are few surviving examples of this circular roundabout rendezvous. Circular Sofa values: Turkish style, circa 1890, rough condition, $340; Upholstered, good condition, $600. Illustration on page 51.

CIVIL WAR MEMORABILIA

A growing number of collectors are searching for Civil War-related items, dating between 1861 and 1865. The present interest indicates that any article concerning the War Between the States has monetary value. The military objects represent the largest and most extensive group. This all-encompassing field also covers prints, buttons, paper memorabilia, clothing and a host of Civil War-connected paraphernalia. Civil War Memorabilia values: Bowie Knife, ivory handle, without maker's mark or scabbard, $72; Mess Kit, leather, complete with utensils, $26; Saddle Bag, leather, good condition, with maker's name, $52; Sword, Confederate, 36" long, with scabbard, $210.

CLAREMONT PATTERN

A table top triumph of the 1870s was this dinnerware service printed in blue, orchid and other colors. Deep loops and acanthus leaves surround the borders, while the central motif features a typical garden view, containing antique urns atop pedestals, elm trees, vines and a large spray of English flowers in the foreground. The royal garter trademark,

with a crown, reads "Royal Semi-Porcelain" within its border, and inside the garter mark the pattern name "Claremont" appears with the initials "CB," representing the Clementson Brothers, potters of Staffordshire, England 1865–1916. The word "Staffordshire" is printed within a ribbon below the garter mark. Claremont values: Creamer, $15; Plate, $5; Platter, medium size, $24.

CLOCKWORK TOYS

Clockwork toys, equipped with an inner clockworks that when wound enabled them to move, enjoyed tremendous popularity between 1860 and 1900. The toys were made of wood, tin, cast iron, or cloth and were wound with a crank or key. Standard favorites included dancing or walking figures, circus wagons, merry-go-rounds, boats and other moving vehicles. The early clockwork toys had brass clockworks, while turn-of-the-century toys had steel works. Moving clockwork toys will almost always move a toy collector in the direction of his checkbook, without the winding of a crank or key. Clockwork Toy values: Carrousel, good condition, circa 1880, $190.

CLOISONNÉ

Napkin rings, vases, boxes, cups and saucers, incense burners and inkwells are a few of the tempting teasers awaiting the seeker of Victorian cloisonné. This enamel work on a metallic background originated in the Orient centuries ago. The majority of nineteenth-century wares are of European or Chinese origin, covering both utilitarian and ornamental objects. Consistently beautiful cloisonné combines exciting colors with dragon, floral, bird, butterfly and landscape decor for maximum appeal. Cloisonné values: Ginger Jar, 8″ high, colorful, $50; Napkin Ring, flowers, butterflies, $13; Teapot, flowers, dragon, $70; Vase 5″ high, bird, cherry blossom, $43.

CLOTH BOOKS

Children's books of linen or cotton, first introduced in the 1820s, were found so indestructable and saleable that by the 1850s they were being advertised by many publishers. Energetic youngsters, regardless of their strength, could not tear apart a cloth historical, alphabet, railway, steamship, pleasure or study book. Cloth books bearing the name of an English publisher, such as Dean's of London, Darton's of London, or

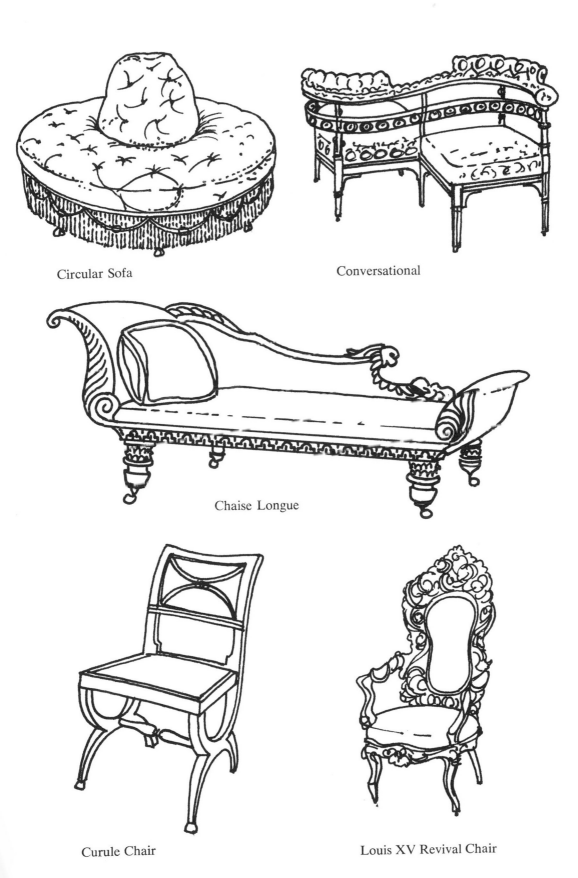

Circular Sofa

Conversational

Chaise Longue

Curule Chair

Louis XV Revival Chair

Wheeler and Company of London, can date from the early 1850s onward. In the 1860s McLoughlin Brothers of New York listed cloth and linen books in oil colors retailing for thirty cents each. Their firm name appears on such selections as the Dame Dingle Series, Susan Sungrime Series and even *Little Slovenly Peter*. Untearable books of cloth were still being made and distributed by firms in the 1890s, although their scarcity would belie this fact. Cloth Book values: *Little Slovenly Peter,* good condition, $24; McLoughlin, *Alphabet Book,* good condition, $14.

CLOTHING

Who would want Aunt Hattie's old black silk gown? A woman's club, staging a special event, a photographer for some advertising work, or perhaps an exhibition or social event at the local Historical Museum would be trunk-searching happenings. Wearing old clothing to a fancy ball or costume party was once considered fun and daring. Nowadays, old clothing has been rediscovered by members of the "now" generation. They wear it daily, buy it feverishly, and consequently the prices are often less than amusing. Antique clothing has staged a comeback. Victorian Clothing values: Coat, black cloth, monkey-fur collar, circa 1890, $72; Dress, black lace, circa 1870, $22; Top Hat, black silk, $26; Shawl, Spanish silk, orange, 48″ square, fringed, $45.

COALPORT

John Rose founded this important English porcelain firm during the 1790s. Their beautiful floral-encrusted naturalistic porcelains were highly regarded during the rococo revival period of the middle nineteenth century. Their Coalbrookdale line was already known by the beginning of the Victorian period, and was to be continued over many decades, as this applied floral encrustation work had a pronounced rococo touch. The factory concentrated on producing copies of Sevres porcelains of the eighteenth century which defied detection, even duplicating the marks of the famous French factory. The Indian Tree porcelain pattern continued being produced by the firm between 1840 and 1900, when a large amount of the factory output was destined for export to America. Coalport values: Cup and Saucer, demi-tasse size, bluebirds and floral decor, circa 1850, $17; Indian Tree Plate, 8″ diameter, circa 1880, $12; Vase, 5″ high, floral, gold trim, rococo design, circa 1860, $40.

COAL SCUTTLE MUG

The small protruding pocket extending from the front part of this mug gave it a shape similar to a coal scuttle. The pocket was actually placed there to hold the shaving brush. During the late Victorian period these mugs, which appeared as soap packages, were a clever advertising gimmick. Should you brush up against one of these oddities, don't procrastinate, as hesitation may find it in the next browser's collection. Coal Scuttle Mug values: Porcelain, blue and gold, $26; Porcelain, floral decor, $32.

COAL VASES

In the late nineteenth century coal scuttles were gradually replaced by the more affluent families with attractive coal vases and boxes. These were filled from buckets of coal brought from the cellar, and the contents of these decorative fireside containers were concealed by lids. A zinc-lined inset held the coal, and some boxes were covered with needlepoint or upholstery and doubled as occasional seats. The metal types were japanned with floral or other suitable decoration, and some were available in pairs. Unusual tureen and shell shapes, or others with Gothic fonts, made Victorian fireplaces fun places Coal Vase values: Brass Coal Box, repoussé, circa 1860, $100; Coal Box, slanted top, brass and walnut, $90. Illustration on page 71.

COFFEE GRINDERS

The crowd that gathered around the general store's pot-bellied stove found something new to talk about, aside from town gossip, when coffee grinders hit store counters in the early 1870s. The large one-wheel Enterprise was patented in 1870, closely pursued by the two-wheel model in 1873. Other large floor and counter-top models date from about the same period. They are in demand when complete and with original paint. Lap and wall coffee-mills became standard household items of the 1890s. The Royal, Fast Grinder, Superior and other models were mentioned by name in company catalogs. The small coffee-mill, with drawer, has enjoyed a revival and has been reproduced. Coffee Grinder values: Enterprise, two-wheel, original paint, 10" wheel, $120; 17" wheel, original paint, $190; Lap type, dovetailed, iron cup and lid, $27; Wall type, wood with iron, glass front, $26.

COIN PATTERN GLASS

The Central & Hobbs Glass Company produced the coin pattern for a period of about five months in 1892. The molds were made from newly-minted coins of 1892, which appeared frosted in the pattern. The United States government considered this illegal and ordered the molds destroyed. Short supply and high demand have resulted in premium prices on the original coin pattern glass. *Tip:* During the 1960s a version of the coin pattern appeared without names or dates on the coins. Be certain not to confuse this with the original, as this later coin pattern glass is without any antique value. Coin Pattern Glass values: Bread Tray, Dollar, $250; Covered Compote, Dollar, $530; Sugar Bowl, Half Dollar, covered, $450; Toothpick Holder, Dollar, $150.

COIN SILVER

Between about 1830 and 1860 silver with a content equal to United States coin, 900 parts of pure silver out of 1,000, was marked accordingly. Pieces were stamped coin, pure coin, standard, quality, dollar, or the initials C or D. One of these marks on the silver would indicate a piece of nineteenth-century coin silver. Coin Silver values: Butter Knife, circa 1848, $8; Tablespoon, heavy, marked pure coin, set of six, $65; Teaspoon, circa 1850, set of six, $45; Teaspoon, fiddle back, circa 1840, $8.

COLUMBIAN COIN GLASS

Government interference ended the short-lived production of the coin pattern glass in 1892. The glasshouses realized that the public response to the pattern had been enthusiastic and they were quick to introduce a substitute. Columbian coin glass with Spanish coins replacing the United States coins was marketed without any repercussion. The glass met with public acceptance and is collected today, although it is not as costly as the original frosted coin glass. Columbian Coin Glass values: Creamer, $72; Spooner, $45; Syrup Pitcher, $90; Tumbler, $52; Water Tray, $65; Water Pitcher, $110.

COLUMBIAN EXPOSITION

The World's Columbian Exposition, held at the Chicago Fairgrounds in 1893, ushered in the age of electricity. Visitors were aghast

at what a little bulb could accomplish. Among the architectural wonders were the Transportation Building with its golden door and the Hall of Manufactures and Liberal Arts. Thousands of mementos were dispensed and sold to eager souvenir-loving Victorians. Articles depicting various buildings, inscribed items mentioning the fair, admission tickets, photographs, and all other Columbian Fair memorabilia are saleable. Columbian Exposition values: Fair Directory, good condition, $9; Deck of Playing Cards with Exposition Buildings, $33; Souvenir Spoon, sterling silver, Columbus Taking Possession of New World, $14; Tumbler, ruby, flashed glass, inscribed 1893, $15. Columbian Exposition Commemorative Coins: 1892, half dollar, very good condition, $5; uncirculated half dollar, $14; 1893, very good condition, half dollar, $4; uncirculated half dollar, $12.

COMMODE

In the pre-plumbing Victorian years the commode was a necessary bedroom accessory, providing a storage space for the chamber pot. The commode bears a resemblance to the chest of drawers, except that there is a double door cupboard, a single full-width drawer above the cupboard area, and usually a gallery. Except for a limited quantity made by cabinetmakers in the early 1840s and 1850s, the majority of commodes were factory-produced. The cupboard portion had a storage area on one side and narrow drawers on the other side. Cottage commodes of pine were often painted to match the bedroom furniture. The typical late-Victorian commode had a marble top with splash rails. Commode values: Lift Top, pine, rough condition, $95; Lift Top, pine, refinished, off-center drawer, medium size, $170; Small Cottage-type Renaissance, good condition with back board, $110; Walnut with Marble Top, circa 1870, $190.

COMPOSITION DOLLS

The heads of middle and late Victorian period composition dolls were sometimes cast in the same molds that had been designed for the more expensive china head dolls. Composition was a hodgepodge of materials including plaster of Paris, sawdust, glue and bran, which was inexpensive and hardened into a durable form. The dolls were extremely popular, as they were within the financial range of the less affluent. Com-

position Doll values: Chinese Boy Doll, circa 1880, dressed, 16″ tall, $55; Girl, 18″ tall, dressed, circa 1870, $90.

CONE WORK

The romantics' love of nature was awakened anew when the art of cone work came upon the scene in the 1850s. The initial attempts at this homecraft originated in rural areas, but by the 1870s, artisans in both town and country considered it a serious art. Pine-cone scales formed the basic pattern, intermingled with twigs and tiny cones for a naturalistic effect. Wood or pasteboard foundations were suitable for pasting or sewing the material into imaginative designs. A coat of varnish gave the completed article a striking similarity to a fine wood carving. Lambrequins, wall pockets, picture frames, hanging baskets and other articles brought a look of the outdoors, indoors. Cone Work values: Hanging Basket, good condition, $32; Wall Pocket, good condition, $34.

CONVERSATIONAL

Empress Eugénie prevailed upon the French furniture designers of the 1850s to create a tête-à-tête seat. They obligingly conceived the "conversational," whereby two people could sit and converse face to face. The result was an equivalent of two chairs joined together by an S-shaped form. Favorite woods were black walnut or maple, often painted with white striping or a gilded effect. If you turn up one of these at the next country auction, you'll adore it, just as Eugénie adored her Napoleon III. Conversational values: Walnut, good condition, circa 1860, $750. Illustration on page 51.

COOKIE CUTTERS

Catalogs of the 1880s were bulging with cookie cutter suggestions, many based on earlier primitive designs. The influence of the Pennsylvania craftsmen can be observed in the traditional heart, bird, tulip, stars, animal and floral shapes. There were also geometric patterns, eagles, log cabins, peacocks, frogs and fish, made both with and without handles. Local nineteenth-century tinsmiths turned out cookie cutters with the same regularity as homemakers popped cookies out of the oven. *Tip:* Antique tin cookie cutters are heavier than the reproductions. Cookie Cutter values: Chicken, $6; Heart within a Heart, $11; Rabbit, $6.50; Rooster, $6.

COPELAND

Copeland and Garrett operated the original Spode Works at Stoke-on-Trent between 1833 and 1847. Then W. T. Copeland became the owner. Following their highly successful showing of parian at the London Exhibition in 1851, the firm name became synonomous with Victorian parian. The impressed "Copeland," often accompanied by other dating information, appears on their parian art objects. The firm enjoyed a fine reputation for their transfer-printed earthenwares, colorful majolica, bone china and painted tiles designed for interior decoration. Their Japanese inspired porcelains of the 1870s and 1880s usually bear the name Copeland within a variety of different marks. Copeland values: Parian Bust, Shakespeare, circa 1860, marked Copeland, $125; Plate, Ornate Floral Motif, circa 1870, $16; Washbowl and Pitcher Set, marked Copeland and Garrett, White with Burgundy Grape Design, circa 1845, $170.

CORALENE

During the 1880s, this type of satin glass with tiny glass beads applied to the outer surface was made by glasshouses in Europe and America. The coralene decorating process was first patented in Germany by Arthur Schierholz in 1883. The satin glass was usually shaded, although some pieces were a solid color. The sparkling beads provided a striking contrast to the matte finish of the satin glass. A natural coral branch was an effective motif, resulting in the name Coralene. Other Coralene designs were seaweed, leaf, floral, bird and wheat, some being quite elaborate. "Beaded Glassware," "Coralene Beaded" and "Lustra" were being advertised by wholesalers in 1886, all being European imitations of Coralene: *Tip:* The recent fakes resembling Coralene have beads adhered with transparent glue that fall off when touched. Coralene values: Pitcher, 8" high, pink to white shading, all over beading, $500; Tumbler, blue, beaded, $410; Vase, 5" high, cranberry to pink, all over beading, $400; Vase 7" high, Seaweed Pattern, yellow beading, $460.

CORAL JEWELRY

The Victorians believed that wearing coral jewelry provided a child with protection from danger. One reason why you may find numerous small coral necklaces is that they were often given as christening gifts to children of the 1800s by doting grandmothers and great-aunts. Coral

jewelry was deemed proper by leading authorities on etiquette to be worn during morning activities, reserving more precious stones for formal evening affairs. A thriving industry was created in Italy by the 1860s, as coral fishermen were kept active meeting the demand. *Tip:* The color varies, and the deeper the color the better the coral. Coral Jewelry values: Child's Necklace, 88 graduated beads, gold clasp, $50; Coral Branch Pin, 2" long, 14-karat, gold mounting, $24.

CORK PICTURES

The Victorian artisan never lacked the self-confidence to undertake the most arduous of crafts. When cork pictures popped on the scene in the 1860s, men, women and children turned their efforts to creating lasting cork mementos. Against a selected colored velvet background, they built up castles, ruins, landscapes, harbors, and other pictorial delights with pieces of cork. Interspersed for additional depth and reality was artificial foliage, seaweed, shells and other material thought to enhance the overall effect. A finished cork masterpiece usually was fitted with a gilt or maplewood frame. Cork Picture values: Framed, 12" x 16", Harbor Scene, $48.

CORN AND OATS PATTERN

Plain white ironstone decorated with embossed designs, including the corn-and-oats motif, graced tables in the second half of the nineteenth century. Handles and finials of covered pieces have the corn design and corn shucks are prominent on serving pieces and sugar bowls. Flat pieces in this dinner service have long repeat ribbons of corn foliage, oat heads, and here and there an ear of corn. Wedgwood pieces will bear the maker's mark, and variants are encountered since the corn-and-oats white ironstone pattern was made by other factories in England and America. Corn and Oats values: Cream Pitcher, $12; Gravy Boat, $18; Plate, $6; Platter, large size, $34.

CORNELIUS & BAKER LAMPS

This firm produced the largest number of lamps in the United States between the 1820s and the 1870s. Crude lard and whale oil cottage lamps, beautiful bronzes and expensive cut-glass lamps were sold by this Philadelphia company. They operated as Cornelius & Company until 1853 when the Baker name was added. A number of the lamps are

marked with the factory trademark. Cornelius & Baker Lamp values: Argand Lamp, 26" high, frosted shade, circa 1855, $240.

CORNER CHAIR

The corner chair introduced during the Queen Anne period (1710–1750) enjoyed a place in the Victorian parlor as an occasional chair. The back of the chair is supported by three turned extensions of the three rear legs, into which are socketed the two top rails and the matching lower cross rails. The open back is usually of vase-and-ball-turned spindles, and the square seats may be either caned, rushed, or upholstered. Corner chairs were factory made of natural-finish maple or oak, and the matching front leg is seat high while turned stretchers brace the legs. The turned sections often simulate bamboo. Corner Chair values: Circa 1870, good condition, $90; Circa 1890, fair condition, $65. Illustration on page 61.

CORONATION ITEMS

Souvenir pieces commemorating the various activities of English royalty have attracted the attention of antique buffs. Beginning with the coronation of Queen Victoria in 1837, a number of china and glass items were issued to celebrate important events in the lives of English monarchs. Plates, mugs, paperweights and medallions are just a few of the collectibles attracting interest. Coronation pieces are generally regarded as the antiques of the future and are certain to gain in value. Coronation Item values: Victoria and Albert Pink Lustre Plate, $40; Victoria Diamond Jubilee Plate, 10", $22; Victoria Silver Jubilee Tumbler, $25.

COTTAGE MIRROR

Produced in considerable quantities between 1850 and 1900, this wall mirror with its rectangular molded frame was simple in design, having rounded lower corners and flat arched top. They were usually of pine coated with gesso and painted to simulate mahogany, black walnut, or rosewood. Some were painted black or a solid color to blend with other painted cottage bedroom furniture. The low-cost cottage mirror was ideal for summer cottages and hotels, for the servant quarters or as an auxiliary mirror for the kitchen wall. When found they are invariably covered with one or more coats of paint, a minor job for a professional do-it-yourselfer! Cottage Mirror values: Rectangular Pine Frame, re-

finished, 22″ x 14″, $50; Rectangular Frame, painted, rough condition, 30″ x 18″, $45.

COUNTRY FURNITURE

This inexpensive furniture was made of native woods including hickory, pine or maple. The designs were simple adaptations of the more ornate Victorian furniture designs. It was light, durable and practical, and answered the needs of rural America. Earlier designs were hand-crafted by skilled craftsmen, and later in the century certain forms were mass-produced by numerous American furniture factories. Country furniture was referred to as "cottage furniture" during the nineteenth century. Country Furniture values: Blanket Chest, pine, One Drawer, circa 1850, $210; Cradle, pine, hooded top, circa 1840, refinished, $135; Deacon's Bench, 6′ long, refinished, $140; Spool Towel Rack, $26.

COZY CORNER

A divan covered with textiles from the East, mounds and mounds of exotic pillows, a canopy of Oriental fabrics, Persian scarves, a pierced lamp, brass jardinieres—stir gently and you have a Turkish Cozy Corner. A tiny alcove, a bit of space under the stairs, an irregular portion of the room thus became a canopied shelter for the lady of the house to lounge in and romanticize. Divans flooded the western world in the 1880s, and plain corners were rapidly transformed into luxurious "cozy corners" the country over.

CRACKLE GLASS

Venetian glassmakers excelled in producing fine crackle glass, and the Art Glass period saw a renewed interest in this age-old technique. The Boston and Sandwich factory produced a type of crackle glass known as Sandwich overshot glass. It is recognized by its smooth inner surface and rough crystalline-looking outer surface. American factories produced crackle glass in colors and with applied decoration. It is also called Craquelle or Ice Glass. Crackle Glass values: Punch Cup, $18; Vase, 5″ high, Cranberry Shade, $25; Vase, 12″ high, Clear, $55.

CRAFTSMAN'S LABELS

The presence of a label on any antique article assures positive identification and authenticity and invariably increases the value substan-

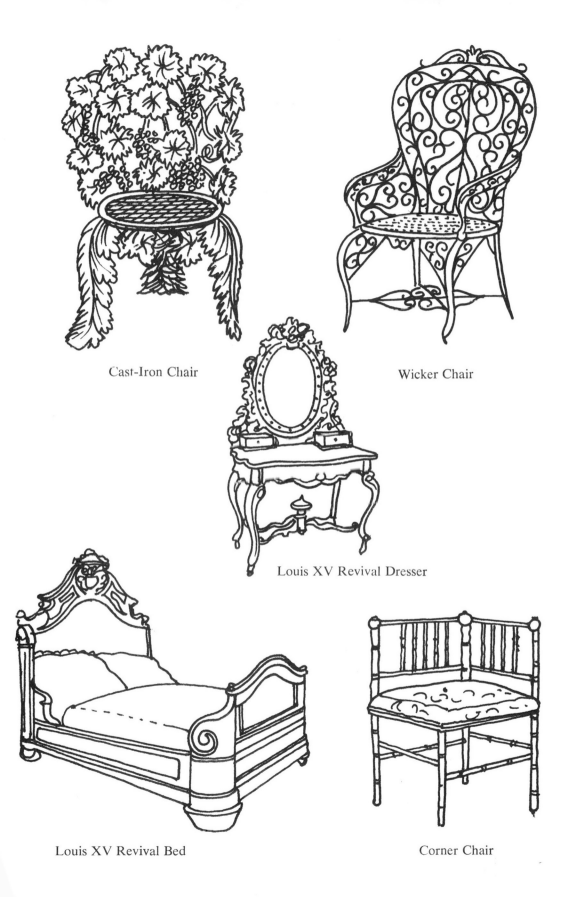

Cast-Iron Chair

Wicker Chair

Louis XV Revival Dresser

Louis XV Revival Bed

Corner Chair

tially. A name, address, signature or other pertinent information contained on an engraved, printed, lithographed or hand-written craftsman's label should always be left intact. The specific type of label will vary according to the object, and even one in tattered condition should not be altered. A label enables you to document an antique find with relative ease and definitely boosts its saleability.

CRANBERRY GLASS

The cranberry color was achieved by adding gold to the batch of glass on reheating. It resulted in a beautiful blue-violet tint. Some cranberry was made with an addition of copper. It is less desirable and has an amber red shading. The glass became fashionable after the Civil War, and cranberry was also made in pattern glass. A wide variety of tableware and decorative pieces were produced in cranberry glass, some with gold leaf and enamel decor along with applied decorations. Reproductions exist, but they do not have the fine quality blue-violet tint of true cranberry glass of the late 1800s. Cranberry values: Gas Shades, 7″ diameter, Hobnail, $35; Syrup Jar, circa 1890, $82; Water Set, Pitcher and Six Tumblers, $175; Wine Glass, Clear Stem, $18; Vase, 8″ high, Jack in Pulpit, $62. Illustration on page 11.

CRAZY QUILTS

A textile scrapbook: a piece of brocade, a bit of silk, a little touch of velvet, a satin remnant—you have the necessary ingredients for a crazy quilt. Children loved the quilts, and the stories connected with the various materials—grandmother's hat, grandfather's ascot, Aunt Becky's wedding dress—all together on one colorful quilt. However, the quilts were not practical as bedcovers due to their fragile materials, but when draped across the back of a dull horsehair sofa, they brightened the room and were admired by visitors. A fabric catch-all of the late Victorian period, the crazy quilt was simply a version of the traditional patchwork quilt. Crazy Quilt values: Colorful, all hand-sewn, circa 1870, $100; Crazy Quilt, Fan pattern, colorful Tie Silks, large size, $120.

CREWELWORK

American women, adept at needlework, found great satisfaction in the happy hours spent engaged in crewel embroidery. They excelled in naturalistic motifs which were bolder, more colorful and freer than de-

signs found on European crewelwork. Simple embroidery stitches that merely outlined but never covered the entire background in floral, bird, Biblical, Oriental, tree or fruit patterns were accomplished by ladies proficient with the needle. The crewelwork design was sewn on a cotton, linen, or wool background and completed endeavors were perfect for chair seats, draperies, bed hangings, coverlets, or framed as a crewelwork picture. Crewelwork values: Biblical Scene, framed 14" x 18", $56; Pillow Top, good condition, circa 1880, $35.

CROSLEY MOSAICS

This type of needlepoint picture was made from slices of yarn, glued upon a canvas backing. The yarn was gathered together in a bunch and then sliced with a razor-sharp knife. To complete a picture required perseverance, as it took an enormous quantity to finish a subject. English in origin, the colorful Crosley Mosaic was a decorative home craft of the 1840s. Crosley Mosaic values: Maplewood frame, small size, $55.

CROWN MILANO

Frederick Shirley was responsible for Crown Milano, an art glass of the 1880s made by the New England Glass Company of Massachusetts. The satin finish resembled fine porcelain in soft shades of beige, brown and pink with a decor of flowers and gold scrolls. The monogram "CM" for Crown Milano is your assurance of an authentic piece, often accompanied by varying designs. A look-alike was Albertine, another opal glassware similar to Crown Milano, made by the same firm during the 1880s. The gilded or enameled opal glassware from other factories may bear identifying marks distinguishing it from Crown Milano wares. Crown Milano values: Cookie Jar, Melon Ribbed, signed, $475; Salt and Pepper Shakers, Pewter Tops, $125; Vase, 8½" high, Oak Leaf and Acorn Decor, signed, $700.

CRYSTAL WEDDING PATTERN

Adams and Company of Pittsburgh made this fine-quality pressed glass pattern in thirty-nine pieces during the 1870s. The design is composed of tight loops resembling rather large teardrops in a ribbon candy effect and was restricted to permit room for engraving. The pattern was available clear, frosted or ruby-stained. Crystal Wedding was still being produced into the 1890s. *Tip:* Reproductions of this pattern exist in clear

and white milk-glass. Crystal Wedding Pattern values: Cake Stand, $22; Celery, $16; Pitcher, $28; Tumbler, $10.

CUCKOO CLOCKS

A considerable number of cuckoo clocks were imported to America from Germany in the nineteenth century. Catalogs pictured exquisite cuckoo clocks, the difference in price depending upon the degree of carving. One with excellent carving might have grape leaves, oak leaves, mushrooms, pheasants, rabbits, deer heads or other appropriate ornamentation. Iron arbors adorned the wooden frames, and cuckoos appeared on the hour, half hour and quarter hour. A cuckoo clock with more than one bird usually had a quail as the second timekeeper. A trumpeter was substituted for a bird on musical cuckoo clocks. *Tip:* Antique cuckoo clocks were handmade, and have a totally different look from the new factory-produced clocks. Cuckoo Clock values: Black Forest Scene, circa 1880, working condition, $140; Cuckoo Stag Head, circa 1890, $90.

CUPBOARDS

Victorian dish cupboards of the 1840s were usually the work of cabinetmakers in styles surviving from the American Empire or earlier periods. There are two basic types: the rectangular, dresser type, and the triangular cupboard designed as a corner piece. Mahogany, rosewood and black walnut cupboards faded from popularity when changes occurred in diningroom furniture in the second half of the nineteenth century. There are some Eastlake examples of the 1870s that are most impressive. The open cupboard or hutch also experienced a decline in favor around the middle of the 1800s. Kitchen cupboards, however, were keeping small furniture-factories and country craftsmen busy, and many a kitchen cupboard of the nineteenth century occupies dining room space in the twentieth century. Cupboard values: Corner Cupboard, Cherry, 1860, $750; Hutch, Oak, 7' tall, good condition, $240; Jelly Cupboard, Pine, refinished, 6½' tall, $175.

CUP PLATES

In the first half of the nineteenth century, tea drinkers preferred sipping their tea from a saucer. China or glass cup-plates were provided to hold the cup of tea. Pressed-glass cup plates introduced in the 1820s

replaced all other types in the hearts of tea drinkers. The Boston and Sandwich Glass Company was the acknowledged leader in the cup plate field, although other glasshouses competed for a piece of the market. The cup plates were impressed with patterns such as hearts, butterflies, grapes, flowers, sunbursts, portraits of important people, and many historical motifs that incorporated eagles, stars and other patriotic emblems. The patterns were brilliantly conceived on lacy glass with a stippled background. *Tip:* To differentiate between an antique and a new cup plate, place them side by side. Close examination will reveal minor differences. Cup Plate values: Chelsea Grape Cup Plate, $12; Hearts and Flowers, $22; Heart Stippled, $30; Thirteen Hearts Pattern, $25; Eagle, $37.

CURRIER & IVES

The lithograph was the most widely distributed picture of the nineteenth century. The American firm of Currier & Ives issued the largest number of these prints, popular due to the subject matter which often related to everyday life. The N. Currier name may be found on prints as early as 1835. He was joined by Mr. James Merrit Ives in 1857, and the first joint Currier & Ives print was issued in the same year. The firm marked their prints with the name of the company and often included the address. Only the copyrighted prints are dated and, therefore, the address of the firm can often aid in dating your print. The prints were done in black and white and then hand colored. The hand coloring often ran over the border. Current reproductions are machine-made and easy to distinguish from the original hand-colored subjects. The size of the print (they were made in small, medium and large folio) will help determine the value. Subject matter is, of course, a primary factor as there are certain subjects more sought after by collectors than others. Railroad, hunting, fishing, sailing, steamships, winter scenes, forest scenes, Western trappers, Indians are some of the subjects most in demand. There is a market, at slightly lower prices, for the appealing rural farm, countryside, and village subjects. Sentimental prints, fruits, and flowers are usually less costly. A number of factors contribute to the worth of prints and rarity is one. There were fewer large size prints made and therefore they are more scarce and difficult to find than the smaller size prints. Currier and Ives values: American Express Train, small folio, $425; Landing of the Pilgrims at Plymouth Rock, small folio, $130; Life in the Woods "Starting Out," large folio, $750; "The Poultry Yard," medium

folio, $90; Tomb of General W. H. Harrison, small folio, $150; "Trotting cracks at Home," large folio, $1,200.

CURULE CHAIR

Inspired from the Roman Chair of Office, the curule returned to popularity during the Victorian era when it was a favorite armchair in college dormitory study areas across the country. The upholstered back and seat were usually of black haircloth, without a crease or traverse line in the upholstery to form the normal joining of the two. The legs were replaced by semi-circular segments and favored woods were black walnut, mahogany and rosewood. A variant was the comfortable curule lady's rocker, made with a somewhat less pronounced curve. Curule Chair values: Armchair, good condition, circa 1860–1880, $170; Lady's Curule Rocker, $120. Illustration on page 51.

CUSTARD GLASS

Often called Buttermilk glass, this food family glass resembled milk and egg custard in color. First introduced during the 1880s and produced in quantities thereafter, prized pieces are those with the Northwood Glass Company factory trademark of an "N" within a circle. Certain patterns are highly desirable, including Chrysanthemum Sprig, Argonaut Shell and Louis XV. *Tip:* Reproductions exist. The color is lighter and less striking than on the original glass. Custard Glass values: Banana Dish, Chrysanthemum Sprig, $225; Butter Dish, Argonaut Shell, $220; Goblet, Grape Pattern, $43; Tumbler, Inverted Feather and Fan, $64.

CUT GLASS

Victorian cut glass should be considered in two periods: Middle period, 1830–1880; Brilliant period, 1880–1910. The Middle period glass had flute cutting, engraved decorations, fine line-cutting and the popular colored, flashed or cased glass. The Brilliant glass was the deep miter-cut glass exhibited at the Centennial Exposition in 1876. Cut glass of the Brilliant period is heavy, elaborate and may be identified by pattern or by a company trademark. Check your cut glass carefully for an acid-etched or pressed stamp trademark. Most cut glass has never been examined for a factory mark. Cut glass was never made to withstand the extremes of either heat or cold. *Care Tip:* Wash in lukewarm water, use

pure soap and dry with tissue paper or newspaper for a lint-free finish. Cut Glass values: Bowl, 8″ diameter, signed Clark, $105; Bowl, 8″ x 4″, signed Hawkes, $100; Celery Dish, 12″, unsigned, $65; Champagne, signed Hawkes, $45; Vase, 11″ high, signed Libbey, $130; Tumbler, signed Hoare, $25. Illustration on page 201.

CUTWORK

Combine equal portions of time, patience and skill, as this blending is important before commencing on a paper cutwork project. Able fingers cut standard weight paper or tissue paper into intricate floral and scenic patterns. Those possessed with exceptional ability would often attempt a portrait. The white paper cutout was frequently mounted against a darker background and framed as a picture. A young lady would spend many hours laboring over a lacy cutwork piece to be placed on a Valentine for a special beau. Cutwork values: Lacy Cutwork Valentine, 5″ x 7″, circa 1860, $12; Picture, 8″ x 10″, framed, $30.

DAGUERREOTYPE

Louis Daguerre's development of the photographic process known as the Daguerreotype in France in 1839 caused a severe decline in the silhouette field, as this early type of photograph was widely preferred. The daguerreotype was made on a silvered copper plate, and reigned supreme as the photographic wonder of the 1840s, only to be supplanted by the ambrotype and tintype methods which arrived later. The cases into which the early photographs were mounted were made in numerous interesting designs. Among the case patterns are Jenny Lind, Santa Claus, Forget-Me-Not, Eagle, Star and other historical, patriotic, and sentimental designs and in enough variety to please any daguerreotype devotee. *Tip:* The case will frequently determine the worth of an antique daguerreotype. Daguerreotype values: Cupid and Deer decor, Gutta Percha Case, $14; Leather case, Confederate Soldier, hinged, $22.

DAISY AND BUTTON PATTERN

The Daisy and Button pattern of pressed glass rates as one of the most enduringly popular designs ever offered by American glasshouses.

Tableware and souvenir items, including hats, shoes, slippers, boats and other whimsical oddities were made and sold in the Daisy and Button pattern from the 1880s onward. Hobbs Brockunier of West Virginia made the highly regarded Daisy and Button Amberina glass during the 1880s. The untold reproductions present a hazard to unwary collectors, uneducated to the pratfalls and pitfalls of antiquing. Study is required to distinguish the new glass from the old, and any piece of Daisy and Button that can be authenticated as being made prior to 1900 is valuable. The variants can be easily recognized by their descriptive names, such as Daisy and Button with Cross Bar, Daisy and Button with V ornament, Daisy and Button with single scallop and Daisy and Button with thumbprint, to mention a few. Daisy and Button values: Celery Dish, boat shaped vaseline, $29; Creamer, clear, $13; Milk Pitcher, amber, $34; Toothpick Holder, blue, $21.

DAMASCUS TABLE

The last two decades of the 1800s was the era for Near Eastern decor, a time to satisfy the restless urge for something different, such as the Damascus table. Low side tables in the Moorish style, these eight sided tables with inlaid top and side panels extending downward between the legs, met with approval. Then, around the early 1900s, the fad for Near Eastern decor and the Damascus table suddenly disappeared. The fad gone forever, the tables merely bided time until they were to be rediscovered and classified as antique. Damascus Table value: $85. Illustration on page 21.

DAVENPORT DESK

This small writing desk was of English origin and was continually popular throughout the entire nineteenth century. The Davenport desk had a sloping front, with or without a gallery, and a lift top. Beneath the lift top was a storage space for correspondence necessities which was often fitted with one or two small interior drawers. A distinguishing feature were the deep drawers on the right side that pulled out sideways. Most examples were very elegant and ladies favored them for their numerous writing chores. Rosewood, mahogany and walnut were favored woods for the decidedly different Davenport desk. Davenport Desk value: Walnut, 36″ high, circa 1850, $265.

DAVENPORT SOFA

This upholstered sofa of the late 1800s was often capable of being converted into a bed. The furniture factories centered in the Grand Rapids area produced the davenport in considerable quantities. Many davenports from the turn of the century have the famous "Golden Oak" finish, synonymous with the Grand Rapids factories. The davenport has made the gradual transition, from the second-hand furniture store to the antique shop around the corner. Davenport Sofa value: Oak, Grand Rapids, circa 1890, $165.

DEDHAM POTTERY

The Dedham Pottery gray crackle hand-made porcelain introduced on a limited scale during the mid-1890s, with underglaze blue decorations, met with instant success. The Dedham Pottery of Dedham, Massachusetts immediately developed a full line of tea sets and tableware items in a variety of interesting patterns. Each piece was completely hand made, and the uneven quality of the pieces appealed to the public. The blue underglaze patterns are all highly regarded by seekers of fine American art pottery, who hold Dedham pottery in high esteem. Such patterns as elephant, rabbit, turkey, lion, polar bear, dolphin, crab, butterfly and flowers subjects were produced. The factory mark, a rabbit, in varying forms, accompanied by "Dedham Pottery," provides quick attribution. The firm was an outgrowth of the Alexander Robertson, Chelsea Ceramic Art Works established in 1866. This firm produced a variety of different ceramic wares prior to moving to Dedham in the 1890s. Their gray crackle line, reminiscent of Oriental pottery, proved to be one of their outstanding achievements. Dedham values: Creamer, Rabbit Motif, $58; Cup and Saucer, Elephant Motif, $50; Plate, Turkey Motif, 8", $52. Illustration on page 141.

DELFT

Delft delectables have been made in Holland and England for centuries. Large quantities were exported to America in the 1800s. The Dutch potters excelled in blue and white designs, based on the everyday life of the Dutch people and on Oriental sources of inspiration. English potters made the familiar blue and white Delft, but experimented with polychrome decoration to a larger extent than their Dutch competitors.

Free, spontaneous scenic and floral designs were executed employing a wide range of colors on the tin glazed body. Antique Delft often develops a fine network of age lines and is easily damaged. The appearance of these age lines on a piece of Delft often can aid in distinguishing it from the newer wares. *Tip:* Antique Delft was heavier and thicker and the blue a lighter shade than on the new reproductions. Delft values: Knife Rests, blue and white, $27, pair; Tobacco Jar, large polychrome decoration, circa 1880, $85.

DESSERT MOLDS

Check the pantry area of the next estate auction sale and you may find a copper, brass, pewter or tin dessert mold. The sumptuous contents were easily removed since dessert molds opened on hinges in the center. A festive occasion merited the unexpected, and edible table-top delicacies in helmet, horn of plenty, melon and basket shapes were all made possible with these elaborate molds. Pudding, jelly or ice cream, center pieces and pyramids were conceived by ladies and gentlemen who followed the instructions in leading magazines for their creations. The pewter mold was favored whenever freezing was necessary. The molds were factory produced, in simple and startling motifs, forming treats too beautiful to eat. Dessert Mold values: Bennington type pudding mold, $26; Melon Tin, $10; Pewter Pumpkin ice cream mold, $25.

DIME NOVEL

The Irwin P. Beadle Co. of New York published the first dime novel in 1860. Millions of dime novels were sold and read between this time and the 1920s, when they declined from popularity. Beadle and a long list of competitors kept the blood-and-thunder action story alive and well with their dime novels. Between the pages of these adventure stories, and preserved for historians, are the reading habits of the late 1800s. Collectors prefer the detective and action stories and many specialize in a certain category of dime novel literature. Bicycle, railroad, baseball, circus, and fire fighting categories, plus numerous others, reflect the development of the country in the final years of the 1800s. Would you believe that some of the so-called dime novels really sold for five cents, although all were generally of pocket size. Dime Novel values: Bicycle Story, $18; Fire Fighting Story, $14.

Cast-Iron Umbrella Stand

Coal Vase

Parlor Stove

Bootscraper

DISH CROSS

The dish cross in the shape of an expandable X served duty as a fancy folding trivet. Due to their adaptability, they could accommodate large and small dishes and were heavily used. This eighteenth century table top accessory was still proving invaluable to diners of the early Victorian period. Made of pewter, Sheffield, iron, silver and other metals, a variation came with a spirit lamp acting as a warming device. Dish Cross value: English Plated Silver, circa 1840, $40.

DIVAN

The divan was the pivotal focal point of that artistic triumph of the 1880s and 1890s, the "Cozy Corner." The idea originated in Turkey and Persia, where it was considered proper for a person of importance to be seated on a raised platform upon a multi-cushioned couch. The divan was an upholstered sofa, without back or arms, and showing no visible framework. The demand for divans sparked a mania for Near Eastern decor. Divan value: Good Condition, circa 1880, $225.

DOLLHOUSES

A Victorian dollhouse was often the replica of the owner's own residence, made specifically for her by a member of the family or a talented cabinetmaker. The majority of dollhouses made before 1850 were made at home by individual craftsmen. After this date dollhouses were commercially produced in America and abroad and sold at local toy emporiums. Dollhouses were influenced by the Gothic, French and other revival styles, as they attempted to duplicate in miniature the homes of the period. Their furnishings carried through in every detail down to the smallest item. There were country homes, city homes, toy shops and country stores made in miniature for very special little misses. An antique dollhouse is the one house that rarely has a "for sale" sign nowadays. Dollhouse values: Cottage, Six Rooms, Furnished, circa 1870, $325; Gothic style, large ornate, unfurnished, circa 1850, $550. Illustration on page 161.

DOLLS

Any doll made during the Victorian era in America or abroad has value and interest to a collector. Those battered by the ravages of time can be treated to a rest and restoration at the local doll hospital. There

a team of professionals will restore dolly with tender loving care—and original parts. Sought after is the doll with a head of any unusual material such as papier-mâché, wax, china, leather, wood, celluloid, bisque, cloth or other novel composition. The hair style on a china head doll can often be a guide to determining its age, and many bear a factory mark on the back of the head or shoulder areas. A number of fine dolls were imported from Germany and when a country of origin appears, this denotes a date of manufacture subsequent to 1891. Dolls with blonde hair are considered best by many collectors, and those with brown eyes are a bit more rare than the blue eyed ones. Collectors of antique dolls realize that the wonderful world of dolldom banishes all the doldrums. Doll values: Armand Marseille, Boy Doll, bisque head, 17″ tall, original clothes, $210; Simon and Halbig, bisque head, brown eyes, dressed, 24″ tall, $150.

DOLPHIN MOTIF

The Dolphin has consistently reoccurred as a familiar form on American household furnishings since the 1700s. Famous are the Dolphin candlesticks of the Boston and Sandwich Glass Factory and other glasshouses made between 1840 and 1900. The form of a well-modeled Dolphin rising majestically to support a candle socket is known to every antique enthusiast. Later when the oil font replaced the candle socket, there were Dolphin lamps, some having up to three dolphins supporting the oil font. The sideboards of the late 1800s had graceful dolphins supporting extraordinary epergnes. Furniture and silver designers brimmed over with a multitude of ideas employing the durable dolphin motif in American furnishings. Dolphin Motif values: Dolphin Candlestick, Flint Glass, circa 1840, $56; Dolphin Compote, Clear Glass, $52; Dolphin Brass Candlesticks, pair, $65. Illustration on page 191.

DOOR KNOCKER

Persons with a passion for things past rarely allow an unusual brass, copper or iron door knocker to go by unnoticed. Visitors were greeted and treated by a variety of fascinating knockers, in such shapes as eagles, lion's heads, flowers, birds or hands. Children of royalty had their hands cast as door knockers and another handsome knocker was the one in the form of a lady's hand gripping a ball. Other tappers of note were oval, lozenge or lyre shaped and the presence of a registration mark or com-

pany trademark can be an invaluable guide to dating. Door Knocker values: Anchor, brass, $41; Basket of Flowers, cast iron, $17; Parrot, brass, $46.

DOORSTOPS

Bulldogs, ships, frogs, parrots, lambs, cats, cottages, baskets of flowers and other forms from near and far of brass and iron kept Victorian doors ajar. The majority of door stops were made of iron and further embellished with paint. This is a "floor antique," so classified because they are usually spotted on the floor of an antique shop, pushed back under a counter. The subject matter is varied and if you have a door that refuses to remain open, there is a Victorian door stop anxious to do the job. Door Stop values: Cat, original paint, 10″ high, $19; Flowers in Basket, brass, $25; Parrot, iron, $18.

DOUGHTRAY

The fame of the doughtray had spread well beyond the boundaries of Pennsylvania by the middle of the 1800s. The dough was placed in the trough portion, which was usually about ten to fourteen inches deep, enabling it to rise. The removable flat top was used to knead the dough and this kitchen piece was often called a kneading table. The trough portion was supported by legs, and some early examples were brightly painted, particularly those originating in the Pennsylvania region. Maple was a favored wood for doughtrays and many were combined with a top of pine. Doughtray values: Pine, medium size, rough condition, circa 1860, $110; Shaker type, pine, rare, circa 1850, $260; Walnut, splayed legs, circa 1850, refinished, $205.

DOULTON

The Doulton factory located at Lambeth, England was established in 1858. They became noted for their superior stonewares which generally consisted of utilitarian objects such as bottles, jugs and flasks. The majority of wares were clearly marked Doulton, Lambeth, accompanied by the artist's initials and often the date of manufacture. The factory was an outgrowth of the Watts, Doulton partnership formed in 1815. Doulton was progressive and as early as the 1870s they organized an art pottery staffed by students from the Lambeth School of Art. The firm opened a second factory in Burslem in 1882, concentrating on fine porcelains in-

tended for the American export market, the factory mark being "Doulton, Burslem" with the addition of the word "England" in 1891. *Tip:* A dating guide is the mark "Royal Doulton," the prefix Royal being added to the standard factory mark in 1901. Doulton values: Columbian Exposition Commemorative Pitcher, circa 1893, $62; Vase, blue and white floral, Burslem, 16" high, circa 1887, $82.

DRAPERY PATTERN

Lambrequins covered mantels, chair backs, and bracket shelves, providing V-shaped touches of decor in the post Civil War years. The clear glass Drapery pattern of pressed glass bore a resemblance to the hand-embroidered lambrequins with tassels. Two rows of finely stippled V-shaped drapes beaded around the edges with tassels hanging from the lowest point form the pattern. Doyle and Company of Pennsylvania referred to it as their Lace pattern in original patent papers of 1870. Drapery pressed glass with its stippled drapes and tassels recalls the lambrequin rage of the 1870s. Drapery Pattern values: Butter Dish, $26; Pitcher, $30; Sauce, $9.

DRESDEN POTTERY WORKS

A brown trademark on the base of a piece of china consisting of a globe with the word "Dresden" across the equator can be baffling to a beginning collector. Dresden is automatically associated with the Meissen factory in Germany. Actually, this global trademark is from an American firm active from the 1870s, the "Dresden Pottery Works," also known as Blunt, Bloor, Martin and Company. Decorated ironstone services and washstand sets were marketed by the firm into the 1890s. Many of their marks incorporated the name Dresden, perplexing the novice. Dresden Pottery values: Bowl and Pitcher Set, California Pattern, circa 1890, $60.

DRESSING TABLE

A dressing table of the 1840s was actually a table fitted with drawers and a small standing mirror, with minor differences in design according to the maker. By the 1850s, dressing tables were becoming heavier in weight and definitely more ornate to conform with the then popular French revival styles. A fitted looking glass replaced the earlier swing type mirror, and legs were draped with attractive fabrics. A combination

washstand/dressing table appeared later in the century, cleverly concealing the mirror under the lift top lid. Dressing Table values: Walnut, circa 1870, $155; Victorian Pine, circa 1860, $110.

DRY SINK

Rural areas lacking the luxury of indoor plumbing continued using the dry sink well into the nineteenth century. A kitchen piece, the dry sink consisted of a cabinet below and an open sink above. The sink top was equipped with a zinc lining where pots, pans and dishes could be washed. The cupboard below the open trough was usually of maple, pine, birch, poplar or cherry, left in a natural condition. Occasionally a dry sink had a top section with small drawers to hold the family silverware. You may even find one which has been covered with a coat of paint or two! Dry Sink values: Dry Sink, Pine, Green Paint, rough condition, $160; Dry Sink, Pine, High Back, refinished, $270, Maple with Knife Drawer, refinished, 48″ high, $240.

DUX

Magnificent Dux figure groups adorned Victorian mantels and marble top tables during the 1800s. E. Eichler organized this important porcelain factory in 1860 in Bohemia. The company focused its attention on the American export market and their highly decorative wares met with instant approval. Pleasing to nineteenth century tastes were their animal groups and busts of lovely young ladies, ornate vases and innumerable figure subjects. Their distinct triangle mark in various colors, along with the inscription "Royal Dux, Bohemia," affords easy identification. *Tip:* Reproductions are marked "Royal Dux, Czechoslovakia." Dux values: Figure, Pair of Cats, Pink Triangle Mark, 17″ long, $350; Figure, Girl with Water Jug, 18″ high, $160; Figure Stalking Lionesses, Pink Triangle Mark, 15″ x 7″, $210.

E

EASTER CROSS

This home craft project was always created to coincide with the Easter season. A piece of wood in the shape of a cross approximately 8″

to 10″ in height was completely covered with a base coat of plaster of Paris. Wax or paper flowers or often both were applied to the entire cross and when completed it was encased in a bell jar for protection and preservation. The Easter Cross was relegated to safekeeping quarters for most of the year, except for its annual visit to prominent mantel space each spring. Easter Cross value: Original, Under Glass Dome, 14″ high, $125.

EASTLAKE STYLE

Charles Eastlake's "Hints on Household Taste" was published in England in 1868 and in America in 1872. It was widely read for the remainder of the century. Eastlake deplored the shoddy work of the machine age and was opposed to the numerous revival styles, advocating a return to simple hand craftsmanship. English cabinetmakers attempted to carry out his designs by reviving the rectangular lines associated with Jacobean furniture. American versions of the Eastlake concepts are characterized by rectangular shapes and straight lines, machine scroll carving, applied molding and trim, burl walnut veneer panels, simple rosettes, inset tiles, and many galleries and marble tops on selected forms. American designers and furniture factories ignored his plea for fine craftsmanship, seizing upon the popularity of the style to mass produce American Eastlake furniture between 1870 and 1890. Eastlake values: Eastlake Pier Glass, Black Walnut Burl veneer trim, 6′, $260; Gentleman's Arm Chair, Reupholstered, circa 1875, $170; Settee, reupholstered, good condition, circa 1880, $340. Illustration on page 83.

EGGS

Collectors love eggs, Victorians loved eggs—and so often the twain shall meet. A baker's dozen of eggs from a century ago would include Bristol or camphor glass eggs, often with hand painted sentimental messages, whittled-from-wood darning eggs, and fancy jeweled eggs reminiscent of the work of Peter Carl Faberge. There are plain old glass nesting eggs, once used in a hen's nest and fancy glass egg shaped hand coolers. Eggs from the confectionery store were covered with bright prints and held Easter candies. These are as much in demand as the spun sugar peek-in eggs with tiny scenes to delight tiny tots. Egg hunts once associated only with the Easter season now occur every Saturday, year round, as thousands of egg collectors hit the egg trail. Egg values: Camphor

Glass, dated 1891, large size, $23; Spun Sugar Peek-In Egg, circa 1895, $12.

ELIZABETHAN REVIVAL STYLE

Early in the Victorian period a style of furniture developed bearing a resemblance to the Cromwellian forms of the 1600s. Characteristic of this furniture was the ball and spiral twist turning, and this style enjoyed its greatest influence in America with the mass produced cottage furniture. The spiral twist associated with the Elizabethan revival forms can be recognized in the simple ball-and-spool-turned straight member found on the lightweight, but durable country cottage pieces. The extent of the Elizabethan revival style was limited in the United States and never approached the magnitude of other revival styles of the 1800s. Elizabethan Revival Style values: Chair, High Back, Upholstered Seat, good condition, circa 1850, $260; Dresser Mirror, mahogany, $165.

ENGRAVED GLASS

Engraved decoration on glass is an age old technique revived with typical Victorian enthusiasm between 1840 and 1900. A series of copper wheels accomplished the desired design on the outer surface of the glass, which was most often left unpolished. Simple and intricate patterns were frequently combined with cutting for additional effects. Classical, historical and mythological motifs ruled engraved glass designs of the mid-eighteen hundreds. Colored glass of the 1870s and 1880s was highly suitable to engraving, a technique associated with glasshouses active in both America and Europe. Engraved Glass values: Pairpoint Bowl, engraved, 12″, $90; Vase, ruby, 10″ high, circa 1875, $75.

EPERGNES

Silver epergnes were gradually being replaced in the 1850s as favorite centerpiece attention getters by lovely glass epergnes. Epergnes of frosted, opaque, cranberry and other color glass innovations were made by leading American glasshouses such as the Boston and Sandwich Factory. The branching arms spreading from the center held fruit or flowers, some being so fragile that only the lightest ferns and flowers were placed in the chalices or baskets. There were some made with two tiers of glass bowls rising from the single vase center portion. There were combinations of silver plate, satin glass, cut glass and opaque glass that created

exquisite epergnes for formal dining occasions. Due to their extremely fragile quality and size they were easily damaged, and surviving perfect examples fetch substantial prices. Epergne values: Cranberry, Three Arms in Center Trumpet Vase, $220; White Milk Glass with opalescent effects, threads of cranberry glass, three branches, center stem, circa 1890, $230. Illustration on page 201.

ÉTAGÈRE

Magnificent étagères graced parlors and halls with a central mirror flanked on either side by numerous shelves. The family display of bric-a-brac was shown to great advantage on rosewood and black walnut or ebonized wood étagères. The detail of the étagère bore out the influence of the prevailing furniture style. The étagère differs from the what-not in that it had a central mirror and was not a corner piece, but was made to be placed flat against the wall. The size of the mirror varied, and the more elaborate étagères had a cupboard base, or shallow drawer with a marble top. Quality furniture factories made the étagère and often the more elaborate types were custom made by cabinetmakers. Étagère values: Long Mirror, black walnut, 7' tall, circa 1870, $580; Walnut, painted black, rococo details, 6' tall, fair condition, circa 1865, $400; Walnut, marble top base, Eastlake details, elaborate, good condition, 7' tall, $550. Illustration on page 83.

ETRUSCAN MAJOLICA

Griffin, Smith and Hill of Phoenixville, Pennsylvania made the prized Etruscan majolica between 1879 and 1890. Leaf-shaped dishes were made from butter pat to large platter size, along with other colorful tablewares in collectible patterns such as shell and seaweed, cauliflower and maple leaf. Marked Victorian majolica pieces are scarce and this firm clearly marked their wares, contributing in part to their antique importance. The monogram "GSH" with the words "Etruscan Majolica" surrounding the monogram appear separately or together on the firm's varying trademarks. An impressed letter and number system used by the firm can provide positive identification when they match the company's shape chart. Etruscan Majolica values: Butter Pat, leaf shaped, $7; Cup and Saucer, Shell and Seaweed Pattern, $72; Cauliflower Pattern plate 9", $32.

EUGENIE PATTERN

The McKee Glass Company of Pittsburgh, Pennsylvania was responsible for this pressed glass tableware pattern, designed with a decidedly French flavor. The distinctive shapes were heightened in importance by the design consisting of leaves, shields and thumbprints. The clear glass pattern was named to honor Napoleon III's Empress Eugénie. Since the Empress enjoyed world wide attention and admiration, one is left to ponder whether the pattern, or merely the pattern name, was the cause of its enduring acceptance into the 1880s. Eugenie Pattern values: Castor Bottle, $16; Champagne, $26; Goblet, $18; Tumbler, $28.

F

FAIRING

What-not shelves sagged under the weight of the fairing during the reign of Queen Victoria. Sold at fairs and gatherings, these low-cost brightly colored trinkets and treasures were made by potters in England and the Continent. Glass and china figures, ornaments, early-to-beds, nodding figures and hundreds of other whimsical novelties opened the eye and the purse of souvenir-loving Victorians. Fairings sold at fairs in the 1800s for lower prices than they sell for at the flea markets today. Fairing values: Marriage Bed Series, $40 to $50 each; Staffordshire Slipper, $45; Trinket Box, Little Red Riding Hood on Cover $38.

FAIRY LAMPS

Samuel Clarke of the Child's Hill Works, England received a patent for his candle lamp design in 1885. These glass burning night lights had a base and shade in two parts and he advertised them by stating that if every home used a night light, burglars would be frightened away. His patent rights were extended to include other countries, and by the following year, the United States was included. The lamps have "Clarke Fairy Lamp" impressed into the base. The quality of glass employed to make night lights varied according to the maker involved, from inexpensive colored glass, to art glass. Fairy lamps were made in burmese, nailsea, satin, amberina and peachblow. The fairy lamp evolved from

Clarke's earlier designs, such as the Cricklite which was popular in the 1860s. The name Cricklite is derived from Cricklewood where Clarke established his factory. Clarke's fairy lamps were always considered superior, despite severe competition from other manufacturers. Fairy Lamp values: Blue shade, diamond point pattern, $65; End of Day Glass, soft colors, $120; Satin Shade, pink, enameled decor, $190.

FANS

Fantastic fans from the reign of Queen Victoria are important collectors' items. Fans were a fashion must and were exchanged by ladies, much as we exchange photographs and greeting cards today. There were fans for every special occasion, such as operas, weddings and everyday street fans as well as mourning and church fans. Tortoise shell sticks were complemented with ostrich feathers, while a point lace fan often had mother of pearl sticks. Fans fluttered into the United States from Europe and the Orient and were so much in vogue that fan holders and boxes were everyday necessities. The Language of the Fan was registered at the patent office in 1879, and a young lady could transmit messages across a room by holding or moving her fan in a particular manner. Fan values: Bridal Fan, ivory, hand-painted silk, $45, Mother of Pearl, black lace, $14. Illustration on page 91.

FASHION PLATES

The fashion plate enjoyed its major thrust of popularity with the reign of Queen Victoria. Its importance is attributed to the leading fashion journals of the day which featured line engravings and etchings colored by hand. They were often the work of leading artists, many of whom signed their drawings. The change that occurred in fashion plates of the Victorian era was the fact that two or more, and often groups, began to appear on fashion plates, whereas those of an earlier date always had a single figure. Fashions and furnishings of the late 1800s can be observed in the fashion plates, which were generally French in origin. *Godey's Lady's Book, Peterson's Magazine* and *Lady's Friend* were three of the American magazines which contained fashion plates. They are frequently removed from a magazine and individually framed. Fashion Plate values: Godey's Lady's Fashion Plate, framed, circa 1862, $14.

FEATHERWORK

Goose, duck and chicken feathers were cut, curled, painted and dyed in the home craft project involving featherwork. Victorian ladies excelled at creating floral wreaths, flower pictures, or bird, figure and foliage arrangements displayed under glass domes. Featherwork wreaths were placed against dark velvet backgrounds and set in deep shadow box frames. Pips and stamens of wax provided touches of detail and tongs were employed to curl the feathers. Later in the century it became fashionable to dye the feathers. The feathers were intricately cut in shapes of leaves and petals for interesting wall ornaments. Featherwork that has weathered the years will find an immediate buyer with an appreciation for nineteenth century homecrafts. Featherwork value: Shadowbox Frame, Floral Wreath, 16" x 18", $90.

FENDER

Fenders to edge the hearth were found in Victorian homes, particularly among the more affluent. They were of polished steel, cast iron, and brass. The more detailed the brasswork, the better the fender. The low fender of Georgian popularity was gradually replaced by a slightly higher version, which often concealed unsightly fireplace necessities. The model with leather seats at either end would certainly be considered a rare find. Kitchen fenders invariably had a broad flat top to accommodate serving and cooking utensils. The majority of nineteenth century fenders were English in origin, although some were made in America. Fender values: Brass, 38" long, circa 1870, $95; 48" long, brass, circa 1840, $140.

FERN MOTIF

Fragile ferns provided a decorative airy touch to Victorian interiors between the 1850s and the 1870s. Ladies made dried fern arrangements in vases and then encased them under dustproof glass domes. Manufacturers, realizing the potent power of the fern, made fern engraved tableware glass, wallpapers, fabrics and hand-painted and transfer-printed china—all designed with the fern lover in mind. A Minton vase or needlework project having a fern motif may be attributed to this fern fever of the middle 1800s. Fern Motif value: Copeland Vase, Fern motif, handpainted, 10", circa 1860, $45.

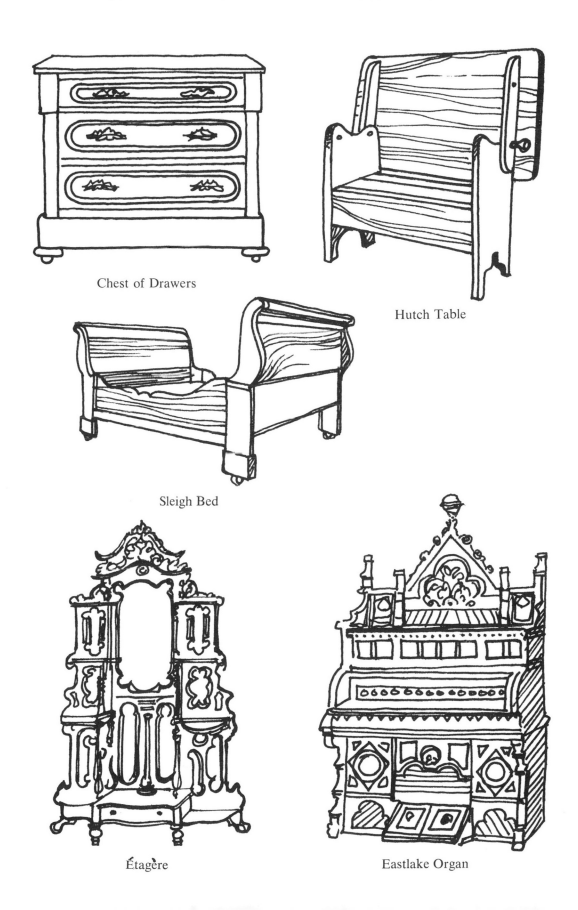

Chest of Drawers

Hutch Table

Sleigh Bed

Étagère

Eastlake Organ

FIGURAL BOTTLES

The patent office of the United States was kept active with fancy and unusual designs being registered for glass and pottery figural bottles in the second half of the nineteenth century. These figural bottles depicted animals, fish, birds and notables among the numerous captivating designs. Never had liquids been contained in so many handsome and unique bottles and in such a full range of exciting colors. The Clown Bottle, the Bob Fitzsimmons Bottle, the Washington Bust Bottle, the Monkey Bottle and the Boxing Glove Bottle are just a few of the exceptional American figural bottles of importance to collectors. Figural Bottle values: Bob Fitzsimmons, frosted, folded arms, $68; Columbus Bust, pedestal type, $28; Washington Bust, clear, $20.

FINE CUT PATTERN

This American pressed glass pattern of enduring popularity was made by many firms and under numerous names. Adams & Company, glassmakers of Pennsylvania, referred to it in the 1870s as their "Cottage" pattern. Bryce, McKee and Company, also of Pennsylvania, preferred the name "Panel Russian" during the 1880s. Despite the various glasshouses making the pattern, and the numerous variants, all have some portion covered with a fine-cut design. Flattened Fine Cut, Fine Cut and Panel Russian, Fine Cut and Rib and Fine Cut and Feather are a few of the variants made in this pattern, available in both clear and colored glass. Fine Cut Pattern values: Fingerbowl, Amber, $18; Goblet, clear, $15; Sauce Blue, $14; Tumbler, amber, $20.

FINGER BOWLS

English in origin, finger bowls were once known by the very descriptive name "wash hand bowls." They were made by leading glass factories around the world in the time of Queen Victoria. Fine quality flint glass finger bowls, clear and colored, are choice collectors' items. Finger bowls of the post Civil War era became considerably fancier when the new glass techniques were employed in their production. Cut glass finger bowls in clear and colored glass adorned table tops of the 1880s and 1890s. Finger Bowl values: Amber thumbprint, 4½" diameter, $24; Cut glass with underplate, $35; Silverplated, $11.

FIREBOARDS

Victorians bored with unattractive fireplace openings in full view over the summer season covered them with elegant fireboards. Cut to fit the desired opening, they then lent themselves to the usual Victorian passion for beautification. Hand-painted portraits, scenes, floral, fruit and other subjects were created by those possessed with art ability. The less fortunate were forced out of sheer lack of talent to avail themselves of the splendid array of fireboard prints, some having borders and cut-outs in patterns duplicating dinner service patterns. Fancy fireboards with Dresden and Wedgwood china patterns are real finds. A Victorian fireboard is certain to spark your decor! Fireboard values: Landscape, handpainted, artist signed, circa 1850, $130; Print of Floral subject, circa 1880, $65.

FIREHOUSE WINDSOR

A revival occurred during the Victorian period of the low-back Windsor chair which found great favor in the quarters of fire companies and was dubbed the "Firehouse Chair." The heavy horseshoe shaped arm was supported by seven to nine spindles and the deep seat was either flat or slightly saddled. There were many variations and on some of later origin there may be a finger-hole center on the horseshoe arm of bentwood. Frequently the seats were caned. The earlier chairs made between 1840 and 1880 usually had seat and arm of pine, combined with legs, spindles and stretchers of maple or birch, while after this date many were made of oak. They were mass produced and very inexpensive, yet durable and sturdy. Firehouse Chair values: Pine, refinished, circa 1860, $78; Oak, late, $52.

FIREMARKS

The first firemarks were issued during the eighteenth century even though professional fire fighting companies were not formed until the middle 1800s. The firemark indicated the house was an insured property and preventing it from burning would mean an award to the fire fighters. There was a noticeable decline in the number of firemarks issued after 1840; however, some late terra cotta, lead, wood, or iron marks were made. Flowering trees, eagles, trumpets, hydrants, fire fighting figures, along with some marks distributed for advertising purposes, date from

the middle 1800s. *Tip:* Reproductions are usually made of iron. Fire-mark values: Hydrant, circa 1840, $40; Trumpet, circa 1850, $38; Firemark Insurance Co., advertising, circa 1870, $30.

FISH SETS

A fish set solved the wedding gift dilemma of the 1880s and 1890s. A complete set consisted of six or twelve plates, each with a different fish center, and a large matching platter. The platter often featured a salmon. Finer sets had a matching covered vegetable dish, sauce or bone dishes. The porcelain sets from leading European factories were often hand painted, while the semi-porcelain sets being less expensive were transfer printed. China painters often preferred painting their own fish sets and important factories in America and abroad supplied them with blanks. A well known factory mark, artists signature, date and quality of workmanship contribute to determining the value of a fish set. Fish Set values: Limoges, six plates and platter, handpainted, circa 1890, $140; Elite Limoges, transfer printed design, seven pieces, $78.

FLASKS

Flasks are flat or convex and range in size from a few ounces to over a quart in capacity. The various collectible designs were accomplished by professional mold makers who cut them into the mold, after which the glass was blown into the mold creating the desired pattern. Among the numerous categories of interest are the decorative, portrait, Masonic, fraternal, historical, and pictorial flasks. Special collector emphasis centers on those flasks depicting important events in American history. Flasks remained popular until about 1870 and prices vary depending on subject matter and rarity. Exceptional flasks have been discovered by adventuresome bottle enthusiasts who dig them up from their underground hiding places. Flask values: General Taylor Never Surrenders, circa 1850, $60; Washington, Jackson olive green, pint flask, $90. Illustration on page 191.

FLINT ENAMEL

Christopher Webber Fenton of Bennington, Vermont patented this flint enamel process in 1849, and it became known as "Fenton's Enamel." Streaks of color, yellow, green, blue and orange were achieved by this glazing process, which was actually an elaboration of the English Rock-

ingham glaze. The additional coloring gave the Fenton wares a mottled effect. A wide range of items were produced using the flint enamel process. Marked examples are rare; unmarked examples, worthy acquisitions. Flint Enamel values: Bedpan, $135; Candlestick, circa 1849, $165; Lion Figure, 9½″ long, $750.

FLOW BLUE

Staffordshire potters of the nineteenth century found a lucrative market awaited their flow blue earthenware designs. Flow Blue, Flowering Blue or Bleeding Blue is the name given to a type of earthenware in which the cobalt blue color flows away from the transfer-printed pattern into the white base. This blurring of the design was intentional and found great favor between about 1820 and 1900. Early flow blue patterns often had Oriental pattern names including Kyber, Formosa, Chapoo, Scinde and Manila, many employing flower and fruit motifs. Marked examples exist from some of the leading English potteries. Between 1880 and 1900 there was a revival of flow blue which differed somewhat from the earlier wares. Late patterns were mainly floral designs, touched with gold, and the blue color was often lighter than the earlier cobalt blue. The patterns were also more legible, with less blurring. *Tip:* A piece of flow blue with the country of origin on the underside indicates a date of production after 1891. Flow Blue values: Butter Dish, Fairy Villas Pattern, $68; Plate, Manila Pattern, 7″, $16; Tureen, Manila Pattern, large size with platter, $280.

FLOWER PRINTS

American lithographers found flower prints blossomed into immediate profits with botanical loving Victorians. Every major and minor lithographer issued flower subjects, led by Currier & Ives who made over one hundred different flower prints. Some of their titles reflecting the sentimental feeling of the era include "The Flower Vase," "Choice Bouquet," "Floral Offering," "Ladies Bouquet" and "Bouquet of Roses." A number of important lithographers such as Kellogg's of Hartford, Connecticut, Haskell and Allen, Kimmel and Forster, and William Sharp found floral subjects saleable to the masses. Floral and botanical magazines and ladies magazines such as *Godey's Lady's Book,* abounded in flower prints. They were drawn by some of the foremost Victorian artists and many are exceptional examples of Victorian lithography. Flower

Print values: Currier & Ives, "The Flower Vase," small folio, Upright Vase, $65; Currier & Ives: "Floral Offering," small folio, $65. Illustration on page 91.

FOOD BOTTLES

Country and city storekeepers found that the glass bottle containing a food product had a definite advantage in that the contents could be seen. Manufacturers agreed and a variety of fascinating bottles, some labeled or with embossing and others with a shape suggestive of the contents, was used to market numerous items. They are very sought after, especially those in cobalt, red, green, amber and other colors, which bring better prices than the clear glass examples. A date is advantageous, increasing the worth, and a patent date can mean additional value even though it does not always indicate the date of production. Pickles, tomato cocktail, root beer, horseradish, catsup, honey, peppersauce, mustard and salad dressing are just a few of the appetizing delights packaged in appealing bottles. Food Bottle values: Pickle Bottle, purple, 9½" high, circa 1885, $16; Peppersauce, green, 3-tier Gothic design, 14 oz., $60.

FOOD SAFE

Homemakers of the nineteenth century stored their family food supply of baked goods in this kitchen cupboard. A country furniture piece, the wooden frame characteristically had a metal front. The front was usually tin, pierced with imaginative designs and motifs, and often had regional details. The cabinets had a number of shelves, varying according to their size. The food safe was actually a type of early refrigerator. The pierced panels, in addition to being decorative, also provided ventilation and protection from insects. The work of rural craftsmen, particularly of the Midwest, the pierced tin panels can help determine both origin and value. Food Safe values: Large Size, Pennsylvania origin, rough condition needing work, $115; Tin Pierced Panel, refinished pine, large size, $180.

FOOTMEN

Known since the eighteenth century and still considered standard fireside equipment during the Victorian era, these high four-legged trivets were usually made of brass or iron. They had straight back legs and cabriole front legs, providing the necessary support for the top piece,

which was elaborately pierced on the finer specimens. The footmen stood by the fireplace to hold various household items, including a kettle or hot pan, or was an auxiliary piece for use alongside the dining room table. Footmen value: Footed Brass Pierced Design, circa 1860, $95.

FOOTSTOOL

The footstool was a standard piece of furniture found in every Victorian home. They varied from the early Empire styles to the fancy rococo carved footstools of the middle 1850s and 1860s. Many had upholstered or needlepoint tops, were oversized and overstuffed, and supported by legs of wood. The circular or rectangular spool-turned footstools with tops of wood or upholstery are quite scarce. Footstools were made as a part of a parlor set and range from low footrest size to chair seat high. Footstools surrendered to the Turkish influence during the 1880s and 1890s. Footstool values: Spool Turned Black Walnut, circa 1855, $75; Upholstered Top, Slender Cabriole legs, walnut, circa 1860, $80; Victorian Empire Mahogany, $65.

FOOTWARMER

There are several types of footwarmers that may be puzzling at first glance to the novice antique buff. A familiar type made early in America was the wood or metal box with handle. This type had a metal drawer where hot coals were placed to carry on a cold winter trip. By the nineteenth century railway stations rented footwarmers of metal or stoneware to travelers. They could be filled with hot water and further encased in a wrapping to retain the heat. The hot water was placed within a copper vessel prior to being inserted into the actual footwarmer. The shape and size may vary, but all had handles and some bear printed information pertaining to the maker or a patent date. Footwarmer values: Ironstone, 12" high, $36; Tin pierced heart, wooden frame, $29; Wooden, large cherry, $55.

FORMOSA PATTERN

Thomas Furnival and Sons, Cobridge, England registered their Formosa dinner service design with the English registry office in 1879. Flowers, scrolls, brocades, cherry blossoms, scenes, opened fans and wavy cloud bands printed in gray blue formed the Japanese motif. The original pieces were treated with overglaze decoration in yellow, red,

blue and other colors. The overglaze decoration is missing on most of the antique pieces, having been rubbed away with daily washings. *Tip:* Factory wares made after 1895 are marked "Furnival, Ltd." Formosa Pattern values: Butter Pat, $2; Plate, $3; Soup Plate, $4.50.

FRENCH FASHION DOLLS

The Jumeau toymakers of France are credited with creating many of the fashion dolls of the Victorian era. The Jumeau dolls were very lifelike, with delicate faces set with glass eyes and beautiful hair. The majority had bisque heads, although other materials were used, depending on the maker. The dolls were completely dressed in stylish fashions of the day. A typical trousseau had as many as eighteen different outfits. Their clothing was perfect to the most minute detail, including underclothing, kid gloves and parasols. French Fashion Dolls of the late 1800s are exquisite and represent a triumph of Victorian toy making. French Fashion Doll values: Bisque swivel head, black human hair, 17", fully dressed, $440; Blue eyes, blonde hair, all original, 18", $425.

FRETWORK

"Free Cutting and Perforated Cardboard" published in 1869 gave complete instructions and designs for fretwork projects. Demonstrations at the Philadelphia Centennial in 1876 gave further impetus to the fretwork frenzy of the 1870s and 1880s. Men, women and children could easily follow the patterns for openwork brackets, wall cabinets, table mats, mirrors, bread platters, book rests, card rests and other fretwork fabrications. A wall pocket towel-rack or other object might be embellished with a panel of Berlinwork. Leaves, birds and elaborate scrolls adorned fretwork pieces. All were cut with a small scroll saw. This type of work is also known as jigsaw work. Fretwork values: Bric-a-Brac, hanging walnut, three shelves, $65; Wall Pocket, walnut, large size, $60. Illustration on page 91.

FRIENDSHIP QUILTS

Ladies of the 1840s and 1850s engaged in quilting sessions to make special quilts for a specific person, honoring the minister's wife or some other special person for whom a group decided to make a presentation. This quilt top was made in separate blocks, each lady supplying a block

Fretwork

Fans

Flower Prints

of her own choosing, usually signed with indelible ink. The friends then gathered for an afternoon of assembling and quilting the separate blocks into a finished quilt. They represent one of the more interesting groups of nineteenth century quilts. The effectiveness was even greater when the various blocks were applied with care and color coordination for overall beauty and attractiveness. They are also known as Signature, Autograph or Album quilts. Friendship Quilt value: Makers' signatures, dated 1856, colorful, size 60″ x 72″, $210.

FROSTED GLASS

Sandblasting or grinding techniques were employed on glass to produce a frosted effect before 1850. An improved technique achieved by the application of acid was perfected after the middle of the century. Pre-1850 frosted glass accomplished by the earlier methods is rough to touch while the acid-treated pieces are very smooth. The leadless lime glass of the post Civil War period showed many imperfections which could be covered by the frosting process. Glasshouses started making pressed pattern glass with clear and frosted combinations about 1870. The resulting frosted patterns include Westward Ho, Classic, Jumbo, Deer and Dog, Lion and Three Face and are the aristocrats of American pressed glass. Frosted Glass values: Butter Dish, Classic Pattern, Clear and Frosted, $68; Lion Pattern Covered Compote, large, $72; Water Pitcher, Three Face Pattern, $220.

FROZEN CHARLOTTE

The Frozen Charlotte doll is surrounded by numerous legends. There supposedly was a girl named Charlotte who on one bitter cold day rode five miles in a flimsy dress and was frozen stiff at the end of her journey. The doll depicts the frozen child and is usually made of china with immovable arms and legs. The arms are almost always found at the side of the doll, or pointing outwards, although some dolls were made with arms folded in a prayer position. Due to their rigidity they are also known as "Pillar Dolls" or "Twenty-Five-Cent" dolls, as they originally sold for this modest price. Warm-hearted souls can never resist the legend of Frozen Charlotte and consequently she has become a hot item in the field of antique dolls. Frozen Charlotte Doll value: Highly glazed china, black painted hair, 4½″ high, $38.

FRUIT JARS

The fruit jar was used for preserving numerous household edibles. Lucky you if you have preserved your grandmother's fruit jars. Blue ribbons were presented at country fairs to happy homemakers who had preserved their delicacies in fruit jars such as the "Independent Jar," "Woodbury," "The Queen," "Crown Cordial and Extract Co.," and others of the late 1800s. The amber jars bring highest prices and generally colored glass jars sell for somewhat higher prices than clear examples. Fruit jars marked "Mason's, Patent Nov. 30, 1858" are sought after. However, this date continued appearing on these jars for many years thereafter and should not be assumed as the date of production. Fruit Jar values: Mason's Patent Nov. 30, 1858, aqua, ½ gallon, $14; Mason's Patent, Nov. 30, 1858, amber, quart, $45; Star Glass Co., green, circa 1870, $22.

G

GAMES

W. & B. Ives introduced the Dr. Busby card game which was conceived to enlighten players in the art of conversation during the 1840s. This game was a forerunner in the field of educational Victorian parlor games. Indoor games were so cleverly designed that young players were completely diverted from their instructional contents. Among the makers of American games who gained prominence in the late 1800s are Crandall's, McLoughlin Brothers, Parker Brothers, Sehlow and Righter, Milton Bradley and S. L. Hill firms. A game bearing the name of one of these American makers is almost certain to have interest to a collector. Packaged amusements including board games, puzzles, card games, toy picture books, drawing books and other table and carpet games of pre-1900 vintage are worthwhile acquisitions. Game values: Dr. Busby's Card Game, $12; "Birds" Card Game, circa 1880, $7; McLoughlin Board Game "The Messenger Boy" dated 1889, $28.

GAME SET

A game set consisted of six or twelve plates and a matching platter, each with a different game bird. The porcelain sets were often hand-painted, while those of semi-porcelain were transfer-printed. The specific game birds varied according to the individual artist; however, wild turkeys were frequently featured on the large platters. The game set craze coincided with the china painting fad of the 1880s and 1890s and manufacturers furnished blanks that could be decorated at home. A game set from a known factory, with an artist's signature or possibly bearing a date, would bring highest returns. Game Set values: Bavarian, hand painted, circa 1890, $140; Limoges, transfer-printed, semi-porcelain, $85.

GAUDY IRONSTONE

English potters introduced brightly-colored Imari type ironstone wares around the 1850s. Many of the pieces were decorated with floral designs in bold colors and further embellished with copper luster or gilding. Gaudy ironstone was exported to the United States where it met with limited approval and was therefore never heavily produced. A number of pieces will bear a factory mark, making attribution possible. Tea and dinner services were made in Gaudy Ironstone as English potters attempted to duplicate the designs of the popular Japan pattern porcelains on the ironstone body. Gaudy Ironstone values: Cup and Saucer, circa 1855, $60; Pitcher, 8″ high, $110; Platter, 24″ diameter, $125.

GAUDY WELSH

This is not to be confused with the earlier imported wares from England known as Gaudy Dutch. Gaudy Welsh pieces are heavier and more crudely decorated with Imari type designs, highlighted with copper luster or gilding. Gaudy Welsh pottery was exported to America between about 1830 and 1850 and all patterns are extremely collectible, particularly Wheel, Tulip and Vine. Gaudy Dutch is an earlier ware also from England which was exported to the United States between 1810 and 1830, primarily to the Pennsylvania German areas. The best known pieces in Gaudy Welsh are the tea services and coffee sets and other tableware pieces. *Tip:* The cups on Gaudy Welsh pottery were handleless. Gaudy Welsh values: Cup and Saucer, Morning Glory Pattern, $63; Milk Pitcher, Tulip Pattern, $102; Plate, Oyster Pattern, $58.

GENTLEMAN'S CHAIR

A present-day term for a Victorian upholstered balloon-back arm-chair which was usually one piece in a complete set of matching parlor furniture. Matching sets of furniture became fashionable in the middle 1800s during the Rococo revival period. The number of pieces in a parlor set varied. A standard one consisted of a sofa or love seat, a lady's chair, a gentleman's chair, and four or six side chairs. An ottoman or center table were optional additions, while those sets designated for drawing room use had numerous other pieces. Gentleman's Chair value: Carved, upholstered, circa 1860, $360.

GIBSON GIRL COLLECTIBLES

Charles Dana Gibson created the Gibson Girl in the 1890s and the nation fell in love with her. Newspapers and magazines devoted enormous amounts of space to the Gibson Girl and she developed into a business bonanza. Now rated as collectibles are such Gibson Girl items as hats, pillows, shoes, silver spoons, wall hangings, buttons, buckles, belts, pictures and all china bearing her portrait. The pen and ink drawings of Charles Dana Gibson, whether found singly or in book form, would be a noteworthy piece of Gibsonia. Gibson Girl Collectibles values: Belt Buckle with Gibson Girl, $16; Pillow with Gibson Girl case, $28.

GIBSON GIRL PLATES

Royal Doulton, potters of Lambeth, England, presented a series of twenty-four plates based on the pen-and-ink drawings of the Gibson Girl by Charles Dana Gibson in 1901. Blue borders surround these ten-and-a-half-inch plates. Each one has a different center of a pen-and-ink sketch printed in black against the white background. The various drawings and accompanying printed story relate another chapter in the trials and tribulations of the recently widowed lady. They are marked "Royal Doulton" and sold for fifty cents each when first issued. The firm made a second series of Gibson Girl plates, each having a large portrait of a Gibson Girl as the center subject, printed in black on white with a blue border. Gibson Girl Plate value: The Widow and Her Friends Series, each plate, $45 to $55. Illustration on page 141.

GILLIAND PAPERWEIGHTS

Choice millefiori paperweights were made in America about 1850 by the distinguished glassmaker, John Gilliand. Millefiori weights attributed to Gilliand often featured faceted cutting on the crown and sides which tend to frame the minute green, pink and white flowers. Three or four slices of cane were formed in the making of his coveted bouquet weights. The bouquet, supported by a short pedestal cane, seemingly floating over the latticinio background. *Tip:* Gilliand paperweights in the millefiori style are clear and sharp; study is required to differentiate them from the current flood of reproductions. Gilliand Paperweight value: Geometric Design, Canes above Latticino Background, $675.

GIRANDOLES

Magnificent girandoles graced Victorian mantels and sideboards during the second half of the 1800s. These three-piece sets usually consisted of a three-branched candelabrum and two matching single holders. Their elaborate fixtures of brass, bronze or other metal were in ornate figural forms, including Paul and Virginia, Christopher Columbus, Pocahontas and others. Paul and Virginia were such favorite subjects that girandoles were often called Paul and Virginias. Many girandoles had marble or alabaster bases and all were prism-hung. A bronze candelabra often had a parian figure and the three-piece girandole represents mantel garniture at its finest. Girandole value: Paul and Virginia, marble base, bronze with prisms, three-piece set, $390.

GLOBE WRITING TABLE

From all outward appearances this ingenious writing table resembled a large size globe. The upper section was made to rotate into the lower section, revealing a writing surface. There were several compartments for storing writing materials, in addition to the writing surface. It may take a world wide trip to uncover one of these globe writing tables; however, why not check the attic first! Globe Writing Table value: $110.

GOSS WARES

Diversified collectible wares from the William Goss firm established at Stoke-on-Trent England in 1858 rate the attention of all collectors of

Victoriana. A specialty with the firm was their beautiful Beleek resembling pearly luster parian ornaments and their jeweled porcelains made by fusing colored enamels to the porcelain. Exquisite parian jewelry, brooches, hair ornaments and necklaces were delicately modeled and met with immediate success. Attracting the eye of aware collectors are the Goss crested "ivory porcelains," souvenir pieces of the 1890s. Tableware and other miniature novelties, with town and country coat of arms, known as Goss Crested China are in the category of "tomorrow's antiques." Goss Ware values: Jug Lighthouse, $7; Loving Cup, 1½" high, $9; Vase, Shakespeare Arms, $8; Parian, figurine 10" high, $65.

GOTHIC CLOCKS

There were over one hundred different Gothic clock cases made by American clockmakers of the 1840s and 1850s representing their contribution to the Gothic revival style in architecture and furniture. A major form was the sharp Gothic top, also known as a steeple clock. Other versions included a double steeple. There were less pronounced round and pointed Gothic shelf clocks in numerous sizes. Elias Ingraham originated the Gothic case, quickly copied by other clockmakers. Variations in movements occur depending on the maker. Door frames of the finer clocks were brass, the glass in the lower section being engraved or painted in suitable subject matter. Gothic Clock values: Gilbert Clock Steeple, $100; F. N. Welch, Forrestville Connecticut, eight-day, Rosewood, $140; Waterbury Steeple, Rosewood, eight-day movement, $160.

GOTHIC REVIVAL STYLE

The Gothic revival style in America from 1840–1865 coincided with the vogue for Gothic architecture, an influence developed in the early 1800s. By the 1840s churches and public buildings with Gothic influences were being joined by mansions and country homes, designed by architects in Gothic style. A number of finer pieces such as bookcases, sideboards and chairs were designed by architects too and were custom made to blend with the existing Gothic structures they created. Side chairs are more numerous than armchairs, and matching bedroom sets were very popular. The Gothic influence had its greatest recognition and continued popularity as church furniture. Characteristics include the pointed arch, cusps, finials, trefoils, heraldic devices and elaborate cut

carving, drawing mainly from medieval sources. Gothic Revival values: Armchair, Walnut, upholstered seat, $340; Side Chair, upholstered seat and back, circa 1850, $280; Secretary with cupboard base, circa 1850, $1,700. Illustration on page 99.

GRANDFATHER'S CLOCK

The tall case clock has been a favorite in America since the late seventeenth century. The name Grandfather's clock has been used since the middle of the nineteenth century and often the clock papers will provide you with the history pertaining to a tall case clock. A grandfather's Clock bearing a label from a prominent eighteenth or nineteenth century clockmaker has the greatest value. Other factors contributing to its worth would be the condition of the painted portions and the amount of original parts still intact. They are also known as hall clocks and long case clocks, while the smaller examples are often called miniature grandfather clocks. Grandfather Clock values: Pine, Brass works, weights, pendulum, 7' tall, circa 1850, $600; Oak case, late, good condition, circa 1885, 6' tall, $210. Illustration on page 41.

GRAND RAPIDS FURNITURE

This term was applied to the inexpensive mass-produced furniture originating at factories in or near the area of Grand Rapids, Michigan. From the middle of the 1800s into the early twentieth century, furniture from this region was sold by mail order catalogs and low priced furniture stores. Oak finished in a very light color known as "Golden Oak" was a specialty with the furniture makers of Grand Rapids. Hall stands, china closets, tables, bookcases and sofas were purchased by the average wage earners of the late 1800s and scorned by their wealthier counterparts. Grand Rapids furniture has rapidly moved from thrift shop to antique shop status and this furniture, once neglected, is now respected. Grand Rapids Furniture values: Desk Bookcase Combination, golden oak, $290; Roll Top Desk, two drawers, Oak, carved detail, $370; Round Dining Table, 54", Oak, circa 1900, $210.

GRAPE FURNITURE

Cast-iron furniture makers found the naturalistic grape motif ideally suited to garden furniture designs between 1850 and 1900. A number of important cast-iron furniture factories made garden chairs, tables and

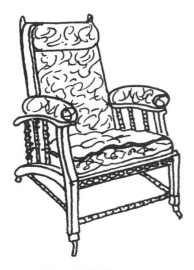

Morris Chair

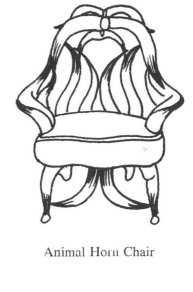

Animal Horn Chair

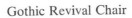

Gothic Revival Chair

Medallion-Back Sofa

Turkish Armchair

settees in matching sets employing the grape motif. The round-tree settee was breathtaking, as this circular piece was adjustable to fit around any size tree trunk. The circular back and seat had a pierced grape design with leaves and tendrils, supported by scrolled legs with leaf shaped feet. On a sunny afternoon a family could escape to the garden and commune with nature, while relaxing amid grape furniture. Grape Cast-Iron values: Chair, $210; Table, $190.

GREENAWAY, KATE

As early as the 1880s and 1890s Kate Greenaway drawings were avidly collected by a host of admirers and there has been no diminishing of the public's fascination with her work over the years. This beloved English artist is known for her drawings of children in high-waisted dresses which appeared in a series of children's books and on greeting cards. The first book, *Under the Window,* was published in 1878, followed by *A Day in a Child's Life* in 1881 and *Marigold Garden* in 1885. She influenced children's fashions on both sides of the Atlantic. Soon there were Kate Greenaway almanacs, birthday books, alphabets and of course a host of imitators. The artist designed greeting cards for English publishers, including Marcus Ward. There is a buyer for all Kate Greenaway related items, as the demand far exceeds the supply. Kate Greenaway values: Child's China Place Setting—cup, saucer and plate, $43; Napkin Ring, good condition, $52; Plate, 7" diameter, dated 1890, $32.

GREEN GLAZED EARTHENWARES

First introduced in the 1700s, green glazed earthenwares benefited from gradual improvements and by the 1840s were being extensively made by many English potters. The semi-translucent green glaze covered the raised molded design, giving this ware an attractive subtle shading. Molded leaf and floral motifs, and later in the century landscape and figural subjects dominated the designs. The impressed name "Copeland" appears on green glazed earthenwares of the 1840s onward. Wedgwood pieces are clearly marked and from 1860 have a three-letter code mark, which when deciphered, will give the month and year a piece was potted. Green Glazed Earthenware values: Leaf motif dish, Copeland 1858, $16; Plate, floral design, Wedgwood, circa 1865, $14.

GREENWOOD ART POTTERY

When this company was formed in 1861, Trenton, New Jersey, was rapidly becoming one of the leading ceramic centers in the United States. The original name was Stephen Tams and Company until reorganization in 1868 as the Greenwood Art Pottery. James Tams, the president, served his apprenticeship in the pottery field in Staffordshire, England, prior to relocating to America. The firm specialized in the so-called hotel china, stone china and fine white wares. Later in the century they made thin porcelain art wares in the tradition of Royal Worcester. Greenwood Art Pottery values: Hotel China Plate, $4; Ironstone white cup and saucer, circa 1865, $9.

GREINER DOLLS

Ludwig Greiner has the distinction of receiving in 1858 the first patent ever issued to an American dollmaker. A German toy maker, he came to the United States during the 1840s and settled in Philadelphia. The patent covered his papier-mâché doll heads with painted features and occasionally glass eyes. Greiner dolls are marked between the shoulder blades "Greiner's Improved Patent Heads. Pat. March 30, '58," or "Greiner's Patent Doll Heads, Pat. March 30, '58 Ext. '72." Size numbers may be found on some specimens and the hair style may be a guide to dating. Greiner Doll values: Doll with 1858 label, 20", $220; Doll with same label, dressed in original clothing, 24", $265.

GRUEBY POTTERY

As a result of the swift public acceptance of their architectural bricks and tiles, the Grueby Faience Company of Massachusetts entered the art pottery field in the late 1890s. Their exhibit at the Paris Exhibition in 1900 was well received and their factory output was influenced by Egyptian and Art Nouveau styles. Their unique matte finish on leaf-like forms in low relief brought about a distinct line of vases. Their pottery was sold at Tiffany's in New York and Grueby lamp vases were ordered for Tiffany lamps. The individual artist's monogram often accompanies the firm name on this group of American art pottery wares. Grueby Pottery values: Vase, green and yellow cattails, $140.

H

HADLEY WARES

James Hadley, one of the foremost designers and modelers of nineteenth century ceramics, was employed by the firm of Royal Worcester from the 1870s on. His Japanese designs earned the Worcester firm highest awards at the Vienna Exhibition in 1873. Hadley acted as an independent modeler, and the Worcester firm distributed his wares. Their relationship continued in this capacity after Hadley established his own factory in the 1890s. He was responsible for a group of children's figures dressed in Kate Greenaway costumes, which are highly collectible today. His Hadley Wares consisted primarily of exceptional quality porcelain vases painted with floral motifs. Hadley value: Vase, floral decor, circa 1895, $170.

HAIR RECEIVER

A true Victorian keepsake is this dresser top accessory conceived to hold strands of hair clinging to a brush or comb after grooming. A hole in the center of the removable lid accommodated the hair on the appropriately named hair receiver. The simple round shapes are more numerous than the oblong, heart, square or oval types. These two-piece mementos were made of porcelain, silver, silver plate, pressed and cut glass. Hand-painted hair receivers of opal glass and other materials from the C. F. Monroe firm of Meriden, Connecticut date from the 1890s. Hair receivers were imported to America from factories the world over between 1880–1900. Those bearing company marks bring best returns. Hair Receiver values: China marked R. S. Prussia, $60; China marked Royal Rudolstadt, 4½" diameter, $25.

HAIRWORK

The art of hairwork in several differing forms left no hair unturned by clever Victorian ladies with creative urges needing to be satisfied. The most familiar type was the hairwork picture, accomplished by using strands of human hair in the manner of thin pencil lines to outline the overall subject matter. The hairs were applied to a selected background, with white slipper satin a particular favorite. Hairwork wreaths and bou-

quets were made and framed in deep set shadow box frames as wall ornaments. Hair albums and hair-embroidery work were further excursions into the sentimental tokens undertaken to preserve the hair of friends and relatives. Hairwork values: Shadow box frame, wreath with cross hairwork, coral beads and seed pearls, 17" x 18", circa 1865, $125.

HAIRWORK JEWELRY

A hairwork jewelry memento may be the work of a professional jeweler or the preoccupational effort of a Victorian lady. Beautifully detailed landscapes and floral designs were executed by jewelers using human hair by as early as the eighteenth century. Hair bracelets incorporated human hair with seed pearls and commercially-made hairwork jewelry enjoyed a vogue lasting into the middle of the nineteenth century. The decline in professionally-made hairwork jewelry pieces occurred when memorial jewelry created with the hair of the deceased was practiced extensively as a homecraft. *Godey's Lady's Book* and *Peterson's Magazine* and other periodicals gave instructions for making brooches, cuff links, necklaces, earrings and other pieces. When completed, they were taken to a jeweler for mounting. Hairwork jewelry was a home art that flourished between 1850–1900. Hairwork Jewelry values: Brooch, Oval, braided hair under glass with seed pearls in gold mounting, 2" x 1", $65; Ring, with braided hairwork, $40.

HAND COOLER

These oval objects of Victorian vintage are often mistaken for fancy eggs or paperweights. They were held in the palm of the hand to provide relief from the heat of the day, being too beautiful for simple darning chores. Multi-colored swirled glass hand coolers were made by leading factories during the 1800s. Cased and swirled glass examples from the French Baccarat firm are eagerly collected. Various types of colorful Victorian art glass were employed in making lovely hand coolers. Hand coolers of onyx, marble, alabaster, and agate were always close at hand to refresh a lady at a social gathering or to provide relaxation from a tedious needlework project. Hand Cooler value: Swirled glass, $38.

HANDEL LAMPS

The Philip Handel firm of Meriden, Connecticut, and New York City was a leader in manufacturing fine art glass shades between the

1880s and late 1930s. A number of their leaded glass shades are of the same overall type as the coveted Tiffany shades. A specialty with the Handel firm was the painted glass shade which was designed to show a scene or other selected subject when the lamp was lighted. The Philip Handel firm made various other articles, but is best known for its decorative lamp shades, which are currently enjoying a resurgence of popularity. Handel Lamp values: Table lamp, floral decor, signed, 19″ high, $430; Table lamp, roses and butterflies, signed, 14″ high, $280.

HAT PIN HOLDERS

Dresser tops were crammed with countless trinkets and treasures including the hat pin holder. Cartwheel hats of the 1890s brought the hat pin into style and a lady had more than one hat pin to match her favorite hat. They were stored in hat pin holders resembling sugar or powder shakers with small holes over the top section where the hat pins were placed. Hat pin holders were a part of a complete dresser set, but are offered for sale singly nowadays. Leading porcelain factories made attractive hat pin holders and the price can be determined by the factory mark on the underside. *Tip:* Hat pin holders never had a hole in the base. The base was always solid and a hole would indicate the piece was a sugar or powder shaker rather than a hat pin holder. Hat Pin Holder values: Royal Rudolstadt, pink flowers, $17; R. S. Prussia, $47.

HATRACKS AND TREES

The hatrack was developed in the 1840s as a hall piece to accommodate outer clothing. It was particularly suited to urban area homes with narrow hallways. The idea quickly spread to rural regions and by the 1860s hatracks became as popular as knicknacks. They followed the designs and lines of the existing furniture styles and ranged from simple hanging types to large masterpieces. The hanging wall versions, plain or fancy, had hooks or pegs and usually a central mirror. The freestanding hat tree had retaining arms for umbrellas and canes, the hatrack portion being pierced or scrolled. Some versions had mirrors and a marble base. Hatracks were in constant production during the entire era and both cottage and formal types supported the chapeaux and outer garments of young and old alike. Hatrack and Tree values: Mirrored Oak hall rack with seat for storage, refinished $200; Rococo style with leafy

scrolls, umbrella loop, dip pan, garment hooks, cast iron, 6′ tall, $475; Walnut accordion type hatrack with porcelain knobs, $32.

HATS

Glass hats, blown, blown-molded, blown three-mold and pressed were made in a wide array of clear and colored glass during the 1800s. They were decorative as well as useful. Small ones made excellent toothpick holders, match holders or salts, while larger size hats made interesting spoon holders. Glasshouses tossed into the ring such novelties as caps, bonnets, Quaker hats, firemen's hats, three-corner hats and soft crowned and wide brimmed hats, to mention a few. Every conceivable glass innovation was employed in the making of Victorian glass hats and they appeared in many pressed glass patterns, of which there are countless reproductions. Hat values: Brimmed hat, blue glass, $15; Daisy and Button pattern, amber, $18; Uncle Sam's hat, white milk glass, $22.

HAVILAND

The sight of the family set of Haviland being placed on the dining room table always caused a stir and meant company was coming. Haviland china is fondly referred to as "company china," or "Grandmother's china," since practically every grandmother owned a set of Haviland. David and Daniel Haviland organized the Haviland factory in the Limoges district of France during the 1840s. Their factory output was destined for the American market, and their porcelain dinner services and ornamental objects earned immediate recognition for superior quality and workmanship and beauty of design. Several branches of the family became connected with the business over the intervening years and the name Haviland became synonomous with fine tableware service. Complete sets are highly regarded and the search continues for missing pieces to a family set of Haviland. Even separate pieces are readily in demand. Haviland values: Chocolate Pot, Morning Glory Pattern, $55; Covered Vegetable dish, pink rose sprays, circa 1880, $34; Cup and Saucer, floral decor with gold, circa 1870, $18; Tea Set, Wedding Ring Pattern, service for eight, $230.

HIRED MAN'S BED

This narrow spool-turned bed was heavily produced by Eastern and Midwestern factories between 1840 and 1900. The mattress rests solely on the eight wooden splats, since the bed is devoid of springs. They were

generally made of birch, maple and assorted hardwoods with natural finish or painted to simulate black walnut. Hired Man's Bed value: Good condition, circa 1860, $180.

HISTORICAL BLUE

Staffordshire potters, beginning about 1820 and for several decades thereafter, produced transfer-printed pottery depicting American subjects. The dark blue prominent on earlier wares was gradually supplanted by the light blue, pink, sepia, green and often two-color combinations. Favorite views included American landscapes, historical events, patriotic emblems, portraits of heroes and notables. Each maker had his own characteristic border. Unmarked pieces can be accurately attributed to a particular potter by studying the border design. Early Historical Blue made before 1850 is prized. There were limited quantities made for the remainder of the century and the later production is known to collectors as Anglo American printed wares. There was renewed interest following the Philadelphia Centennial in 1876 for Historical Blue. Another revival occurred about 1900 when a group of Commemoratives was issued with new subjects, due primarily to public enthusiasm for old blue-printed wares. Historical Blue values: Cup and Saucer, Stubbs City Hall, New York, $95; Plate, Beauties of America series, blue, $44 each; Platter, William Adams 15½" x 12½", Harper's Ferry, $300.

HITCHCOCK CHAIRS

Authentic Hitchcock chairs have a stencil across the back reading "L. Hitchcock Warranted," or "L. Hitchcock, Hitchcockville Ct.," or "Hitchcock, Alford & Co." Painted or stenciled chairs without one of these distinguishing marks are best referred to as Hitchcock-type chairs. The Hitchcock chair had a rectangular back, a wide crest rail, one or more horizontal slats, and a square rush seat. They were usually painted black or reddish brown with stencil-decorated splat and crest rail, with gilt lines on stretchers and leg turnings. The original Hitchcock factory was in operation from the mid-1820s into the 1850s. Presence of a factory mark and condition of original decoration determine value. *Tip:* The original stencil portion should never be altered, as this will decrease the worth of a Hitchcock chair. Hitchcock Chair values: Hitchcock chair painted black, stencil good condition, $120; Pillowback Rush seat, original stenciling, good condition, $160. Illustration on page 31.

HOBBY HORSE

Benjamin Potter Crandall introduced his first commercial hobby horse, "The Crickett," during the 1840s with crudely shaped head and legs set on rockers. This was a slight improvement over the imported hobby horses of the period and the homemade versions which were generally the work of family members or local cabinetmakers and carpenters earlier in the century. Wooden hobby horses were soon being marketed by toy firms, painted red, gray, tan and other colors and having painted swirls resembling hair. Several firms experimented with stuffed bodies, but found the wooden ones were more practical. The Crandall patent rocking horse of the 1860s was the large type with hind legs connected to the platform, the movement created by a metal spring. *Tip:* A hobby horse made prior to 1900 is, of course, an important acquisition and should always be left in its original condition. Hobby Horse values: Small, with rockers, good condition, $90; Larger size on rockers, $140; Early primitive type, original paint, circa 1845, $230. Illustration on page 161.

HOBNAIL

The overall design on this pressed glass pattern resembling drops of dew accounted for it being known originally as the Dewdrop Pattern. The pattern, which also resembles the heads of hobnails, is often attributed to the Boston and Sandwich Factory of Massachusetts. There were countless variations of the well-known Hobnail pattern between the 1840s and 1900. Hobnail was made clear, colored, and in milk glass, as well as opalescent, and due to its heavy production by many factories, definite attribution is next to impossible. The Hobnail family tree boasts some of the following names: Hobnail and Diamond, Hobnail with Line Band, Hobnail with Colored Bands, Hobnail in Square, Hobnail with Thumbprint Base and Hobnail with Fan Edge, to mention a few. Hobnail Pattern values: Clear Sugar Bowl, $32; Opalescent Tumbler, $30; Spooner, Amber, $22; Water Tray, blue, $42.

HOOKED RUGS

Two enterprising gentlemen were responsible for the renewal of interest in hooked rugs, starting about 1870. Edward Frost, a New Englander, devised a method of tracing designs on burlap using a metal

stencil, and by varying the colors of paint he could indicate to the home-maker the colors to be employed. Happy homemakers got hooked on these innovative hooked rugs, sold by street peddlers and shops with relative ease. Mr. Pond of Biddleford, Maine, reached a mass market for his stencil rug patterns by means of newspaper and magazine advertise-ments. Hooked rugs have been a part of American life since the landing of the Pilgrims. Any such rug should be carefully preserved by using it for decorative purposes only, such as a wall hanging. *Tip:* There has been a reissue of the Frost rug patterns clearly different from those of the closing decades of the last century. Hooked Rug values: Good con-dition, circa 1880, $78; Rough condition, $42. Illustration on page 109.

HOOPS

Young ladies in France were encouraged to participate in hoop playing as an exercise of grace. The hoop revival of the Victorian period took hold when American magazines and newspapers featured articles and advertisements about the "Game of Graces." Toy manufacturers re-sponded and New England firms' catalogs listed wooden hoops available in twelve different sizes. The small hoops were brightened with bits of velvet, ribbons, leather and tinsel and were sold with a pair of hoop sticks. By the 1860s, boys and girls alike were happily hooping away the hours. Hoop values: Wooden, circa 1880, good condition, $18; Rough condition, $8.

HORN OF PLENTY

Choice is this early pressed glass pattern which was kept in con-stant production between about 1850 and 1900. The curved horns of plenty with bull's eye circles were usually made in a brilliant heavy weight. The seeker of this pattern will find it in both clear and colored glass, stained or decorated with gilt trim. Bryce McKee Company of Pennsylvania listed the pattern as Comet, a name familiar to collectors. Horn of Plenty has proven plenty popular with collectors, a fact reflected in the high values on this glass pattern. *Tip:* A late inexpensive pressed glass pattern known as Dickinson closely resembles the more expensive Horn of Plenty. Exercise your expertise before buying. Horn of Plenty values: Celery, $75; Creamer, Clear glass, $100; Plate, 6″ diameter, $55.

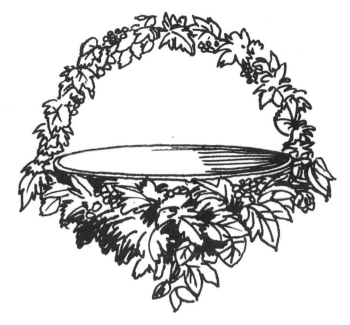

Leatherwork

Beadwork

Hooked Rugs

HOUND-HANDLE PITCHER

The hound-handled pitcher form originated in England around the early 1800s and was being copied by American firms during the 1840s. Slight variations may occur depending on the maker. However, the basic form remained unchanged for the duration of the century. A mottled brown Rockingham glaze covers the pitcher, depicting in relief a hunting scene, or dog and deer battle, or other animals of the chase. The distinctive handle is in the form of a fox, hound, or other dog. One hound design only was made at Bennington, Vermont, with distinguishing details providing accurate identification. Any unmarked hound handled pitcher would be difficult to attribute to a particular maker, due to the fact that this form was widely potted in England and America by various firms. Hound-Handle Pitcher values: Bennington American eagle under spout, $250; Rockingham, 9″ high, $125.

HUNTZINGER CHAIRS

George Huntzinger was one of the foremost furniture makers in the New York City area during the 1870s and 1880s. His listing under "chairs" occurs in city directories of the 1860s. He registered a patent for reclining chairs in 1861. Retailers' catalogues of the 1870s listed ten different Huntzinger chairs which were illustrated and described. Huntzinger earned a reputation for a series of fancy chairs based on the reclining or folding chair form. These upholstered versions of the simplified camp chair met with success. Bamboo chairs and settees were distributed by Huntzinger in the post Civil War years. A chair bearing the stamped mark of the Huntzinger factory is of museum quality. Huntzinger Chair value: Folding Chair, circa 1865, $135.

HUTCH TABLE

This dual purpose piece originated in Europe during the seventeenth century. Hutch tables of the middle nineteenth century were usually made by country carpenters, mainly Pennsylvania in origin. The hutch table succumbed to the age of industrialization and late in the 1800s was factory produced. When the top is in a vertical position it becomes a settee and when in a horizontal one, doubles as a table. The chest-resembling section varies in size, being from about eight to ten inches deep with a hinged lid. The hutch table was often of softwood

stained to simulate black walnut or painted a solid color. Hutch Table is an American term for this chair-table combination having a storage area beneath the seat. Hutch Table values: Pine, refinished, 42″ diameter, $360; Round, Pine, refinished, 52″ diameter, $420. Illustration on page 83.

I

ICE-CREAM SET

Dessert time was close at hand when the ice-cream set was taken from the china closet in the 1880s and 1890s. The sets of china or glass consisted of one large serving piece or bowl with twelve matching smaller dishes. Hand-painted porcelain sets, marked by a leading firm and often artist signed, are considered best. China-painting practitioners could purchase the china blanks and create their own individual designs. Retailing at somewhat lower prices in the last two decades of the century were the transfer-printed sets, usually of semi-porcelain. Cut-glass ice-cream sets of the Brilliant period, 1870–1910, were made with a deep miter cut employing intricate designs. Ice-Cream Set value: Limoges Platter and Twelve Plates, floral design, gold edge, $160.

ICICLE PATTERN

Washington Beck created the Icicle pattern of pressed glass in 1874 for Bakewell, Pears of Pittsburgh, Pennsylvania. The design consists of vertical ribbing of different lengths terminating in points, giving the general overall effect of rows of icicles. A variant was introduced having the same vertical ribbing with a sunken star above the highest point around the pattern. The pattern was marketed in clear and milk glass. A late Icicle pattern was made by Fostoria Glass Company of Ohio in the early 1900s and although inferior to the earlier version, it is beginning to melt the hearts of glass collectors. Icicle values: Clear Butter Dish, $30; Clear Goblet, $17; Milk Glass Pitcher, $42; Sugar Bowl, milk glass, $48.

IMARI

Porcelain of Japanese origin having bold floral designs in bright colors such as red, rust, blue, orange, gold, tangerine and green is known as

Imari. The bulk of Imari available to collectors dates from the second half of the nineteenth century, although the wares were made as early as the seventeenth century. The name is derived from the port of Imari, from which the porcelains were exported around the world. The demand for Imari reached such sizable proportions that English firms copied the Imari type of decoration on a group of porcelains known as Japan patterns. A small amount of Imari originated in China. *Tip:* Imari seldom bears a factory or other distinguishing mark. When one is present, caution is advised. Imari values: Bowl, 8″ diameter, $90; Ginger Jar, 9½″ covered, $120; Plate, 10″ diameter, $75.

INDIAN TREE PATTERN

Chinese in origin, this china pattern pictures a gnarled tree, thought to be the trunk of a peony tree, in brown with pink peonies, green foliage and other floral motifs. The outer border has a Chinese fretwork design, slight variations occur according to the maker. Coalport has marketed this perennial Indian Tree pattern since 1801 and factory marks from this firm can be researched to establish a date of production. Doulton and other English and American firms also made the Indian Tree dinner service. A less expensive semi-porcelain version was sold during the 1880s and 1890s. *Tip:* The pattern is still in production; rely on factory trademarks as a guide to establishing authenticity. Indian Tree Pattern values: Spode Waste Bowl, $14; Teapot, circa 1870, $50; Minton Covered Sugar Bowl, $40.

INDUS PATTERN

Ridgway and Sparks first made this dinner service pattern in the 1870s. It was kept in production for several decades. There are surviving examples stored in barrels around the country as it was imported in large quantities. The earthenware pattern was printed in several different shades of gray, brick red, blue and other colors. A twig encircles the edge of the design with flowers, leaves and birds encircling the center . scene of a pond, water lilies, iris and wading birds set against the white or cream colored body. *Tip:* The factory mark is helpful in dating any piece of Indus pattern. The firm marked their wares "Ridgway and Sparks" between 1873 and 1879 and simply "Ridgway" between 1879 and 1920. Indus Pattern values: Covered Vegetable Dish, medium size, $20; Cup and Saucer, $12; Platter, medium size, $18.

INK BOTTLE

The small inkwell and the larger bottle for holding the supply of ink are both classified as "interesting acquisitions" to a horde of bottle buffs. The inkwells were made in numerous shapes, clear and colored, and in well-known patterns during the 1800s. The larger bottle holding the ink supply will often have the name of the individual ink company and the color range is varied. The large ink bottles had matching glass stoppers, or cork stoppers. Names such as "Diamond Ink Co.," "Carter," "Chas. Higgin's & Co." and "Sanford Mfg. Co.," will cause a collector to reach for his pen and checkbook anytime. Ink Bottle values: Diamond Ink Co., amber, $6; Mrs. Carter, red and white, $27; Sanford Inks, amethyst, $7.

INKSTANDS

Inkstands and inkwells of any material including china, brass, cast iron, pewter, copper, silver or glass are important Victorian objects. Those designated for home use are generally more impressive than the less expensive types used in office or business establishments. China inkstands resembled exquisite ornaments, their real use camouflaged with elaborate figures, flowers and animal forms. Decorative inkstands of metal or glass were standard items in Victorian libraries, some having more than one matching inkwell and complementary pen holder. China inkwells had metal fittings and hinged lids and porcelain examples were made with delicate floral motifs. There were also blue and white Delft inkwells and pottery types in amusing bird or animal forms. Finding two inkstands exactly alike would be most improbable, if not impossible. Inkstand values: Cut glass well, sterling top and tray, $50; Inkstand, lion motif, ornate brass, circa 1870, $140; Silverplated with crystal wells, $100. Illustration on page 191.

IRON CLOCK CASES

Clockmakers' catalogues of the 1850s and 1860s pictured cast iron front-shelf clocks to match existing furniture styles of the day. The Gothic influence was strong, with one elaborate example taking the form of a Gothic cathedral with detailed fretwork, available in several sizes. Intricate rococo cases had embossed leaves, birds and other natural forms frequently painted or embellished with mother-of-pearl inlay. Plain and

cottage shapes were for those wanting something less ostentatious. The clock label found on the interior of an iron front clock may credit it to an important American clockmaker. Iron Clock values: Iron front, rococo style, handpainted, circa 1860, $90; Mantel clock plain type, eight-day, $55.

IRONSTONE

Charles James Mason patented his formula for ironstone in 1813. The dense hard earthenware body contains pulverized iron and rings clearly when struck. It was the ideal body for durable dinner services and objects designated for heavy use. Factories in England and America developed and marketed similar white earthenwares. They were called by a variety of names such as Granite Ware, White Granite, Opaque Porcelain, Stone China and Hotel China among others. Ironstone was a suitable base for flow blue patterns and Imari type designs in bold colors known as Gaudy Ironstone. Transfer-printed ironstone followed the designs on porcelain, and luster-decorated pieces found favor after 1850. White ironstone with raised embossed patterns in floral, fruit and other motifs was afforded great public acceptance in the second half of the nineteenth century. Most makers marked their ironstone pieces with factory trademarks, a guide in establishing their origin and age. Ironstone values: Bowl, Morning Glory pattern, 8″, $12; Chamberpot with lid, $20; Pitcher, Wheat Pattern, $21.

IRON TOYS

Cast iron toys existed in America prior to 1880. However, after this date they suddenly became increasingly important in the world of toy-dom. Those of an earlier date were primarily banks, cap pistols, small toys or specific toy parts. During the 1880s and 1890s and into the early twentieth century, push-and-pull vehicles of all types became larger and more fascinating. Circus wagons, horse-drawn vehicles, passenger vehicles, fire engines, trolley cars and animals, many with moving parts or tricky mechanisms, captivated young and old alike. Iron toy trains rate a special mention. All iron toys of the nineteenth century have considerable worth and marked specimens are important finds. Among the leaders in the field of cast iron toy makers were E. R. Ives, W. B. Carpenter, Kenton Hardware Company and the Hubley Mfg. Company. Iron Toy values: Bakery wagon, good paint, $140; Circus Wagon, driver

and two horses, $120; Fire truck with horse team, circa 1890, $120. Illustration on page 211.

ITALY PATTERN

Antique china, whether purchased or inherited, invariably leads the owner in a quest for knowledge pertaining to its acquisition. Factory trademarks of nineteenth century manufacturers have been thoroughly documented over the years and dating and origin can often be ascertained on a majority of marked wares. The trademark found on the Italy dinner service of the 1870s is a perfect example. The firm's trademark was a greyhound with initials "E. M. & Co." below on a ribbon with the words "Leci, Gulf of Italy." Edge Malkin and Company of Burslem, England, was the maker, operating in the Staffordshire district between 1871 and 1903. The central scene pictures an Italian village and includes water, mountain peaks, a castle, church and a harassed driver coaxing his oxen up a steep hill. Italy Pattern values: Plate, $12; Platter, medium, $28; Sugar Bowl, $22.

IVORY

The Victorian ivory carver often reproduced an earlier work of art and there was a considerable amount of carving achieved between 1840 and 1900. Carved figures of Chinese and Japanese origin enjoyed widespread popularity. Sewing tables displayed small embroidery or sewing accessories of turned ivory. Ivory jewelry included brooches, necklaces, lockets and other pieces, all finely carved in intricate designs and fitted with gold or silver mountings. Perfect pieces bring premium prices as they were easily damaged. *Tip:* Carved ivory figures from the Orient are known as Netsuke. Ivory values: Figurine, boy with goose, 10″ high, $140; Letter Opener, carved elephant handle, $18; Napkin Ring, shield for initial, $12.

J

JACK-KNIFE CARVINGS

An assortment of birds, busts and beasts await the seeker of nineteenth century jack-knife carvings. Schimmel and Mountz are two of the

recognized carvers, but thousands of unknowns are waiting to be discovered. Amateur and primitive carvings ranging from humorous caricatures to copies of important cast-iron pieces were attempted by whittlers of wood from a century ago. Skilled cabinetmakers and carpenters displayed amazing carving ability, and after the Civil War, a host of carvers roamed the countryside carving primarily for food and lodging. Both professional and amateur wood carvings represent excellent investment possibilities, with a nod in favor of the signed examples. Jack-Knife Carving values: Eagle Head and Wings, 8″ x 9″, unsigned, circa 1860, $110; Owl figure, unsigned, 18″ tall, circa 1870, $125.

JACOB'S LADDER PATTERN

John Bryce of Pennsylvania called this glass pattern, also known as Maltese, Imperial in original design papers of 1876. Company catalogs of the 1880s listed it as Maltese, the name being derived from the finials and knobs which were formed to resemble the Maltese Cross. A late Jacob's Ladder was made into the early 1900s, lacking the detail of the earlier pattern. Vertical panels of ladders form the overall design, alternating with panels of fine line cutting and diamonds; variants differ according to maker. Climbing prices should not deter your stepping up to an acquisition of this clear glass pattern. *Tip:* A few colored serving pieces were made in the Jacob's Ladder pattern which are classified as "rare" by collectors. Jacobs Ladder values: Cake Stand, $24; Water Pitcher, $45; Wine Glass, $15.

JADE

Jade has always been a costly substance and jade jewelry and carved accessories were mainly acquired by wealthy Victorian families, many of whom purchased their pieces while traveling through the Orient. The continued progress in trade with China during the nineteenth century resulted in more jade articles being available. Carved statues, boxes, incense burners, inkwells and snuff bottles were coveted by those who could afford them. The ladies were impressed by bracelets, brooches, necklaces, earrings and other treasures of jade jewelry. Jade values: Brooch, carved, $52; Buddha, 5″ tall, $175; Fish, 3″ long, $57.

JAPAN PATTERNS

Japanese Imari type designs on china from famous English porcelain factories are known as Japan Patterns. The Derby factory and other important firms made these bold floral designs in a wide range of colors including blue, green, red and gold. Low-cost labor employed to paint the wide areas of color made Japan patterns inexpensive to produce. Between 1850 and 1900 many original Derby Japan patterns were revived and renewed interest was apparent when Japanese styles prevailed in the 1870s and 1880s. Tea sets and dinner services in Japan patterns were plainly marked with factory trademarks; deciphering the mark can be easily accomplished. Japan Pattern value: Tea Cup and Saucer Imari pattern, circa 1885, $37.

JELLY CUPBOARDS

Used to store jellies, jams and other old-time fixin's, this Midwest term was applied to small cupboards of the 1800s. A typical kitchen cupboard had two doors with two drawers above and was usually made of local woods such as pine, maple or cherry. Resist the temptation to paint them. Retain their country charm by refinishing them in a manner to preserve their original condition. Jelly Cupboard values: Cupboard, pine, rough condition, 6½' tall, $150; Refinished cupboard, $230.

JENNY LIND BEDS

Spool beds and Jenny Lind simultaneously captured the American public during the 1850s. The low-post spool beds are now fondly referred to as Jenny Lind beds. The early spool beds had straight lines, often the work of local cabinetmakers. Rounded corners appeared on foot and headboards after 1850, and all types continued being mass produced by furniture factories until the 1880s. There were high-post and low-post spool beds. Strongly favored was the type with head and footboard of equal height. Jenny Lind beds are of a size to make them practical for modern day use. Jenny Lind Bed values: Full size, refinished, $280; Three-quarter size, rough condition, $150.

JENNY LIND MIRROR

A cast iron dressing mirror frame of the middle 1800s is often referred to as a Jenny Lind mirror, in honor of the Swedish singer. The

design varies slightly. A typical example has an openwork iron border surrounding the glass with cupids in the center top portion. The mirror frame is supported by two ladies in crinoline dresses, one on either side of the frame, and an American flag and monument complete this most distinctive dressing mirror. Jenny Lind Mirror value: Cast iron mirror, fair original paint, circa 1860, $125. Illustration on page 119.

JERSEY TURTLE PAPERWEIGHT

This name was applied to a paperweight, developed in America around the Civil War era, of green glass and other colors which were roughly molded into the shape of a turtle. The rounded glass crudely formed turtle was often made as an end-of-day piece by factory workers. The earliest weights date from the 1860s and 1870s and have been in almost continuous production since this date. Examine a Jersey Turtle Paperweight that may cross your path for signs of wear as a clue to determine age. Jersey Turtle Paperweight value: Late, $35.

JET JEWELRY

The vogue for jet jewelry started in the 1860s when it was worn primarily as mourning jewelry. During the 1870s jet jewelry became very fashionable and was found acceptable worn with any type of attire. Jet appeared heavy and impressive but was actually very light in weight. Necklaces, brooches, earrings and bracelets of jet were made, usually of high quality. True jet is a type of fossiled coal having a glassy surface and intensely black in color. It is easily distinguished from the inexpensive Victorian Jet black glass imitations known as "French Jet." Jet Jewelry values: Necklace with 14K gold clasp, $21.

JEWELED PORCELAINS

The Sevres factory of France was associated with jeweled porcelains late in the eighteenth century. There was a revival during the 1850s of jeweled porcelains in England, sparked by the Copeland firm. Exquisite ornamental pieces of porcelain were created by a treatment coating them with colored "jewels." The method consisted of adhering colored enamels, resembling jewels, to gold foil and firming them to the porcelain body. A slightly improved technique was introduced by the W. H. Goss firm in the 1870s. They made many fine examples having jeweled decoration. Jeweled Porcelain value: Copeland vase, blue background with jewel trimming, gold, 10″, $160.

Overmantel Mirrors

Jenny Lind Mirror

Art Nouveau Picture Frame

JUMBO PATTERN

P. T. Barnum's elephant from The Greatest Show on Earth was honored by the Canton Glass Company of Canton, Ohio with this pressed glass pattern of the 1880s. A sought-after rarity is the Elephant pattern spoon holder, bearing a patent date 1883 impressed in the glass. The Jumbo covered butter dish is another treasure, complete with elephant finials. The design is attributed to David Barker and the pattern when first marketed failed to attract an audience. The Aetna Glass and Manufacturing Company of Ohio advertised a Jumbo covered compote with elephant finial, stating that it was a perfect imitation of Mr. Barnum's attraction. The Jumbo pressed-glass pattern, once viewed, is truly unforgettable. Jumbo Pattern Glass value: Butter dish, oblong, $130; Covered dish frosted, $60; Spooner, $45.

JUMEAU DOLLS

The Jumeau dollmakers of France were active in the 1840s and contributed immensely to the beautiful dolls of the Victorian period. The first dolls made by this firm had head and body molded in one piece. Later improvements were made whereby the heads were molded separately and could turn. Their lovely dolls with bisque faces, dressed in fashions of the day, became known as French Fashion Dolls. They were known for their lifelike features. They were made in numerous sizes and in an era when many lovely dolls were created, the Jumeau dolls ranked among the finest. Jumeau Doll values: Kid body, original clothes, 17", $410; Open mouth, pierced ears, circa 1880, 15", $350.

K

KALEIDOSCOPE

Sir David Brewster invented the kaleidoscope in 1817. The foot long kaleidoscope had a tube which encased pieces of colored glass in the base with a fixed lens. A turn of the tube enabled wide-eyed children to view vari-colored eye-popping geometric patterns. A swivel stand was standard equipment with the finer models and some had hollow balls with drops of water inside which were set in motion with the turning of the tube.

The amount of excitement generated by the kaleidoscope could only be duplicated by a trip to the circus. Kaleidoscope value: Large size model with base, circa 1850, $135.

KEW BLAS GLASS

Victorians found iridescent glass absolutely irresistible and numerous glasshouses in the wake of enthusiasm for Tiffany glass attempted a version of this glassmaking accomplishment. The Union Glass Works of Somerville, Massachusetts, joined the list of Tiffany imitators with their Kew Blas glass, which was made between the 1890s and 1920s. The unusual name was derived by scrambling the letters of the factory manager W. S. Blake. Collectors clamor for Kew Blas glass and signed specimens bring highest returns. Kew Blas Glass values: Tumbler, signed, $170; Vase, signed, 5″ high, $170.

KNIFE RESTS

Among the interesting table top novelties of the 1800s was the individual knife rest. Set in front of each diner to provide a resting place for his knife, it was actually a preventative measure against soiling the fresh table cover. Cut-glass knife rests shaped like miniature barbells can be found in many patterns in both clear and colored glass. The large size rests were made to accommodate a carving knife. Knife rests of pottery, porcelain, silver and other materials are available in usual and unusual shapes. Noteworthy are the silver examples in bird, animal, fowl or other unique forms. Not to be overlooked are the homemade rests of wood with wire supports. The knife rest quest is certain to yield an unexpected surprise or two. They are a tribute to Victorian ingenuity. Knife Rest values: Cut glass, 5½″ long, $42; Ruby glass, 4″ long, $32; Silver plated with peacocks, $16. Illustrations on page 191.

KNOBS

File these under the "unnoticed category." Unnoticed, that is, until you decide to acquire one and discover they are no longer available. Knobs were pressed, cut and molded in clear, colored and opaque glass. Knobs and rosettes adorned mirrors and pictures, as well as countless curtains. The noted pearl-and-shell tieback of the Boston and Sandwich Glass Factory is well known to a legion of knowledgeable knob seekers. Tiebacks of clear, colored and milk glass were made by numerous glass-

houses. Those of cut glass generally date from the 1880s and 1890s. Door knobs were made periodically throughout the Victorian era, and in the closing decades art glass, cut glass, along with silver and mercury glass doorknobs, appeared on town and country doors. Knob values: Mercury glass doorknob, $32; Tieback, opalescent, pair, $62.

L

LACQUER FURNITURE

Furniture made to resemble Oriental lacquer became fashionable in the craze for Oriental decor which developed in the 1870s and 1880s. Black Lacquer furniture, embellished with gilt stenciling, mother-of-pearl inlay work and naturalistic flowers and landscape designs, found its way to America from Europe and the Orient. The majority of lacquered furniture was destined for use in the parlor or boudoir and closely resembled papier-mâché. The major difference was one of weight. The lacquer furniture pieces were heavier than the papier-mâché objects. Side chairs, arm chairs, tables and cabinets provided decorative accents to Victorian interiors. Lacquer furniture was made throughout the period and some examples may date from the 1840s and 1850s. Lacquer Furniture values: Armchair, mother-of-pearl inlay, good condition, circa 1880, $275; Tilt Top Table, mother-of-pearl inlay, $175.

LACY GLASS

There are two main categories of pressed glass; the first group was known as Lacy glass, which was made between the mid-1820s and 1850s. The second group was made after 1850 and is known as Pattern glass. Lacy glass is characterized by its finely stippled background. The completely stippled background set off the various patterns on objects including cup plates, oil lamps, pitchers, salts and curtain tie backs to mention a few. The bulk of lacy glass was clear, although some colors such as blue, green, amber and amethyst were made. The Boston and Sandwich Glass Factory of Massachusetts was a leading maker and often the term Sandwich Glass is applied to lacy glass. While some patterns made after 1850 continued employing some stippling, complete backgrounds were not covered in the manner of earlier lacy glass examples.

Lacy Glass values: Lacy Glass, Princess Pattern Bowl, $66; Peacock eye bowl, 5½", $60; Creamer, $62.

LADY'S CHAIR

The lady's chair was a standard piece in a parlor set or drawing room furniture and the style varied in accordance with existing furniture styles of the era. This upholstered balloon-back chair, without arms, was designed to permit a lady wearing hooped skirts to sit with a maximum of comfort. It first became fashionable in the 1850s when the Rococo Revival style flourished in America. Lady's Chair values: Early Victorian, Mahogany, $185; Eastlake, reupholstered, $95; Walnut, finger carved, $260.

LADY'S MAGAZINES

Periodicals published for the lady of the house set the tone for fashion, manners and morals during the nineteenth century. They related proper forms of etiquette, contained important receipes and gave detailed instructions on the latest wax fruit rage or embroidery project. Sewing hints were found tucked between the pages as were hand-painted French fashion prints and flower prints. Latest fads in furnishings were inaugurated and obliterated in articles dedicated to keeping the interiors of Victorian homes attractive with the latest imported and domestic household accessories. *Godey's Lady's Book, Peterson's Magazine, Lady's Friend, Demarest* and the *Delineator* were among the magazines found in the favorite chair of an aware Victorian lady. Magazine values: *Godey's Lady's Book*, bound edition, 1879, with color prints intact, $30; *Peterson's Magazine*, complete bound edition, 1884, $20.

LAKE OF COMO PATTERN

Tabletops of the 1840s were beautified by the blue-printed earthenware dinner service called Lake of Como. J. M. P. Bell, potters of Glasgow, Scotland, originated the pattern, which has their company trademark and pattern name on the underside. The firm trademark was often a Roman vase, known as the Warwick Vase. Lake of Como is a detailed design with mountain lake, villa, boats, fisherman, mountain peaks and a picturesque view framed in grape foliage surrounded by a border of vines. Lake of Como Pattern values: Cup and Saucer, $28; Plate, circa 1845, $16; Sugar Bowl, $45.

LANTERNS

A nineteenth century lantern, whether intended for indoor or outdoor use, is a worthwhile find. Railroad lanterns may bear an identifying mark which can be accurately traced to a particular railroad. Ship lanterns were made in innumerable varieties. The hinged starboard and port lights that open to insert a candle are very desirable. Glass lanterns carried by a leather strap or metal bail were often elaborate and, since they dispersed a considerable amount of light, were subject to heavy usage. Farmers, policemen and miners all had their special lanterns. The gas street lanterns have not only vanished from American streets and byways, but from the antique shops as well. Lantern values: Ship Captain's Lantern, copper, $95; Ship Stern Lantern, copper, $110; Railroad Lantern, $35.

LAUREL WREATH PATTERNS

Elsmore and Forster, Tunstall, England, created this elegant white ironstone design which was registered in 1867. The embossed seal on the base has the firm name, pattern name "Laurel Wreath" and the registry mark. The raised relief laurel wreath dominates the pattern which is similar to Wedgwood's "Medic" white ironstone design. Both of these fine patterns feature a wreath, and although they vary slightly, they are often interchanged. The two separate white ironstone services are identified collectively by antique buffs as "Federal," a modern name for the two designs. Laurel Wreath Pattern values: Pitcher, 9″ high, $35; Platter, 14½″ long, $30; Sugar bowl covered, $32.

LAZY SUSAN TABLE

Country-furniture makers of the nineteenth century, particularly from the Pennsylvania regions, made lazy Susan tables in limited quantities. The raised circular revolving tray with various compartments in the center of the circular top makes the lazy Susan table unmistakable. Favorite woods were cherry, maple, and black walnut. Some examples have a pine top. Attached to the four legs were X-shaped stretchers and some tables were painted blue and dark green, which were the preferred colors. The majority of lazy Susan tables were made between 1840 and 1880. Lazy Susan Table values: Refinished Pine Table, 60″ top with 40″ Susan, $525; Table in the rough, $325.

LEATHERWORK

Another dusting delight of the 1800s was leatherwork which was made of dampened sheepskin and then cut and modeled into leaves, flowers and fruit. They were left to dry and harden to rigidity and then sized, stained or varnished, and applied to a selected article. Wall brackets, hanging baskets and tables were a few of the objects which lent themselves to a leatherwork project. Leatherwork went commercial in the 1850s when sheepskin was thought to be more practical than wood for carving and also more durable. Creative hands fashioned leather flowers and leaves around picture frames and everything else imaginable. Leatherwork values: Wall Frame, good condition, 12″ x 14″, $42. Illustration on page 109.

LEEDS WARE

Cream-colored earthenwares of the highest quality were made by this prominent English pottery located at Leeds, Yorkshire, England. The pottery was active under various ownerships between the 1760s and 1870s. Characteristic of Leeds ware are the twisted handles terminating in delicate leaves and flowers and the openwork and pierced borders that decorate the pieces. The ware is light in weight and although some painted examples exist, the majority of pieces were left undecorated. Wainright and Company acquired ownership after 1840, using the original eighteenth century molds—which presents a problem so far as distinguishing the late Leeds ware from the earlier output. Leeds Ware values: Cream Pitcher, floral decor, $78; Cup and Saucer, $48; Pitcher, colorful flowers, 7″, $135.

LENOX

Walter Scott Lenox and Jonathan Coxon, Sr. founded the Ceramic Art Company of Trenton, New Jersey in 1889. Lenox brought with him an understanding of manufacturing fine Beleek which he had learned while in the employ of the Trenton-based Ott & Brewer firm. The firm first issued the famous Beleek swan dish in 1890 and it was to become a standard item in the Lenox line. The firm, which still exists, was renamed Lenox in 1906. Lenox values: Cup and saucer, Beleek, $43; Pitcher, tankard type, hand painted, marked "CAC," $160; Vases, pair, Beleek, 9″ tall, $100.

LETTER OPENERS

Victorian letter openers were always designed to be admired as well as useful, which accounts for the fact that ornate openers with gold or silver handles are now true collectors' items. Gems both precious and semi-precious further embellished the handles. Letter openers of wood, bronze, ivory, brass, celluloid, ebony and other materials are eye openers when spotted by a group of questers. Letter openers with advertising represent an interesting phase of American life and their varied subject matter makes them doubly desirable. Letter Opener values: Brass Lion figure, 10½" long, $14; Celluloid with advertising, $5; Sterling mother-of-pearl handle, $14. Illustration on page 131.

LIBBEY HATS

The throngs of people attending the Columbian Exposition in 1893 found it impossible to resist buying the frosted glass hats of the Libbey Glass Company. They were marked inside the crown "Libbey Glass Company, Toledo, Ohio." Since a multitude of frosted glass hats were made into the twentieth century, the appearance of this mark assures you of an authentic Libbey Hat. Libbey Hat value: $24.

LIBERTY BELL PATTERN

Gillinder and Sons of Philadelphia, Pennsylvania, registered this pressed glass pattern conceived for the Philadelphia Centennial Exposition in 1876, naming it "Centennial." The pattern is best known to collectors as the Liberty Bell pattern. The Liberty Bell is pictured along with the inscription "100 Years Ago, Declaration of Independence 1776, 1876." The bread tray and child's tea set are both very scarce. A complete line of tableware items in clear glass were issued, with the Liberty Bell salt and pepper shakers made with pewter tops. Gillinder and Sons set up a complete glass factory at the Centennial, where glass articles were made and sold to the visitors. The mark "Gillinder and Sons, Centennial Exposition" appears on wares made by them at the exposition. Liberty Bell Pattern values: Plate, 8", $30; Covered Sugar Bowl, $70; Pitcher, $70.

LIGHTHOUSE CLOCK

Simon Willard, designer of the famed banjo clock, patented the Lighthouse clock in 1822. Technical difficulties were encountered and although marketed in limited quantity, the clock was never a true success. The lighthouse shape supposedly was patterned after the Eddystone lighthouse that lies off Plymouth in the English channel. The style, copied by other clockmakers, always had the overall lighthouse form. The tapering wooden base, topped by a removable glass dome housing the dial and bell, was shaped to resemble a lighthouse. Lighthouse Clock value: Willard Lighthouse Clock, $6,800. Illustration on page 41.

LILY OF THE VALLEY

White ironstone delicately embossed with the Lily of the Valley pattern, from makers in the United States and England, filled cupboards of the late 1800s. Lily of the Valley in low raised-relief encircles the borders of plates and platters, interlaced with foliage. Creamers and pitchers have the lily of the valley draping gracefully from the handles. The factory mark and design varies with the different makers and a complete set can be accumulated by mixing and matching. Lily of the Valley Pattern values: Chamber Pot with lid, circa 1860, $24; Cup and Saucer, $12; Pitcher, 8″ high, $30.

LIME GLASS

William Leighton discovered this substitute for lead glass in the 1860s while in the employ of a West Virginia glasshouse. This leadless glass was inexpensive and easily produced by combining bicarbonate of soda with proportions of lime and other ingredients. Factories engaged in lead glass production faced severe competition and following the Civil War lime glass was used extensively for making pressed glass. Lime glass lacked the resonance and heavy weight of flint glass. Between the 1860s and 1900, clear and colored pressed glass patterns were made using lime glass.

LIMOGES

The Limoges area of France became known as the "porcelain town" due to the concentration of fine factories located in this area. The Limoges name became synonymous with quality porcelains which were

exported in increasing quantity during the nineteenth century. The last quarter of the 1800s brought French porcelains from such firms as Haviland, Elite China, Charles Ahrenfeldt, R. Delinieres and Pouyat China to the American market. Limoges factories, in addition to their own trademarks, often incorporated the word *Limoges,* or the letter *L* into the mark and after 1891, the word *France* appears on imports from this area. Limoges values: Dresser Tray, 12″ x 8″, $20; Hand-painted Cake Plate, signed and dated 1896, $42; Platter, 16½″ marked C. Ahrenfeld, $22.

LINCOLN DRAPE PATTERN

The assassination of Abraham Lincoln motivated the design of this American pressed-glass pattern. The glass had swagged draperies in low relief, based on the funeral trappings of the assassinated President. A dignified pattern glass, it was manufactured by the Boston and Sandwich Glass factory. *Tip:* A variant was the Lincoln Drape with Tassel which is the scarcer of the two patterns. Lincoln Drape values: Egg Cup, $18; Goblet, $35; Water Pitcher, $110; Tumbler, $24.

LINCOLN ROCKER

Abraham Lincoln was supposedly sitting in one of these rockers when he was assassinated, giving rise to the term "Lincoln rocker." The actual rocker was of a style reminiscent of late Empire designs and mass produced between 1850 and 1870. The rockers are known for their graceful curved frames. The high back and seat were upholstered on these French-type rockers. The carving varied depending on the maker. Some examples are quite elaborate, while other versions are very simply carved on the arms and back crest. Lincoln Rocker values: Grape Carved Rocker, refinished, $190; Rough condition, $120.

LION PATTERN

The combining of clear and frosted glass on tableware patterns emerged in the 1870s and the Lion design proved to be a roaring success. Richards and Hartley Flint Glass Company of Pennsylvania, and the Gillinder and Sons firm, also of Pennsylvania, both issued the Lion pattern. The frosted representation of a Lion was the distinguishing feature. Variations occur, depending on the glasshouse, with finials having a frosted lion's head or a crouching lion figure resting on a pad. The

frosted head of a lion decorated stems of certain tableware pieces, while flat plates and platters have bands containing one or more lion figures. Cagey collectors realize that this pattern is rated as one of the top ten pressed-glass patterns. Lion Pattern values: Jam Jar with knob of Lion's head, $35; Master Salt, oval, $75; Tumbler, $26.

LITHOGRAPHY

A giant step in graphic arts was achieved just prior to 1800 with the development of lithography. Without the help of an engraver, an artist could draw directly on a lithtographic stone from which his image was printed. By the 1840s, lithography in the United States was a thriving business. Prints reflecting the American way of life in both city and country were sold by the thousands. Contemporary events were suitable lithography subjects and the drawings were done by some of the finest Victorian artists. The growth of the country during the period between 1840 and 1900 has been carefully recorded in the amazing and varied subject matter captured by ingenious lithographers of the era. There is a storehouse of interesting material available to the collector, with specialization in certain areas possible for increased enjoyment. Lithograph values: Framed lithograph in color, "Johnstown Flood," 29" x 38", $165; Lithograph print "Steamer," Endicott and Co., Hartford, framed, $100.

LITHOPANE

The lithopane, or Berlin Transparencie, was invented in 1827 by M. P. de Burgoync. These are closely associated with the Berlin Royal Porcelain Manufactury where they were first made. Between the late 1820s and 1900 other factories in Europe and England experimented with lithopanes. A lithopane when held to a light shows a picture achieved by varying thicknesses of the transparent porcelain tablet. The thick parts appear dark, the thin parts lighter. Most were white, although some rare colored lithopanes exist. Typical designs included children with pets, figural subjects and floral motifs. Lithopanes were used as window plaques, lamp shades, candle shields, or at the base of a child's mug or drinking glass. They were made in limited quantities as their production was costly. All are very desirable, with a special nod to any bearing a factory mark. Lithopane values: Panel 5" x 6", Cupid and Child, $58; Panel 8" x 10", Girl with Cat, $80; Panel, Harbor scene, 4½" x 4", $50.

LOETZ GLASS

The Loetz firm of Austria is a prominent name in the field of iridescent glass. They are noted for this particular type of glass which often bears a striking resemblance to the American glass of Louis Tiffany. Loetz was a contemporary of Tiffany's, having been in his employ before returning to Austria to establish his own factory. His inspiration was derived from Art Nouveau sources, which are apparent in the fine cameo achievements on cased glass from this firm. Signed "Loetz" iridescent specimens attract connoisseurs of fine glass. Loetz Glass values: Pitcher, blue background, gold decor, 8″ high, $165; Vase, orange background with silver tracery design, $425.

LOG CABIN PATTERN

Proving their versatility, the Central Glass Company of Wheeling, West Virginia, added in the 1870s the unmistakable Log Cabin pressed-glass pattern to its list of achievements. This pattern recreated the log cabin outline. One can plainly discern the wooden logs, cabin doors and detachable log roof on covered pieces. The Log Cabin covered compote has a stem in the form of a tree trunk. The romantic rustic nature inherent in our forefathers is awakened by this realistic Log Cabin motif. Log Cabin Pattern values: Butter Dish, $46; Pitcher, $82; Sauce Dish, $14.

LONHUDA

Messrs. Long, Hunter and Day founded the short-lived American art pottery firm of Lonhuda Pottery. The pottery originated by this firm closely resembled the wares of the Rookwood Pottery. Samuel Weller purchased the Lonhuda factory in 1895 and continued making the pottery, renaming it Louwelsa. Mr. Long joined the Weller firm briefly but left to join the Owens Pottery Company of Zanesville, Ohio. There he developed the highly regarded Utopia art pottery. Eventually he founded the Denver China and Pottery Company of Denver, Colorado, where he drew upon his vast experience by experimenting with new lines of art pottery. Lonhuda value: Vase, brown glazed with floral spray, 8″, $100.

Letter Openers

Paperweights

Trivets

Bookmarks

Pin Cushion

LOSANTI

Louise McLaughlin of Cincinnati, Ohio, perfected this American art pottery in the 1870s. Losanti was exhibited to favorable reaction at the Paris Exhibition in 1878. Mrs. McLaughlin founded the Pottery Club of Cincinnati of which Marion Longworth Storer, who established the Rookwood Pottery firm, was a member. Losanti ware was named for the former name of the city of Cincinnati, Losantiville. Losanti value: Vase, 8″ tall, $95.

LOTUS WARE

The Knowles, Taylor and Knowles firm of East Liverpool, Ohio was established in the 1850s. It earned a fine reputation for its diversified wares including white granite, Hotel China and semi-porcelain. They are best known for their superior porcelain, similar to Beleek, which was developed about 1890 and is known as Lotus ware. This is considered by many as the finest porcelain ever produced in America. Lotus ware was advertised as being adaptable to the china painting rage of the 1890s and the firm furnished blanks in various shapes suitable to this artistic endeavor. The wares decorated at the pottery were usually marked with the decorator's initials. Due to expensive production costs, the Lotus ware line was only produced for a short span of time. The wares were marked in varying designs, incorporating the name or initials of the firm along with the name "Lotus ware." Lotus ware values: Large Bowl dated 1896, floral design, $290; Vase, hand-painted, signed, colorful flowers, 8″ high, $425.

LOUIS XIV REVIVAL STYLE

The grand scale massive baroque forms which had been in favor during the reign of Louis XIV were revived around the middle of the nineteenth century. This furniture style coincided with the revival of Louis XV furnishings and was actually a combination of the various French styles that were revived with vigor after 1850. The American architect A. J. Downing made references to this revival style, noting that American homes were being furnished with French furniture and decorations which imitated the Royal palaces abroad. This so-called "Modern French" style was exhibited at the London Crystal Palace Exhibition in 1851 and the New York Exposition in 1853, both of which contributed

to the mania for reviving French furniture styles of the past. Louis XIV Furniture values: Mahogany Sideboard, refinished, 45" long, $900.

LOUIS XV REVIVAL STYLE

The best known of all Victorian revival styles is the Rococo Revival of the middle nineteenth century. This was when furniture designs freely interpreted the French furniture popular at the reign of Louis XV during the early eighteenth century. The revival started with the reign of Louis Phillipe, who approved of the furniture style which was eagerly welcomed to the United States about 1850. The graceful curvilinear lines and scroll, shell and floral carvings were ideally suited to the romantic Victorian nature. Among the furniture innovations introduced during the Louis XV Revival period were the parlor center table, the étagère, as well as the lady's chair and complete sets of matching furniture for the parlor or drawing room. Curves and carving dominated this revival style, which brought numerous American furniture craftsmen into prominence, including John Belter. Louis XV Revival values: Armchair, oval back-carved cresting, black walnut, $375; Center table, marble top, ornate, large, $580; Sofa, serpentine back, rosewood, circa 1860, $875. Illustrations on pages 51, 61.

LOUIS XVI REVIVAL STYLE

Between 1860 and 1875 there was a revival of French furnishings similar to those made originally during the reign of Louis XVI. The revival was attributed to Empress Eugénie who, after her marriage to Napoleon III in 1853, started a Marie Antoinette cult in France. Louis XVI furniture styles had their greatest thrust of popularity in America in parlor decor and were fashionable here along with other French styles. American cabinetmakers gave a heavier treatment to the light straight lines and classical details of the French furniture. A slight public trend away from the curving lines of the Rococo Revival furniture gave impetus to this revival style after 1865. Louis XVI values: French Sofa, excellent condition, walnut, circa 1865, $1,000; Lady's Chair, low, red velvet, classical details, circa 1865, $290; Sewing Table, ebonized maple, circa 1875, $235. Illustration on page 21.

LOUISE PATTERN

Wedgwood and Company, Tunstall, England registered this semi-porcelain design at the English patent office in 1881. The brown-printed

design on the cream-colored body had border decoration only, a Japanese motif. Cherry blossoms; woody twigs, brocaded ribbons, flowers, birds and tiny scenes formed the border pattern. The design was highlighted with overglaze decoration in rose, yellow, orange and other colors and the underside bears the firm trademark, a unicorn, with factory name and pattern name, along with the English registry mark. Louise Pattern value: Butter Pat, $3; Cup and Saucer, $14; Gravy Boat, $24.

LOVE SEAT

A love seat is actually a small upholstered sofa, or settee, of a type favored in Queen Anne styles and enduringly popular in the Victorian era. The love seat is smaller, lower and shorter than a sofa. Between 1840 and 1860 love seats were often armless, which made them perfect for the daguerreotype photographing of ladies with hooped skirts. They were a part of a parlor set and had enclosed or open arms. Oval-back love seats of rosewood, mahogany or black walnut appeared between 1855 and 1870. Made by John Belter, and in simpler forms by furniture factories, the double love seat was actually the equivalent of two gentleman's chairs joined together. Love seats were influenced by all the Victorian furniture styles and finer examples display hand carving and finger molding. The love seat was designed to accommodate just two people, naturally! Love Seat values: Cameo-back, mahogany, Grape-carved, velvet upholstery, $560; Eastlake Love seat, good condition, $475; Victorian Love Seat, circa 1860, carved rosewood, reupholstered, $420.

LUSTERWARE

Lucious lusterware ranks high with a host of collectors. Perfected by English potters during the early nineteenth century, it remained in favor throughout the 1800s. Gold, silver, purple, pink and mottled pink and white pieces appealed to Victorian homemakers. Real metals such as gold, copper and platinum were employed to make the metallic pigments. Tea sets, dessert services and ornamental figures and busts were made by important potters. The majority of antique lusterware was unmarked in any manner. Lusterware values: Bowl, covered, copper luster, 6", $80; Teapot, high silver luster, 6", $145; Toby Jug, copper luster, $130.

LYRE CLOCK

The lyre was the source of inspiration for this distinctive wall or shelf clock. The American version, credited to Aaron Willard, Jr. in the early 1800s, is adapted from a French clock developed in the late eighteenth century. Lyre clock cases were generally of carved mahogany having a decorated glass panel on the door under the face. Numerous variations occur, but with the lyre shape always in evidence. Other clockmakers copied the Lyre clock style in the 1840s and 1850s. *Tip:* Clock papers pasted inside the case establish the identity of the maker and should be left intact regardless of their condition. Lyre Clock values: Lyre Clock with regulated pendulum, late, $180; Shelf Lyre, Lemuel Curtis, circa 1825, $1,400.

MAASTRICHT WARE

Cupboard cleaning chores will be rewarding if you find a Sphinx trademark on the underside of a ceramic object. The trademark is that of the world renowned factory, The Sphinx, founded in 1836 by Petrus Regout at Maastricht, Holland. Table services and tea sets in transfer-printed tin-glazed wares were a factory specialty. The company exported quantities of its output to the United States in the late 1800s. The trademark "Royal Sphinx, Maastricht," accompanied by the country of origin "Holland" indicates a date of production after 1891. Maastricht values: Bowl, Pajong pattern, 8½" diameter, $14; Cup and Saucer, scenic flow blue, $20.

MAGIC LANTERNS

A whiff of kerosene wafting through the air meant children were being entertained and educated by means of the magical Magic Lantern. Adults also enjoyed the magic lantern show, many of which originated in Germany where they were developed in the late seventeenth century. Colored glass slides inserted between lantern and lens projected the images on the wall. Magic lanterns in small and deluxe sizes were made over the years and improvements can be observed on the later specimens.

A feeling of animation resulted from rapidly-projected dissolving views. The magic lantern was eventually replaced as an entertainment medium by the arrival of the movie palace on the American landscape. *Tip:* Magic lantern slides should not be neglected, but rather collected. Magic Lantern values: Lantern with 16 slides, $60; Slides alone, $3.50 each. Illustration on page 211.

MAIZE PATTERN

Joseph Locke designed this unique pattern of glass in 1889 for W. L. Libbey and Sons of Massachusetts. The pattern is unmistakable, simulating an ear of corn peeled back. The corn kernels are clearly visible on the pattern. The lower areas have the corn husks on this mold blown glassware. Maize was produced in crystal, opaque white and celadon green with gold translucent stains which often rub away with time. Maize Pattern values: Berry Bowl, milk white, 9", $60; Butter Dish, milk white, $95; Cruet, milk white, $85; Toothpick Holder, $35.

MAJOLICA

Victorian majolica, with colored glazes and naturalistic motifs, was first exhibited by Minton of England at the London Exhibition in 1851. American and European factories began producing majolica and it soon became the most popular earthenware of the nineteenth century. Molded relief designs often covered the entire surface with raised flowers, fruits, fans, animals, birds, leaves and branches furnishing the inspiration for shapes and designs. Among the collectible patterns are Shell and Seaweed, Water Lily, Wheat and Jewel, Daisy, Blackberry, Sun Flower and bushels of fruits and vegetables. Marked examples are prized and often majolica made in England will have the English registry mark. Although an unmarked piece of this tin-glazed earthenware may be difficult to attribute to a particular firm, this does not detract from the worth of the piece. Majolica values: Asparagus Plate, unmarked, 17" long, $55; Plate, strawberries and leaves, 9", $20; Teapot in yellow basketware design, embossed with flowers, $34.

MANTEL CLOCKS

Mantel clocks ranging from insignificant to magnificent became fancier and fussier as the century progressed. A prospective buyer had a choice of wood, bronze, papier mâché, cast iron, china or glass among

others, in shapes and sizes of every description. Glasshouses in America and Europe made clock cases in clear, colored, and milk glass in numerous patterns. Royal Bonn, Delft, Dresden, Haviland and other important china firms made exquisite china clock cases. Black marble mantel clocks burst on the scene in the 1890s. Timely treasures of the past are these mantel clocks of Victorian vintage. Mantel clock values: Striking Clock, circa 1895, $95: Seth Thomas Beehive shape, 8-day movement, $80; Oak Case, gingerbread type, circa 1890, $85.

MARBLE TOPS

The marble top was in evidence on furniture during the 1840s and 1850s, but became firmly entrenched in the Renaissance Revival period 1860–1875. Table tops of all sizes, commodes, bureaus, sideboards and numerous other furniture pieces became more marvelous due to a top of marble. Marble in white, white and pink, chocolate and other shades proved continually popular until the end of the century. Splash backs and spatter rails of marble graced commodes of the 1870s and 1880s. Étagères and tall pier-glass bases were often fitted with small pieces of marble.

MARBLES

Children in the 1870s were tempted by over one hundred different varieties of marbles available to them. Every one of these marbles would be of interest to a collector. Marbles were made in the United States, although the majority were imported from Germany. "Aggies" were made from real agate, while the clay marbles were called "migs." Shiny brown or blue pottery marbles were known as "crockies" and shooters were generally imported and made of onyx, jade, marble, cobalt and jasper. The sulphides of glass encased small silver objects. "Steelies" were steel ball bearings. A bag of old marbles is certain to yield, in addition to some collected dust, a few collectible striped glass marbles. *Tip:* The larger the marble the larger the value! Marble values: 1½" diameter, clear glass with sulphide figure of running horse, $27; 2½" diameter, swirled colored glass, $60; 1" diameter porcelain marble with varied colored dots, $12.

MARTIN BROTHERS

Pioneers in the art pottery field were the four Martin Brothers, who joined forces to establish their firm in 1873. Each brother worked in a

different capacity within the company, which operated on a casual non-business-like basis. They experimented with salt-glazed stonewares and employed various colored glazes for unusual effects. Grotesque heads, bird figures and other animals, along with vases and ornamental wares, were thought to be outlandish when first created. They are now considered choice and their wares are easily recognized. Martin Brothers remained active until 1914 and pieces bear their name, place of origin, and numbers specifying the year and month incised into the clay prior to firing. Martin Brothers Pottery values: Coffee Pot, Japanese decoration, $55; Vase, Japanese decoration, $65.

MARY GREGORY GLASS

Mary Gregory was a decorator of glass at the Boston and Sandwich Glass factory during the 1880s specializing in painting white enamel figures, primarily children, on transparent glass clear and colored. She was only one of the decorators but due to her distinct style all colored glass with painted or enameled decoration is now known as Mary Gregory glass. The Mary Gregory children resemble Kate Greenaway children and they are usually captured among trees and flowers on a wide variety of charming glass articles. The figures are always in white enamel against clear and colored glass backgrounds. Enameled Mary Gregory-type glassware was made between the 1870s and early 1900s by American and European glasshouses and it is generally agreed that those pieces with tinted faces and clothing were European in origin. Mary Gregory values: Barber Bottle, amethyst color with boy figure, $75; Pitcher, sapphire blue glass figure of boy, 10" high, $90; Toothpick Holder, cranberry glass with enameled girl, $42.

MATCH HOLDERS

Matches came into general use around the mid-Victorian period and along with them, match holders. Whimsical holders were made of iron, glass, china and later, tin. The hanging iron match holders in bird, rabbit, hanging game, coal scuttle, umbrella and other amazing shapes often had a patent date. A firm name indicates an advertising match holder and mechanical iron holders came on the scene in the 1870s and 1880s. Glasshouses reached new peaks of creativity with match holders in hat, shoe, boot, cradle and slipper shapes made in clear and colored glass. The patterns used included Daisy and Button. Slag, souvenir and

art-glass match holders are sure-fire sellers in the antique field. Match
Holder values: Brass Beatle, $22; Clear glass elephant, $14; Iron high-
button shoe, $18. Illustration on page 151.

McGUFFEY READERS

First and second editions of *McGuffey Readers* appeared in 1836,
followed a year later by the third and fourth editions. Millions of Mc-
Guffey readers, containing sixty-six pages including sixteen pages of
pictures and eighty-five lessons in reading and spelling, were read by
children between 1836 and 1895. The McGuffey was intended for chil-
dren from first through sixth grades and fresh stories and poems, with
heavy emphasis on home life and character building traits, were intro-
duced in later editions and combined with ample instructional material
to keep young readers keenly interested. The American Book Company
printed revised editions of McGuffey Readers in the 1920s. *Tip:* The
early McGuffey readers are the most sought after, especially the first four
editions. McGuffey Reader value: Late, good condition, $18.

McKINLEY TARIFF ACT

The McKinley Tariff Act was passed in the United States in 1890,
effective on March 1, 1891. The Act stated that the country of origin
must appear on all imported goods. Thereafter all foreign manufacturers
were required by law to state the country of origin in English on their
import products. Failure to comply meant they were to be denied entry
into the United States. This can be a guide to dating, as articles marked
with their country of origin can often be dated subsequent to 1891. *Tip:*
The words "Made In" preceding the country of origin indicate a date
of production in the twentieth century.

McLOUGHLIN BROTHERS TOYS

Home entertainment was packaged by the illustrious firm of Mc-
Loughlin Brothers of New York, makers of children's playthings in the
1800s. A game, toy, book, paper doll or other minor's merrymaker
having the name McLoughlin is a sure moneymaker. Their wholesale
catalogs during the 1860s bulged with riddles, books, checker boards,
conversation cards, card dominoes, alphabet cards and cut-up pictures,
many packaged in strong cardboard or wooden boxes. Paper dolls, sol-
diers, and paper dollhouse furnishings were company specialties. The

paper dolls were often sold in book form. They made complete paper doll series and their Dolls of All Nations set from the turn of the century was a paper-doll pacesetter. McLoughlin Brothers values: Authors Card Game, $12; Lotto Game, $9; Framed advertisement, 16" x 19", for Valentines, colorful lithograph, $125.

MEDALLION PATTERN

This pressed glass pattern, also known as Cameo and Ceres, is attributed to Atterbury and Company of Pittsburgh in the 1870s. Medallion pattern stayed in production for several decades. The large intricate medallions, comprised of raised diamonds, stippled scrolls and cross hatching with a center square fine-cut diamond, obviously pleased eager buyers. A small fine-cut diamond appears at the top and base of the medallions. The pattern was made in clear glass, vaseline, blue, green, and amber in a complete line of tableware items. Medallion Pattern values: Butter Dish, clear, $34; Creamer, amber, $40; Tumbler, blue, $26.

MEDALLION BACK

Chairs and sofas with an oval-shaped back gained favor with the revival of Louis XV style furnishings around the 1850s and 1860s. The medallion back is very pronounced on this rococo furniture and it is easily recognized by lovers of Victoriana. The large upholstered oval in the center of the back was plain and had a finger-molded top rail and often a pierced cresting of flowers and fruit, which frequently continued over the rounded ends. Furniture factories mass-produced the medallion-back sofa, which was part of a parlor set of furniture of either rosewood or black walnut. This design is also referred to as a mirror-back, since the medallion shape bears a resemblance to the oval mirror frame. Medallion Back values: Sofa, green velvet, rosewood, good condition, $480. Illustration on page 99.

MEDICINE BOTTLES

Reading the wild and wonderful information about the magic cures offered on colorful medicine bottles of Victorian vintage would be the equivalent of spending an afternoon at the library. Medicine bottles, regardless of their other curative contents, invariably had a strong content of alcohol. Drugstores dispensed medicine in bottles to cure coughs,

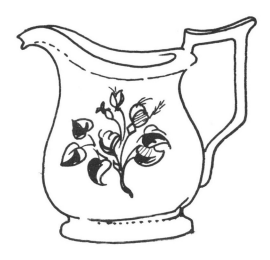

Moss Rose Pitcher

Toby Jugs

Gibson Girl Plate

Dedham Plate

Shaving Mugs

colds, kidneys, hearts, livers, consumption, rheumatism, and other ills, either real or imaginary. There were some medicine bottles which claimed "Cures All Diseases," all, that is, except people suffering from the bottle collecting fever! Medicine Bottle values: Daris Pain Killer, aqua, $17; Dr. Miles New Heart Cure, $7; Paines Celery Compound, amber, $8.

MEISSEN ONION PATTERN

The ever popular Meissen Onion pattern dinnerware has been in continuous production since the eighteenth century. The design is Chinese in origin. It pictures pomegranates and peaches, the pomegranates mistaken for onions by the German factory workers on the original design. There have been only minor changes in the overall pattern as it became less intricate and detailed in the early 1800s, at which time the soft blue was darkened to an almost cobalt blue. Onion pattern pieces bearing a mark from the Meissen factory are most desirable. Other firms, including Doulton and Wedgwood, also made the Onion pattern in the nineteenth century and their versions also bring premium prices. A Pink Onion pattern and a "Red Bud Onion," having red and gold overglaze decoration on the standard onion design, were two innovations of the middle 1800s. *Tip:* The maker's mark should be examined carefully, as the Onion pattern is still in production. Onion Pattern values: Demitasse Cup and Saucer, Meissen, late, $26; Egg Cup, circa 1890, $15; Gravy Boat on tray, circa 1870, $55; Plate, Crossed Swords, 9″ diameter, $28.

MELODEON

Harmony was the keynote of the Victorian household and musical harmonies were accomplished by young ladies on the keyboard of a melodeon. A simplified organ, the melodeon was made with a four- or five-octave keyboard and occasionally with a double keyboard. Organ manufacturers favored rosewood veneered on pine. A typical melodeon had the case supported by side lyre-shaped openwork trestles and braced by a stretcher both of maple, usually stained to resemble rosewood. Important names on Victorian melodeons include Estey of Brattleboro, Vermont, Price and Company, Buffalo, New York, and C. W. Fisk, Ansonia, Connecticut. Melodeons graced parlors between 1840 and 1870. Melodeon values: Restored rosewood, circa 1848, $535; Five-octave keyboard, circa 1850, $550.

MENU HOLDER

File these under the category of "confusing collectibles." A pursuer of menu- or place-card holders is likely to be confronted by two distinctly different types. One version held the menu or place card upright in the holder usually in a delicate floral motif. Another type had a blank flat area large enough to accommodate the name of the diner. The majority are English in origin. A dating guide would be a maker's mark, or the English registry mark. Minus any identifying marks, china menu or place holders can be dated between 1860 and 1900, when the purveyors of proper etiquette deemed them necessary dining niceties. Menu Holder values: Floral decor, circa 1870, $4; Dresden place card, 3½" high with girl figure, $12.

MERCURY GLASS

English and American glasshouses began producing silvered glass in utilitarian and ornamental objects around the middle of the nineteenth century. The technique involved the placing of a nitrate of silver solution between the walls of blown glass and sealing them closed. The tightly sealed silver solution did not tarnish and the finished article resembled silver. Additional highlights were achieved by either engraving or painting the completed object. The pieces where the silver solution does not cover the entire object are less saleable. The mercury-glass fad slowly faded toward the last decades of the 1800s, but staged a comeback in the early twentieth century. Mercury Glass values: Large Compote, $75; Goblet, $27; Rose bowl, 5", $32.

MILLEFIORI PAPERWEIGHTS

Millefiori is an Italian word meaning many flowers. Brightly-colored glass rods were cut to reveal the pattern and were then fused side by side to form intricate and colorful paperweight designs. The millefiori technique was widely used by numerous European and American glassmakers, who experimented with new and exciting designs. Often a date, factory signature, or image was incorporated into the pattern. Dated weights should be approached with suspicion as there are numerous copies. While dates did appear on antique weights, they were placed on in an inconspicuous manner and were never too noticeable. Millefiori Paperweight values: Multi-colored Millefiori Weight, unsigned, circa

1880, $250; Clichy concentric Millefiori on lace background, 2¼" diameter, $385.

MILLVILLE PAPERWEIGHTS

Ranking among the leaders in paperweight productions of the nineteenth century was the Whitall, Tatum & Company of Millville, New Jersey, which began creating paperweights in the 1860s. Their outstanding contribution in the paperweight field was the Millville Rose paperweight in deep pink, white and yellow, made with or without stems. This paperweight was the work of Ralph Barber, who worked between 1905 and 1912. Other paperweights of importance attributed to this firm include those of Michael Kane. Millville Paperweight values: Mushroom, $350; Ship in Sail, $750.

MILK GLASS

Opaque white glass, known to collectors as milk glass, enjoyed tremendous public acceptance between about 1870 and 1900. Glasshouses made opaque white in leading pressed-glass patterns such as Sawtooth, Waffle, Grape, Princess Feather, Wheat and Panel and others. Openwork or lattice-edged bowls and plates and a barnyard of covered animal dishes were made in milk glass and form interesting collecting groups. Milk glass was painted or enameled with bird, floral or other appropriate motifs and was sometimes combined with another color for additional effects, particularly on covered pieces. Opaque glass was made in other colors, but the white is best known. Milk glass has been extensively reproduced. Antique pieces are translucent, oily, and have a bluish tint. Many have a rough-shaped "C" mark on the base, formed in the molding, which does not appear on the reproductions. New milk glass is often made from original molds and is a pure white. It often bears a company trademark lacking on the earlier examples. Milk Glass values: Blackberry Pattern Compote, $125; Boar's Head Covered Dish, red eyes, $330; Hen, glass eyes on basket base, 7", $90.

MINIATURE LAMPS

Small lamps measuring between 4½" and 8" in height, slightly larger than Fairy Lamps, became prevalent between 1870 and 1900. They were often used as "sparking" lamps, burning a small amount of oil, and when the light began flickering, it was a signal for the suitor to

leave. Miniature lamps copied the larger lamp styles and were made of satin glass, clear and colored pressed glass, opaque glass, Amberina, Mary Gregory glass and other types of fancy art glass. Novelty miniature lamps in schoolhouse, animal and other forms gained favor in the 1890s. Miniature lamps of the late 1800s bring substantial prices. Miniature Lamp values: Brass Banquet Lamp with shade, 9" tall, $120; Cranberry glass with handle, $85; Pink satin glass with enameled roses, 6" tall, $110.

MINTON POTTERY

Thomas Minton founded a pottery at Stoke-on-Trent, England, in 1796. The factory continued to operate under the supervision of his son Herbert Minton into the 1800s. The firm established a fine reputation for superior quality products, employing a number of talented artists. Their Victorian majolica with colored glazes, introduced in the 1850s, became a factory standard. They can be credited with the enormous enthusiasm afforded majolica in the second half of the nineteenth century. Louis Marc Solon and his pâte-sur-pâte method of decorating porcelain can be considered one of the firm's foremost ceramic achievements. Table and tea services, parian subjects and magnificent figure groups brought added distinction to this company. Their Art Nouveau ceramics in the 1890s attest to their versatility. Their globe trademark, with firm name across the equator, appears on wares after 1863. *Tip:* The firm name was Minton until 1873 when an *s* was added and the company become known as Mintons. Minton values: Figurine, 12" x 12", two cupids carrying an urn planter, circa 1877, $210; Jardinere, blue and white scenic, circa 1860, $70; Potpourri jar, circa 1845, enameled floral, $185.

MOCHA WARE

Made in limited amounts in America, this cream-colored pottery was made by numerous Staffordshire potters during the first half of the nineteenth century. Banded cream ware is another name for this mocha-colored pottery which had bands of daubed patterns of moss-like decoration. Among the designs formed by a delicate tracery of lines are tree, cat's eye, checkered, combed, scrambled, variegated, seaweed and others achieved in various colors. The term "mocha" stems from the color of the pottery which is coffee colored and was made primarily in utilitarian

objects such as mugs, jugs, bowls and table ware items. Mocha Ware values: Chamber pot, white and blue decoration on tan background, 10″ diameter, $85; Pitcher, Earthworm pattern in tan, grey and black on white background, 7½″ tall, $125.

MOLDED JUGS

Molded relief pattern jugs were extensively produced during the 1800s. The three major categories are stoneware, colored earthenware, and, after the 1840s, parian jugs either white or tinted. Molded jugs of English origin produced between 1842 and 1883 may bear the lozenge shaped registry mark and the manufacturer's trademark. Jugs predating the Victorian era may have a copyright mark, the maker's name, or a date indicating when the design was first published. Parian jugs dating from the second half of the 1800s offer exciting rewards and can be discovered in almost any unlikely place. Molded Jug value: White classic figure, circa 1850, 8″, $60.

MONROE WARES

Beautiful hand-painted opal glassware was made by the C. F. Monroe firm of Meriden, Connecticut, around the turn of the century. The wares marked with company trademarks differ depending on the background colors employed according to company records. Some of these were "Wavecrest," "Kelva" and "Nakara." They purchased their blanks from American and European firms with heavy emphasis on boudoir objects, hair receivers, powder boxes, cuff boxes, jewel boxes and other household and tableware items. The boxes were often lined with satin, having metal feet, rims and hinged covers in unusual shapes. Soft pastel background colors had designs in floral, scenic and other motifs all expertly hand painted. The firm's initials *CFM* may be incorporated into the mark along with the trademarks as noted above. Monroe Ware values: Bowl, square floral on white, signed "Wavecrest," 6″, $210; Hair receiver, brass top, raised enamel decoration, $140.

MOON AND STAR PATTERN

This pressed-glass pattern is also known as "Bull's Eye and Star." This descriptive name befits the design consisting of a series of orbs, quarter-sized rounds in high relief with depressed centers, each stamped with a star in the center. Adams and Company of Pittsburgh, Pennsyl-

vania, referred to the design as "Palace" during the 1870s. The Moon and Star pattern was perfectly suited to the rage for ruby-stained glass in the 1890s, when glasshouses ruby-stained the depressions. The pattern witnessed several revivals and was made into the twentieth century. Moon and Star Pattern values: Cake Stand, $40; Creamer, $55; Tumbler, $26.

MORNING GLORY PATTERN

Manufacturers of white ironstone derived many of their designs from nature and in the 1850s introduced the Morning Glory pattern. Elsnore and Forster of Tunstall, England and other potters made a version of this standard design. The dainty flowers and leaves were arranged in raised relief around the borders, connected by a trailing vine and were the sole decoration on the white ironstone base. Factory marks may be traced to establish the origin of Morning Glory white ironstone, which varies slightly according to the maker. Morning Glory Pattern values: Plate, 9", $16; Cup and Saucer, $20; Platter, 13", $25.

MORRIS CHAIR

This comfortable easy chair was developed by William Morris and his associates in England during the 1860s. American furniture factories made the Morris chair in considerable quantities. This was one of the new furniture innovations of the Victorian years. Lack of beauty was compensated for by the abundance of relaxation afforded in a Morris chair. The deep seated chair with thick soft cushions covering the back and seat had flat broad straight arms large enough to support reading matter. Morris chairs were often made in walnut, cherry, mahogany or oak. Morris Chair values: Golden Oak model, $80; Morris chair, walnut, $90. Illustration on page 99.

MOSAIC GLASS

Also known as slag glass, mosaic glass is streaked with two colors of opaque glass, white blended with another color. Slag glass was made in smaller quantities during the last decades of the nineteenth century than was opaque white milk glass. There are various colors of slag glass, including purple and white, deep tan and white, red and white, pink and white and other colors blended with white. Blue slag is usually English in origin and slag glass pieces of English origin often have the English

registry mark. Some factories making the streaked slag glass incorporated a pattern in the design. However, it is the color that appeals most to a glass collector. Calico, agate, and marble are all acceptable terms for this two-colored streaked glassware of the late nineteenth century. *Tip:* Familiarize yourself with the authentic pieces of Mosaic glass and the reproductions will pose no problem. Mosaic Glass values: Caramel Slag Creamer, Cactus pattern, $95; Match Holder, footed, purple, $30; Red Slag Bowl, $70.

MOSS ROSE PATTERN

Moss roses bloomed in gardens and blossomed on dining tables in the 1800s when potters adapted the pink flower with mossy ferns as a motif for dinner services. Moss Rose table wares in porcelain, semi-porcelain, pottery and ironstone were made by potters in Europe and America. Haviland & Company of France marketed a porcelain version of the moss rose, and the prices on antique pieces vary depending upon the maker and quality of the china. Moss Rose was still popular in the 1890s when Montgomery Ward advertised a one-hundred-thirty-one piece dinnerware set in this durable design. Moss Ross Pattern values: Platter, 12" x 18", $38; Ironstone pitcher, 7½" tall, $35; Teapot, $65. Illustration on page 141.

MOTHER-OF-PEARL SATIN GLASS

The lovely soft color shades and combinations combined with the beautiful patterns make this type of blown molded satin glass very desirable. Mother-of-pearl satin glass, or Pearl Satin was made by American and European factories in the latter part of the 1800s. The majority of pieces had a white lining and a colored coating and are recognized by their various patterns. These patterns include swirl, diamond quilted, geometric designs or zig-zag undulating lines. The technique and methods of achieving the mother-of-pearl effect varied according to the maker. The large amounts of imported glass caused a severe decline in American-made Pearl Satin glass. Threading, applied glass, enameled and other forms of decoration further enhanced mother-of-pearl satin glass of the 1880s and 1890s. Mother-of-pearl Satin Glass values: Bowl, Diamond Quilted, 6", $425; Creamer, threaded handle, $230; Sugar Bowl, Diamond Quilted, $250.

MOTTOES

Also known as "door texts" these sentimental mottoes bring back memories of home. "Welcome" spelled out in bright wools and sometimes glittering beads usually graced the space over the front door on the inside of every home. Such sentiments as "Home Sweet Home," "God Bless Our Home" or "Thou God Seest Me" all were comforting to those viewing these framed needlework projects. Made on a perforated cardboard backing printed with the design in colors, the lady of the house had nothing more to do than thread a needle with wool or floss and follow the pattern with corresponding colors. Bookmarks were made on the same principle and were probably used in training a little girl of the household in the art of motto making. Motto values: Framed Motto "Rock of Ages," good condition, 10" x 24", $18; Original frame, "Simply to Thy Cross I Cling," 10" x 24", $24. Illustration on page 221.

MOURNING PICTURES

Queen Victoria's consort Prince Albert died in 1861 and she remained more or less in mourning for the remainder of her life. Her conduct and demeanor initiated the universal Victorian custom of mourning. Those adept at needlework embroidered on satin grounds mourning pictures inscribed to the deceased. A typical example had one or more figures in dark garb, pictured in sorrowful outlines, a weeping willow tree and usually a form of urn or tomb. The Greek Revival styles were often in evidence in dress and monuments. The urn or tomb bore an inscription to the deceased. Mourning quilts were made using black and white and all other colors were omitted. Mourning jewelry and cast iron urns for cemetery bouquets were all part of the mourning custom. There were shops dedicated solely to selling mourning garb and mourning mementos. This glance back into Victorian mourning customs permits us to understand the degree to which these traditions affected life during those times. Mourning Picture value: framed, date 1860, 12" x 16", $60; Mourning Quilt, circa 1870, $140.

MOUSTACHE CUP

Soggy moustaches came to a dry end with the advent of the moustache cup and saucer. Made of pottery, porcelain or silver, they ranged in size from demitasse to full quart in capacity. All were complete with

an inner ledge containing a small opening through which hot brew could pass while the gentleman's moustache rested dryly on the inner lip. Gift cups and saucers were often inscribed "Father," or "Love the Giver" or some other notable Victorian quotable. Moustaches gradually disappeared around the late 1890s, taking with them the late Victorian fad for moustache cups and saucers. *Tip:* A left-handed cup and saucer is a rarity. Moustache Cup values: Bavarian pink roses with green leaves, with Saucer, $38; Hand-painted Cup and Saucer with forget-me-nots, $45.

MUSICAL TOYS

Miniature replicas of musical instruments for the younger set reached sizable proportions by the 1840s. Noble and Cooley of Massachusetts found toy drums very profitable. Other toy makers drummed up financial rewards making drums including the Morton Converse firm, who substituted paper parchment tops, rather than the more expensive sheepskin drum top, thereby cornering the market in the 1890s. Toy pianos were made by many toy concerns. Shoenhut of Philadelphia, Pennsylvania, was one of the leaders. Tin smiths responded with tin flutes and horns and American makers competed with the large quantities of imported musical toys, particularly from Germany. Musical Toys values: Musical Jack-in-the-Box, $45; Piano Schoenhut, $80.

MUSIC BOX

Though the music box itself may be of unknown origin, the music mechanism is almost always Swiss or French. Music boxes underwent a gradual improvement between 1840 and 1900. About 1840 a two-comb mechanism capable of playing either loud or soft was introduced. Delighting the ears during the 1850s were the new sounds of bells and drums and interchangeable combs were developed. By the closing decades of the century, there were advances in tune changes and springs. Disk cards resembling phonograph records also appeared. All of these various improvements can help you date a music box. Small music boxes were concealed in or under photograph albums, boudoir accessories, steins and toys. Music boxes from the age of Victoria are in demand and prices are continually spiraling upward. Music Box values: Musical Photo Album, green velvet, $95; Musical Stein with tavern scene, pewter top, 12″ tall, $185. Illustrations on page 151.

Weather Vanes

Match Holders

Music Boxes

MUSIC COVERS

Never lacking in the area of music appreciation, the music students of the 1800s carried their sheet music in especially engraved or lithographed covers. The melodious multitude of music pupils found subject matter on the covers relating to their musical endeavors. Music covers pictured musical instruments, cabinet organs, family gatherings around the piano, and innumerable other arresting lithographic achievements. Music Cover values: Organ subject, $8; Parlor scene, elaborate detail, $12.

<center>

ℕ

</center>

NAILSEA GLASS

The Nailsea Glass Factory of England was founded in 1788 and fine-quality glass originated from this firm until its closing in the late nineteenth century. Characteristic of Nailsea are the loopings and swirls of colored glass combined with clear or opal glass, which was widely copied by other European and American firms. Colored, streaked and spatter effects were utilized on bells, bottles, rolling pins, vases, lamps and other articles. Two favorite Nailsea color combinations were red and white and green and white and this firm thrived on new innovations and fresh concepts in glass-making techniques. Nailsea values: Cruet, red and white, 7" high, $38; Striped Glass Cane, colorful, 42" long, $140; Vase, green and white, 5" tall, $32.

NAPKIN PLATES

Pastel borders surround the centers which picture a white folded napkin on these novel luncheon plates of the 1870s and 1880s. Napkin plates of pottery, porcelain and majolica in soft shades of pink, green, blue and other colors sometimes had a small flower on the folded white napkin portion. The Dresden Pottery of East Liverpool, Ohio, marked their version "warranted Dresden, China." "Morley and Co. MAJOLICA Wellsville, O.," is the mark of the Morley pottery firm of Ohio. Those made by the East Liverpool Pottery Company bear the trademark "ELP Co. Waco China." A plate collection minus one late 1800s nap-

kin plate would surely be rated incomplete! Napkin Plate values: Majolica, pink and white, circa 1885, $18; Porcelain, blue and white floral, $22.

NAPKIN RINGS

Nifty assortments of napkin rings were listed in catalogs of the 1860s, although the first patent was not issued until 1869. They were made in pottery and glass; however, the silver examples are best known to collectors. Silver companies made napkin rings in sterling silver and silver plate in designs typically Victorian. Plain silver napkin rings with fancy borders, names, initials, floral or fruit motifs often had a satin finish. The figural napkin rings are of greatest interest to collectors who appreciate the clever whimsical shapes made during the late nineteenth century. Children form one group, standing, playing games, with pets and some in Kate Greenaway costumes. Animal subjects could fill a zoo and include goat, rabbit, duck, cow, rooster, hen and, of course, dog and kitten. The bird subjects are innumerable and all types had the ring attached for inserting the rolled napkin. *Tip:* Marks on napkin rings will give you information pertaining to the maker and the quality of the silver. Napkin Ring values: Chicken, resilvered, $35; Eagle with wings spread, $50; Fox beside ring, need of replating, $32.

NAPOLEON IVY

The Josiah Wedgwood firm created a set of dinnerware expressly for Napoleon Bonaparte while he was in exile on the Island of St. Helena between 1815 and 1821. The Queensware pattern with a cream-colored background and a rim of green ivy leaves was marketed by the firm under the name Napoleon Ivy. Napoleon and vast numbers of consumers found it highly acceptable and the design remains in production to the present day. Napoleon Ivy of nineteenth century origin has entered the collectible realm. The factory mark on the underside provides a dating guide. Napoleon Ivy Pattern values: Wedgwood, Cup and Saucer, $18; Plate, 8″ circa 1870, $12; Teapot, $46.

NELLY BLY

Nelly Bly traveled around the world in 1889 in a record shattering seventy-two days, six hours and eleven minutes. This amazing fete was worthy of commemorative acknowledgment and manufacturers obliged

with innumerable items in china and glass. A Nelly Bly pressed-glass platter was made by the Thompson Glass Company Ltd. of Uniontown, Pennsylvania. A tiny night light was produced as a tribute to this adventuresome lady, whose real name was Elizabeth Cochrane Seaman. Nelly Bly buys can be safely dated from the 1890s. Nelly Bly values: McLoughlin Brothers game, circa 1890, "Around the World with Nelly Bly," $12.00; Nelly Bly Miniature Lamp, $135.

NEWCOMBE ART POTTERY

A pottery located on the campus of the Newcombe College in New Orleans, Louisiana, was opened in 1895 to afford students an opportunity to study pottery procedures. They experimented with techniques, but their primary efforts were focused on simple folk-art designs. They started selling their pottery to the public about 1897 with notable success. Their pottery with functional designs was a return to basic forms known since antiquity. Local sources provided inspiration for certain designs, such as the Louisiana leaf shown on many pieces. There was some effort made in the direction of the Art Nouveau influence and Newcombe art pottery marked with an *N* within a *C* and the initials of the decorator is highly collectible. Newcombe Art Pottery values: Bowl, pink and green, artist signed, 6", $120; Vase, 5" high, $90.

NEWSPAPERS

Antique newspapers invariably contain fascinating reading material, but only selected ones are classified as important collector's items. Sought after are those with news of a significant historical event, announcement of major importance, early advertisements or a first publication of a well-known literary work. A newspaper numbered Volume I, Number I is valuable as are Western papers of the late 1800s, first printed when towns were founded throughout the West. A full run or long run of a particular paper is of interest, as are Southern newspapers of the Civil War era printed on wallpaper. The *New York Herald,* Saturday, April 15, 1865 gave an account of the death of Abraham Lincoln. The original newspaper had eight numbered pages. There have been reprints with two or four numbered pages and a picture of Lincoln which was not in the first edition. The advertisements also differ on the later examples. *Care tip:* Preserve newspapers by keeping them flat or protected under glass. Care should also be taken to refold newspapers into their original

folds. Newspaper value: *New York Herald,* Saturday, April 15, 1865 with account of Lincoln's death, $65.

NEW YORK CITY POTTERY

Morrison & Carr organized the New York City Pottery firm in the 1850s, Carr retaining ownership after 1871 and until the pottery ceased operating in 1888. Exceptional parian, majolica, stone china and white granite wares brought recognition to this pottery. Tablewares and ornamental items may bear varying marks, including the impressed "Morrison and Carr" used in the 1860s and the initials "J.C." or "N.Y.C.P.," abbreviations for James Carr and New York City Pottery. A parian bust of General Grant was executed by W. H. Edge for the firm in 1876, inspired by the Philadelphia Centennial celebration. New York City Pottery values: Majolica Dish, $24; Parian Figurine of a woman, 12", $90.

NICHOLSON CARDS

Eye-catching advertising or trade cards to lure customers to business and service establishments were made by the thousands by this firm. Trade cards marked "Nicholson" or "Central" can be assigned to this Baltimore-based Company. A technical advance of the 1850s enabled them to substantially increase their production of advertising cards. They rolled off the presses in substantially larger numbers and were promptly pasted into scrapbooks with equal momentum. Nicholson Card values: Shoe Emporium, $1.

NOAH'S ARC

The Sunday parlor toy, Noah's Arc, is regarded as the most sought-after wooden toy of the nineteenth century. A homemade Noah's Arc had a simply-constructed house boat with a dozen or more animals. Larger sets had painted decorations on the arc portion and anywhere from twenty to several hundred animals. Children played Bible games with Noah's Arc on the Sabbath, as other toys were unavailable on this day. After playtime the animals were accumulated and carefully placed back in the arc until the following Sunday. Youngsters enjoyed identifying the animals, particularly in the larger sets that contained some unusual species. Wood carvers excelled at making exceptional Noah's Arcs and many originated in the Pennsylvania area. They could also be purchased at the local toy emporium as they were commercially made. Dur-

ing the 1890s a paper doll version was issued as an advertising device by the Willamatic Thread Company. *Tip:* Complete sets are almost impossible to find; even the separate pieces of a nineteenth century Noah's Arc are very saleable. Noah's Ark values: German-painted Arc with 60 pairs of animals, $420; Hand-carved Arc with 84 pairs of animals, original paint, $525.

NURSING BOTTLES

Babies gurgled happily after their parents visited the London Exhibition in 1851 and saw the O'Donnell Baby Bottle on display. Baby feeding bottles soon appeared in many versions and there were gradual improvements noted over the years. The early bottles bring premium prices and were made in a variety of different shapes. This small bottle collecting category has attracted considerable attention and a babyfeeding bottle that can be safely ascertained as being of nineteenth century origin is a real find. Nursing Bottle values: Free-blown Bottle, glass nipple, early, $40; Nursing, glass, H. Wood and Sons, $18.

OG CLOCKS

Introduced during the 1830s by Connecticut clockmakers, the OG clock cases were in constant production for the duration of the century. They were inexpensive to make, easy to ship and found excellent public response due to their realistic price and attractive styling. The name OG is derived from the molding which consisted of a reversed curve similar to the letter *S* found on these rectangular wooden case clocks. Movements vary from brass to wood, thirty-hour and eight-day versions, either weight- or spring-powered were produced. Tablets on earlier examples had reverse paintings while later models had printed decalomanias. OG Clock values: Seth Thomas, 30-hour brass movement, floral tablet, $135; Waterbury Clock Co., 30-hour striking, $100.

ONYX GLASS

George Leighton of Findlay, Ohio, is credited with developing the art glass made during the 1890s known as onyx glass or Findlay glass.

An opalescence was achieved on ivory or opaque white glass by repeated heatings and dippings, which resulted in a multi-layered glass. The patterns were then treated to a luster process and they appear against the opal lining of the glass. Various colored lusters were used, including silver, amber, orange, purple and ruby. By holding a piece of onyx to the light, a fiery opalescence appears. *Tip:* Never apply steel wool or household cleaners to a piece of onyx glass as it will remove the luster stain. Onyx Glass values: Covered Butter Dish, $425; Milk Pitcher, $450; Toothpick Holder, $120.

OPHIR PATTERN

This late flow-blue dinnerware pattern of semi-porcelain was made by Bourne and Leigh, Staffordshire potters of the 1890s. The embossed scrolling around the rim is practically white and the design consists of floral sprays in blue against a background of small Vs. The cobalt color runs slightly into the white body, with touches of gold highlighting the scrollwork and flowers. The design is more distinct than on earlier flow-blue pieces. The pattern name "Ophir" and company trademark are printed in cobalt on the underside of this pattern. *Tip:* The original gold decoration is often missing on late flow-blue dinner pieces, having washed away from frequent washing. Ophir Pattern values: Butter Pat, $3; Bone Dish, $8; Gravy Boat, $28.

OTT & BREWER

The Etruria Pottery of Trenton, New Jersey, was operated between 1863 and 1893 by Ott & Brewer and became one of the foremost ceramic factories in the United States. Isaac Broome was commissioned by the firm during the 1870s to create works for centennials and expositions. Among his efforts were the parian bust of Cleopatra, dated 1876, and the parian baseball vase honoring the national sport which reached professional status in 1876 with the forming of the National League of Professional Baseball Clubs. William Bromley managed the firm after 1883 when their beautiful Beleek, thought by many to be the finest ever made in America, was made to rival the quality of the imported Irish Beleek. The egg-shell-fragile, thin porcelain continued being made until 1893. Varying marks included the name or initials of the firm and a crown pierced by a sword. Ott & Brewer values: Creamer, 4½" high, marked, $45; Vase, marked, 10" tall, $65.

OTTOMAN

Just prior to the Victorian era, the ottoman was introduced as an auxiliary furniture piece in American parlors. The ottoman had comfort and practicality. It was actually an overstuffed divan or footstool without arms or back. The Rococo Revival of the 1850s brought increased popularity to the ottoman when it became a part of a set of parlor furniture. The ottoman, when combined with its matching arm chair, became a serviceable chaise longue. Following the Civil War the ottoman form developed into a circular couch with plant or figurine rising from its center. The adaptable ottoman remained in favor and was cleverly suited to all the furniture influences of the Victorian period. Ottoman values: Large bracket foot, mahogany, circa 1850, $80; Spool-turned Ottoman, circa 1855, $75; Empire Ottoman, $85.

OVAL MIRROR FRAME

The oval mirror frame was in continuous production throughout the 1800s and was usually the work of frame makers employing factory methods. The frames were usually pine-coated with gesso and gilded or painted to simulate rosewood or black walnut. The oval mirror frame was subjected to repeated changes in style, as frame makers kept abreast of prevailing furniture trends. The simpler versions had plain convex frames, with or without beaded bands. The more elaborate examples had simulated carving in fruit, flower or foliage motifs. The more detailed types were frequently gilded with gold leaf. The versatile oval mirror frame was suitable for parlors, dining rooms and bedrooms and was often placed between two windows. Oval Mirror Frame values: Walnut, refinished, 16″ x 14″, $65; Walnut, refinished, 18″ x 15″, $120; Gilded, ornate, circa 1865, 36″ x 24″, $290.

OVERMANTEL MIRROR

Introduced in the Federal period, this mirror was designed to be placed over the mantel. It became more elaborate in later Victorian versions. Size variation occurs from thirty to fifty-four inches in width and from three to six feet in height. They are usually very decorative, with full width cresting on some examples. The cresting often consisted of intertwined flowers and grapes in relief surrounding a central scrolled cartouche. The sides of the frames are often heavily ornamented with

rococo-type designs. They are usually of pine coated with gesso, gilded with gold leaf, and on occasion were painted to resemble rosewood or black walnut. Overmantel Mirror value: Overmantel gilded pine with gold leaf, good condition, 48" x 60", $480. Illustrations on page 119.

OWENS POTTERY

Ranking high with collectors of American art pottery are the wares made during the 1890s and early 1900s from the renowned Owens pottery of Zanesville, Ohio. J. B. Owens established this important pottery and under the guidance of W. A. Long, introduced the Utopia line, resembling the wares of Rookwood and Weller. A staff of talented artists decorated the Utopia pottery line in underglaze slip painting, on light and dark grounds, with floral motifs, animals, birds and portraits of Indians. The ware is marked on the base "Owens Utopia." Among their other lines were Corona, Alpine, Gun Metal, Henri Deux, Venetian and a rustic line in naturalistic shapes and forms. The name Owens accompanied by the individual art line may be noted on the base of their wares. Owens Pottery values: Mug, artist-signed, 5" high, $65; Vase, Lotus, green to pink ground, signed, 4" high, $72; Vase, Utopian, orange floral, brown ground, 8" high, $95.

OYSTER PLATES

Culinary treats were afforded special serving receptacles in the latter part of the 1800s. Oysters were among those given this distinction with the arrival of oyster plates. These special plates had shell-shaped pockets. On some of the oyster plates there was a small center pocket to hold sauce. The irregular-shaped plates came in many attractive color combinations and were made by outstanding firms in America and Europe of pottery, porcelain, majolica, Delft, luster, ironstone and even metal. The more elaborate oyster plates vividly depicted life along a coastal shoreline. Oyster plates often bear a patent date. Oyster Plate values: Limoges porcelain marked "Ahrenfeldt," pink floral trimmed in gold, set of eight, $140; Theodore Haviland oyster plate, $20.

P

PAINTED CHAIRS

Thousands of imitation Hitchcock painted-chairs were distributed by furniture factories in the late 1800s. The painted side-chairs were inexpensive, mass produced and destined primarily for use in the kitchen. They were made from a variety of low-cost woods and a coat of paint covered the assorted woods beneath. The favorite colors were red, brown, green and blue, with black and brownish red favored for areas outside the kitchen. The Arrowback was very popular and this light-weight but sturdy chair with stencil decoration was made in numerous styles and in a variety of shapes. *Tip:* Leave the painted chair in its original condition as repainting will lessen the resale value. Painted Chair values: Fancy splat and back, gold decoration, circa 1870, $42; Fancy turning, rush seat, painted black, refinished, $45; Hitchcock-type, rough condition, $34; Ladder-back, refinished, $40.

PAISLEY SHAWL

Queen Victoria purchased seventeen shawls in 1842 and the shawl makers of Paisley, Scotland were forever grateful. Shawl making had begun at Paisley toward the latter part of the eighteenth century; however, it was not until the Victorian era that shawls really became high fashion items. A typical Victorian paisley shawl was brighter and bolder in both design and coloring than those made early in the 1800s. The Indian Pine motif was by far the most popular of all patterns. The broche shawl with stylized flowers and a solid color oval center became a favorite around the 1850s. Women began wearing coats in the 1870s and the thriving shawl industry at Paisley suffered a severe setback. Shawls were then carelessly abandoned, only to become known as "moth thrivers." Paisley Shawl values: Black Center Paisley Shawl, three yards long, some noticeable wear, $40; Printed Shawl, large, good condition, $65.

PAPER DOLLS

"Paper Dolls and How To Make Them" and "Paper Doll Furniture and How to Make It" were best selling juvenile publications of the 1850s. Tom Thumb and family were greeted with shrieks of approval when the

Paper Doll

Wax Doll

Hobby Horse

Dollhouse

McLoughlin Brothers of New York issued them as paper cutouts in the 1850s. *Godey's Lady's Book* succumbed to the mania for paper dolls in 1859, surprising the thousands of little cut-ups across the country with pages of paper dolls. Ballet dancers, military subjects, royalty from every nation and other captivating dolls were made in series format. Advertising-paper dolls boosted the sales of untold edibles and other commodities as they were snapped off country shelves in the 1890s. A handmade set of paper dolls, hand-colored and hand drawn would prove to be an exciting find for any lover of paper dolls. Paper Doll values: Ballet Dancer, 16″ high with movable arms and legs, faded original tissue paper costume, $9; Costume Paper Doll, 7″ tall with six costume changes, good condition, circa 1895, $18. Illustration on page 161.

PAPER CUTWORK

Tokens of love and friendship were accomplished by ladies of culture and refinement who attempted paper cutwork pictures between 1840 and 1900. The cutout picture designs varied with birds, flowers, animals, hearts, emblems and local subjects heavily favored. A superior cutout artist would endeavor a picture of the Lord's Prayer, a Bible verse, or other quotation, the detailed border painstakingly accomplished in the cutout method. The more proficient artisans sold their intricate cutout designs. *Tip:* A fine paper cutwork can often be discovered nested between the pages of a Bible or other book. Paper Cutwork Picture value: Floral Cutwork, 12″ x 14″ matted and framed, $36.

PAPER TOYS

Articulated paper toys, also known as hot air toys, were displayed at the London Exhibition in 1851. The idea transcended the Atlantic ocean landing in Victorian parlors as the new amusement for children. Paper and cardboard cutout toys were easy to assemble and when placed over a warm stove, register, gas burner, heater or any item dispensing a draught of warm air, their moving parts were set in motion. Animals performed tricks, battleships had moving parts, windmills would turn on a scenic picture. A small trickle of falling sand was another method to set a paper toy into action. Paper Toy values: Lithographed Battleship, many parts, $14; Paper Windmill, fair condition, $10.

PAPERWEIGHTS

Collectors are willing to pay premium prices for any nineteenth century paperweight. There are, however, numerous reproductions that can attract the eye of the unwary. There are some rules to guide the novice in the quest for antique paperweights. The old weights are heavier than the new ones, and when the pontil mark was left unground, this was the sign of an inferior weight. New paperweights have frosted pontil marks and they are flat on the base, whereas on the old weights the glass was slightly rounded. Be wary of dated paperweights. There were many fine paperweights dated by glasshouses; however, they are classified as "rare" and reproductions have been made incorporating nineteenth century dates. Millefiori paperweights have been copied by numerous factories and the quality on the new weights is usually inferior to the antique paperweights. Paperweight values: "God Bless Our Home," 3½" diameter, $60; Millefiori type, unsigned, circa 1880, $250; St. Louis deep-red dahlia-like flower, 3½" diameter, $825. Illustrations on page 131.

PAPIER-MÂCHÉ

Lightweight, highly decorative papier-mâché furniture was enduringly popular throughout the reign of Queen Victoria. The technique involved mashed paper and other materials being molded into various shapes. Factories in Europe and America found papier-mâché furnishings and accessories proved both eye and customer catching particularly between 1850 and 1890. Papier-mâché was finished with a fine black laquer and then embellished with mother-of-pearl inlay, powdered bronze swabbing, painted with scenic and floral designs and enhanced with real and imitation gems set in tinsel. There were many fetching motifs including Oriental and English scenes, birds, butterflies, Gothic and geometric patterns. On those pieces made in America portraits of Presidents and historical scenes were familiar subjects. Papier-mâché values: Inkstand, mother-of-pearl inlay, $72; Snuff Box, print, $14; Tilt Top Table, mother-of-pearl inlay, animal subject, $170; Tray, black floral, mother-of-pearl inlay, 15" x 27", $58. Illustration on page 221.

PAPIER-MÂCHÉ CLOCKS

Ornate clocks of papier-mâché with mother-of-pearl inlay, stencil decoration or hand-painted embellishment graced shelves of the mid-

Victorian years. The Litchfield Manufacturing Company of Connecticut was a leading papier-mâché clock case concern, supplying cases to numerous clockmakers. Generally the cases were small in size, ranging from plain OG types to cottage shapes and fancy rococo models. Gilded papier-mâché clock cases were further enriched with finely executed Oriental scenes, florals, portraits and patriotic motifs in the area below the dial. Papier-mâché shelf clocks brought fresh financial rewards to clockmakers in the 1850s and 1860s. Papier-mâché Clock value: Mantel Clock, Oriental decor with inlaid mother-of-pearl, good condition, $120.

PARAGON PATTERN

Deep ivory-tinted earthenwares of the 1880s often bear the trademark of an Oriental figure on the underside holding a parasol, accompanied by the words "Oriental Ivory." Powell, Bishop and Stonier of Hanley, England, 1878, subsequently Bishop and Stonier 1891–1913, marked their wares with this unique trademark. The Paragon pattern is decidedly Japanese in design and has peacock feathers, rattan fans with typical rice-paper scenes and floral sprays. It is printed in brown on the earthenware body. The pattern name *Paragon* is printed within an open fan on the base for quick and accurate identification. Paragon values: Covered Vegetable Dish, $28; Cup and Saucer, $12; Egg cup, $9; Platter, medium size, $24.

PARASOLS

Ladies of the 1840s carried small sunshades which were a mere twelve to fourteen inches in diameter, a reversal from the cumbersome twelve-pound parasols of the early 1800s. Between 1850 and 1900 a parade of pretty parasols matched existing fashions, changing almost as often as the outfits themselves. Handles of coral, ivory, carved woods, gold, bamboo, silver and porcelain went in and out of vogue with amazing speed. Materials ranged from silks, satins, brocades, velvets, ribbons and taffeta. The parasols had fringes and tassels and were unbelievably ornate. Parasols resembling Chinese pagodas or tropical birds in flight, or others with serpent handles approaching the grotesque enjoyed momentary surges of popularity during the 1880s. Promenades were pretty pictures indeed with a rainbow of bobbing parasols on a Sunday after-

noon. Parasol values: Coral handle, good condition, circa 1870, $18; Mourning Parasol, black silk, circa 1870, $16.

PARIAN

Parian is an unglazed hard-paste porcelain perfected by Copeland and Garret of Stoke on Trent, England in the 1840s. It continued to be popular for the remainder of the century. It was originally referred to as Statuary Porcelain; however, it is best known as *parian* due to its resemblance to parian marble. Reproductions of antique statuary, modern works of art, and utilitarian objects were made by English and American factories. Parian is rarely glazed, although some pieces have a soft luster and any article made to hold liquid was glazed on the inside only. The ware was usually all white, particularly the earlier produced pieces, while later some soft colors were applied. The majority of parian was unmarked, making attribution difficult due to the fact that American factories copied the English parian subjects with amazing accuracy. Parian values: Autumn Figurine, 14″ high, $85; Lincoln Bust, 5½″ high, $53; Pitcher, floral motif, $32; Napoleon Bust, $72. Illustration on page 181.

PARKER GAMES

George S. Parker invented his first game, The Game of Banking, in 1883 at the age of sixteen. Between 1883 and 1900 many new games were introduced and many old games were revived by the firm. The Grocery Store, The Country Auction, and The Yankee Peddler were three new indoor games of the 1880s. There was a reissue of the Mansion of Happiness game first made in the 1840s. The gay '90s were a trifle gayer, thanks to such diversions as Pike's Peak or Bust, The Battle of Manila, Game of Business, and Innocence Abroad. Collectors pursue Parker Games made before 1900 and any game bearing their name is a winner. Parker Game values: "Hen That Laid the Golden Egg," $12; Battle of Manila, $18; Steeple Chase game, $9.

PARLOR STOVES

American iron factories were busy keeping the parlors of America toasty warm with plain and fancy parlor stoves between 1840 and 1900. The stoves were really a throwback to the Franklin stove, but updated with Victorian details such as scrolls, shells, figures, and other winning

forms molded in low relief to complement existing furniture styles. One unique model was a combination cooking stove, hot-water heater and warming stove. Many antique parlor stoves bear a patent date or a maker's name for possible identification. The sight of a cast-iron parlor stove conjures up the feeling of cozy contentment and family together-ness synonymous with the era known as Victorian. Parlor Stove value: Wood Burning Parlor Stove, dated 1870, Whitman and Cox, Phila. Mfgrs., 50″ high, $140. Illustration on page 71.

PASTILLE BURNERS

Musty odors were quickly dispelled from rooms with china incense burners known as "pastille burners" in the first half of the 1800s. Eng-lish potters varied the shapes slightly, preferring castles, churches, cot-tages, and summer houses, all with detachable perforated rooftop lids. They were made for cassolette perfumes, by Spode, Coalport and other prominent English concerns. Pastille Burner values: Small Pottery Cot-tage, late, $60; Small detailed castle, $68.

PÂTE-SUR-PÂTE

The pâte-sur-pâte method of decorating porcelain was developed around the middle of the 1800s by the Sevres factory of France. Louis Marc Solon studied the technique at the Sevres factory and relocated to England where he joined the Minton firm in 1870. He made exceptional pâte-sur-pâte wares over the duration of his thirty-five years with the Minton firm. Solon signed most of his work and never repeated the same subject twice, using various grounds, with black being his personal fa-vorite. He became a master at decorating in low relief with layers of slip usually against a selected dark background. Other potteries attempted the pâte-sur-pâte method of decorating porcelain to a limited degree, although it was never mass-produced as it was a costly method and one which required exceptional skills. Pâte-sur-pâte values: Vase, artist signed, Minton, 6″ high, $480; Limoges Vase, cherubs, blue ground, late, 6″ high, $75.

PATTERN NUMBERS

The pattern numbers on the underside of ceramics from the nine-teenth century can be traced to establish an approximate date of manu-facture. Copeland, Minton, Royal Worcester, Coalport and John Ridg-

way were among the English potters using pattern numbers. Each factory had a different method of marking their patterns and repetitive designs will often bear a number usually found over the glaze.

PAUL AND VIRGINIA

Pierre August Cot immortalized the unhappy lovers of an eighteenth century novel, *Paul and Virginia*, in his painting "L'Orage." Romantic Victorian natures were awakened to these lovers when Paul and Virginia porcelain pitchers were designed. The lovers were pictured in white relief against a dark background, usually blue. Variations in size and design occur according to the maker. T. J. & J. Mayer of the Dale Hall Pottery, England as well as American potters, including those at Bennington, Vermont, made these sentimental pitchers. Marked specimens can be safely attributed to a particular maker. Unmarked examples require study before attribution can be accurately determined. Paul and Virginia value: Pitcher with Paul and Virginia figures, 10" high, $140.

PAULINE POTTERY

Mrs. Pauline Jacobus established the Pauline Pottery firm in Chicago in 1883. One year later the company moved to Edgarton, Wisconsin, remaining active there into the 1890s. Pauline pottery resembles majolica, except that it is lighter in weight and was decorated in the underglaze method. Characteristic colors were peacock blue and green, vibrant yellows, lavendars and soft creamy tints blended against a light ground. Bon bon dishes, vases, tiles, bowls, cachepots, lamps, and other articles were sold by leading firms such as Tiffany, Marshall Field and Kimball's of Boston. Pauline pottery was marked with a crown between two letter Ps, the one reversed. On earlier wares the mark was incised while on later pieces it was printed in black. Pauline Pottery values: Cachepot, blue, green, light ground, $120; Vase, floral motif, 7" high, circa 1890, $87.

PEACHBLOW GLASS

Hobbs and Brockunier of Wheeling, West Virginia introduced Peachblow in 1883. This glass resembled the Chinese porcelain of the same name. Their version was actually an Amberina glass having an opal or opaque lining, usually white with a glossy finish, although some were given a satin finish. The color ranged from red at one end to deep

yellow at the other end. The New England Glass Works in Massachusetts patented a similar ware known as Wild Rose in 1886. New England Peachblow is not lined and shades from rose red at the top to opaque white at the base, having either a glossy or satin finish. The finest Peachblow is attributed to the Mt. Washington Glass Works of New Bedford, Massachusetts, made between 1886 and 1888. The glass shades from rose pink at the top to light blue grey at the base and is solid without a lining, usually in a satin finish. Mt. Washington Peachblow was left plain or decorated with painted or enameled designs or old English script verses. Peachblow ranks as the rarest of all American Art glass. Peachblow values: Celery Vase, Wheeling, $620; Rose Bowl, New England, $525; Tumbler, New England, $520.

PEACOCK MOTIF

Parlor and sitting rooms of the 1880s often had a peacock feather tucked behind a favorite oil painting or an arrangement of peacock feathers were exhibited in a fancy urn or vase. From this quite innocent start there developed in the 1890s a peacock cult. Craftsmen found tremendous sources of artistic stimulation in the peacock and its feathers. Louis Tiffany and other designers of Art Nouveau introduced glass, prints, jewelry, wallpaper, silver, fabrics and a potpourri of peacock related objects. Peacocks strutted proudly through every room in the house in one form or another by the turn of the century. Peacock values: Perfume Bottle, with stopper, Tiffany, peacock motif, $220; Vase, Peacock design, Tiffany, 8″ high, $675.

PEARL WARE

Josiah Wedgwood developed this slightly whiter version of his successful creamware body in the late 1770s. By the middle of the nineteenth century numerous English potters were engaged in producing Pearl wares. The white earthenware body was ideal for blue transfer-printing and outstanding Amorial services were made with blue and gold scroll and feather borders. Wedgwood marked their pearl wares with the word "Pearl" impressed into the body on all pieces during the 1840s and after 1868 the initial "P" occurred in addition to the factory mark. Pearl Ware value: Wedgwood Pearl Ware Teapot, $90; Plate, circa 1870, $28.

PEDDLER DOLLS

"Notion Nannies" is another name given to these charming dolls which were made mostly of wood. The name was derived from the pack peddlers of long ago when women traveled across the country selling small articles such as needles, pins, scissors, pin cushions and countless other portable notions. These "nannies" are much sought after, as they commemorate a social custom and the trays or baskets carried by the dolls often contained 125 or more miniature articles. Most examples have long since retired to the warm secure walls of museums, but keep searching as locating one of these rarities may help boost your own "social security." Peddler Doll value: 23" tall, most of original clothes, with glass eyes and wooden limbs, $200.

PEG DOLLS

Little girls adored these wooden dolls imported from Europe in heavy quantities during the 1800s. Those originating in Holland are usually referred to as Dutch dolls. They are easy to recognize as they are completely hand carved of wood with painted hair and faces. They vary in size from a mere 1" to about 12" in height. Peg dolls were also made in America during the nineteenth century with painted faces and costumes and pre-date the wooden dolls with ball and socket joints. Peg Doll value: Modestly dressed, fair original paint, 12" high, $20.

PEG LAMP

Extensively used until the middle of the nineteenth century and even later in rural areas, the peg lamp was designed to burn whale oil. They pre-date the kerosene lamps of the late 1800s. This lamp was made to fit into the socket of a candlestick. The oil was held in a round globe which had a metal burner at the top. A round peg on the base of the font enabled it to be securely fastened into the candlestick. Metal and glass peg lamps gave additional light due to their height. Candlesticks were easily converted to whale oil lamps with the help of a peg lamp. Peg Lamp values: Sandwich glass Peg Lamp, amber to clear, $130; Tin lamp hook in wooden block, $42; Whale oil Peg Lamp, Pewter, $42.

PEWTER

Pewter is composed of varying amounts of tin, copper, antimony, lead and other metals. The lower the lead content the finer the pewter. There was a decline in the popularity of pewter during the reign of Queen Victoria, as richly ornamented silver was preferred and pewter was used mainly for utilitarian kitchen items, primarily in rural areas. After 1850 Britannia ware gradually replaced pewter, and careful study is required to differentiate between the two as they closely resemble each other. American antique pewter made between 1840 and 1900 is generally marked on the base and pieces bring premium prices. English pewter was marked with the individual artisan's touch mark. Pewter darkens with age and has an uneven surface. Pitting or corrosion usually helps in distinguishing the antique pieces from the new wares. *Tip:* Never scour or buff antique pewter as this brings the tin content to the surface and results in diminishing the soft satin finish so desirable on the antique pieces. Pewter values: Flagon, Gleason American, 10″, $220; Mug, ½ pint, circa 1850, $30; Teapot, J. Munson Wallingford, Connecticut, circa 1850, $140. Illustration on page 171.

PHONOGRAPH

The talking machine was the talk of the early 1880s. Thomas Edison invented the first machine to be placed on the market and other firms manufactured numerous versions in later years. The Columbia Gramophone vied for sales when introduced about 1885. The Victorian talking machine with the full-blown morning-glory horn extending from its top is tops with collectors. There were other phonographs with flowering horns and none of the various horns are scorned, nor are the records with those sweet sounds of yesteryear. Phonograph values: Edison Cylinder Record Player with decorated Morning Glory Horn, $260; Columbia Gramophone, pat. 1885, $220; Edison Cylinder Record, $3 each.

PHOTOGRAPH CHINA

Advertisements of the 1860s declared that photographs could be reproduced with faultless accuracy on china. Business establishments found it ideal for advertising their services and it provided a boon to the souvenir trade. Historical buildings, national parks, vacation areas

Silver Pewter Tankard

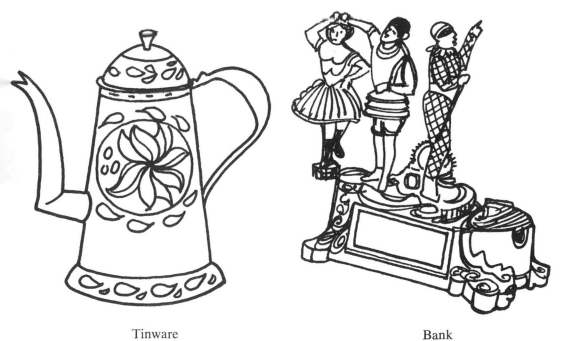

Tinware Bank

and exceptional landmarks were pictured on china plates, vases and other attractive ceramic articles. Customers could have their photographs reproduced on cups and saucers for five dollars, or on a pair of Sevres vases for one hundred dollars. The American Photographic Company of New York was a leader of photographic china in America. Wedgwood, Doulton, Minton and other English firms participated in this prosperous china fad of the 1860s and thereafter. Photograph China values: Independence Hall, Philadelphia, Plate, 10″ diameter, $14; Plate, Public Library, Boston, late, 9″, $13.

PIANO STOOLS

The piano stools of the 1850s were very fancy with upholstered seats of tapestry or velvet, fringed with beadwork. Piano playing encompassed those of every age group and the revolving stool, adjustable for height, was a necessity. The mid-Victorian stools of rosewood, mahogany and walnut often had detailed carving. The later piano stools with wooden seats had ball or claw feet and frequently the claw of brass clutched a glass ball. Most of the earlier upholstered stools require restoration work due to heavy usage. The twin piano stool of the 1880s with two seats that could be individually adjusted to suit either player in a piano duet is a music lover's delight. Piano Stool values: Mahogany Stool, ball and claw feet, $45; Walnut Piano Stool, velvet seat, $65.

PICKLE CASTER

The lowly pickle was relegated to prominence during the 1890s when pickle casters suddenly popped up on tabletops. The glass jars holding the pickles were made of clear, colored or opaque glass of every description. The metal frames, often of silverplate or Britannia metal, had a base and impressive handles rising above the jar often in an arched effect. The pickle caster is easy to recognize as a pair of tongs to procure the pickle from its fancy jar hung from the metal frame. Pickle Caster values: Cranberry Glass in ornate silver-plated frame with fork replated, $125; Blue pressed glass, Daisy and Button pattern in silver holder with fork, $75.

PIER GLASS

Popularized in the American Empire period, the tall pier glass continued being made for the remainder of the Victorian era. The design

is taller and narrower than the overmantel mirror. A tall pier glass ranges from seven to nine feet in height and thirty to forty-two inches in width. The frame rests on a projecting base which was quite elaborate, often with a marble top. The frame may be plain or ornamented and some examples have fruit, flowers and foliage with a top scroll pediment eighteen to twenty inches high. The tall towering pier glass was perfect for a drawing room of an elegant mansion. A smaller pier glass five to six feet in height was suitable for less stately residences. Pier Glass values: Eastlake Pier glass, ornate white marble base, circa 1880, 40" x 96", $525.

PILLAR AND SCROLL CLOCK

Eli Terry, a pioneer in the American clockmaking field, is credited with the development of the Pillar and Scroll clock, also known as a "Terry Type" clock. By the 1840s this clock was a favorite shelf clock, graceful in appearance with slender feet, delicate pillars on either side and a double scroll or broken arch top. Terry began making this style clock in the early 1800s and it was quickly copied by numerous other clockmakers. The movements varied from thirty-hour to eight-day, according to maker. The condition of the painted glass tablet and the presence of a clock label contribute to determining the worth of a nineteenth century Pillar and Scroll shelf clock. Pillar and Scroll Clock value: Terry, 30-hour wooden movement, 31", $875.

PIN BOXES

China manufacturers created a wide array of pretty pin boxes in sizes and shapes galore. European and American makers made irresistible pin holders which were hand painted with bird, floral or scenic designs among the favorite subjects. Bone china boxes and other types were available in standard round, oval and rectangular shapes as well as in odd and whimsical varieties. Miniature bust forms proved to be popular subjects as royalty and famous personages were immortalized on pin boxes. Marked pin boxes from name factories represent the best investments. Pin Box values: Staffordshire Box with Red Riding Hood and Wolf on lid, $42; Staffordshire Box, Washington and Horse on lid, $46.

PIN CUSHION

Pretty resting places for pretty pins were conceived from odds and ends remaining from a more important sewing endeavor. A few velvet

sures. The pin cushion was frequently attached to a fancy silver or brass base in heart, wheelbarrow, crown, carriage or other novel shapes. There were many novelty china ornaments that adapted themselves to pin cushion inserts, and parian cradle bases were considered acceptable. The sizes and shapes of Victorian pin cushions were as varied as those of their makers. Pin cushion values: Niagara Falls, beaded work, floral sprays, dated 1880, large size, $37; Red velvet heart, brass base, $18. Illustration on page 131.

PIN CUSHION DOLL

Leading periodicals encouraged mothers and daughters to test their sewing skills with a pin cushion doll project around the 1850s. The doll heads varied from china, painted wood or papier-mâché, as did the bodies of stuffed cloth or kid or any suitable material into which pins could be easily placed. The dolls were dressed with leftover odds and ends from other sewing chores. A velvet or silk skirt was thought to be superior, as the pins were certain to be shown to best advantage. Home-made pin cushion dolls represent a fascinating area of doll collecting due to their unexpected but always interesting subject matter. Pin Cushion Doll values: German porcelain head, stuffed body, hooped skirt, original clothes, circa 1860, $68; Painted wooden head, kid body, silk skirt, circa 1870, $62.

PIN PRICKED PICTURES

As early as the 1820s directions for pin-pricked pictures began appearing in books and magazines. Pin-pricked pictures were still being made well into the middle of the century. The pin-pricked picture was accomplished by pricking the paper with various size pins, thereby making different size holes in the paper. The holes formed the subject matter and the pricking could be done from either side of the paper. Talented artists would often water color their endeavors which gave them a textured appearance. Pin pricked pictures, upon close examination, may bear the initial or name of the maker and possibly a date. Pin Pricked Picture value: "Woman and Child" framed, dated 1852, 8″ x 10″, $80.

PIN TRAY

Shopping for a pin tray posed a slight problem since the selection was unbelieveably varied and generally most attractive. Pressed glass pin trays in colored or milk glass were often embellished with painted or enameled motifs. They were often especially made for an exposition or

particular event. Ceramic pin trays with scores of fascinating designs either transfer-printed or hand-painted were marketed as were china blanks suitable for those wishing to test their skills at home. Silver, silver-plated and metal pin trays ranged from outstanding to outrageous and some were lettered "Love Token" or "A Woman's Friend." All were selected with utmost care. Pin Tray values: Limoges, T.V. mark, floral decor, $18; R.S. Prussia water lilies, $72.

PINCHBECK PAPERWEIGHTS

This type of paperweight employing pinchbeck metal was introduced in England about 1850. The process involved an intaglio mold being made of the subject, after which a thin sheet of pinchbeck was burnished down on it. The sheet was tooled to bring out the subject matter after it was lifted from the mold. Typical pinchbeck paperweight designs included tavern scenes, landscapes, portraits of royalty or copies of well-known paintings. They were enclosed in glass domes and those with marble bases are thought to be French in origin, with English weights having bases of pewter or velvet. They were either all gold or gold with other colors. Pinchbeck Paperweight value: Tavern scene, 2¾″ diameter, $295.

PINEAPPLE AND FAN PATTERN

Combining pineapples with fans proved a clever and rewarding duo for American glasshouses in the late 1800s. The Adams and Company glasshouse of Pennsylvania made the pattern in clear, colored, and milk glass. The Model Flint Glass Company of Ohio and the A. H. Heisey Glass Company also added Pineapple and Fan to their production schedules. The Heisey version included many pieces in deep green with gilt decoration in the 1890s. The pattern varied slightly depending on the maker, but ever present was the suggestion of pineapple and fan. Pineapple and Fan values: Butter Dish, $35; Celery, large, $30; Spooner, $18; Tumbler, $11.

PLATED AMBERINA

This rare type of American art glass was made exclusively by the New England Glass Company of Cambridge, Massachusetts in 1886. This plated or ribbed glass is the most coveted and expensive of all Amberina. The glass ranges in color from red to yellow and is very brit-scraps and some beadwork transferred bits of nothing into lasting trea-

tle. It was difficult to produce, accounting for its limited availability. Because of its brittle quality surviving examples are at a premium. This type of Amberina was plated or lined with an opalescent lining. The original ware had a cream colored or chartreuse lining, but never white. Plated amberina bearing a paper label from the New England Glass Company is possible but not a probable find. Plated Amberina values: Cruet, $850; Fruit Bowl, $1,170, Pitcher, 10″ high, $950.

PLAYING CARDS

A card or game table graced every Victorian parlor and card playing was one of the favorite indoor pastimes. A playing card which has an unusual design on either side of the card is collectible whether of American or European origin. Subject matter can aid in dating a deck of cards. Counting the number of stars on one picturing a flag or researching the date of an important illustrated historical event can often determine the age of the card. Unwrapped decks are select and even the wrappers are wanted. A deck of cards having the portrait of a famous person is choice. *Tip:* There were no index numbers on playing cards until 1877. Playing Card values: Pennsylvania Railroad, circa 1890, $15; Santa Fe, $12.

PLYMOUTH ROCK PAPERWEIGHT

A replica of Plymouth Rock was the subject matter for this paperweight made in the 1870s by the Inkstand Company of Providence, Rhode Island. The clear glass paperweight is easy to recognize, having the date 1620 on one side and a poem pertaining to the rock on the other. There are slight variations depending on the maker, but the replica of Plymouth Rock remains the distinguishing feature. Plymouth Rock Paperweight value: Paperweight, circa 1880, $45.

POISON BOTTLES

Bottle makers endeavored to alert users, and particularly the young and unwary reaching for bottles in a darkened area, that the contents contained poison. A number of makers marked the word *poison* clearly on the bottle, usually embossed, and they had the familiar skull and crossbones. Another distinguishing feature of the poison bottle was a rough or pointed surface on the bottle or stopper or a shape to signal a warning concerning the contents. Improved closures made the poison bottle obsolete and since they were only made in limited quantities, they

are scarce and in demand. Poison Bottle values: Amber, 7" high, $9; Cobalt blue, embossed Poison, $12; Light green half pint, circa 1860, $10.

POMONA GLASS

Patented by Joseph Locke of the New England Glass Company in 1885, Pomona was a blown or pattern-molded art glass. Pomona is easy to recognize since it is a clear glass with a stippled or fine line background. There is a soft amber border and a simple pattern consisting of a band of flowers, wild roses, cornflowers, blueberries, butterflies or similar design in soft pastel colors. The method was expensive and the production was limited. The expensive type is known as "first grind" and a second less expensive process called "second grind" was attempted in an effort to market Pomona glass employing less costly techniques. Pomona values: Bowl, first grind, 7" diameter, $280; Punch cup, first grind, Cornflower decor, $130; Vase, second grind, 4", $155.

POTCHAMANIA

Ordinary glass jars or containers were swiftly transformed into works of art resembling fine Bristol glass when the artsy-craftsy set discovered Potchamania. Selected colored pictures were cut out and pasted face-out inside the chosen receptacle and when they dried the inside of the piece was coated with a thin layer of plaster of Paris. The plaster hardened, forming a white porcelain-like background for the colorful paper cutouts. The overall effect supposedly resembled a creation of fine porcelain or glass. Potchamania value. Pair of vases with cupids, birds and flowers, circa 1885, 18" high, $95.

POT LIDS

Transfer-printing on pottery was perfected by Jesse Owens of the Pratt Pottery of Fenton, England during the 1840s. The firm specialized in small pottery boxes, round, oval and oblong, with colorful transfer printed covers. Hair ointments, fish paste, meat paste, honey and other items were packed in these attractive boxes. The best known pot lids are those with the Pratt factory trademark, although other potters also made them. They were sold separately as well as being sold with packaged products. The categories include famous people, important buildings, portraits of royalty, American Presidents and copies of famous

paintings among others. Don't be deceived by the reproductions. Old pot lids have a tendency toward crazing and the colors are more vivid than on the newer lids. Trace the maker's mark and be suspicious! Remember the lids alone have value even when the bases are missing. Pot Lid values: Albert Memorial, $57; Shakespeare House, $54; Village Wedding, $48.

POUYAT

The Pouyat name has been associated with fine French ceramics since the eighteenth century. Jean Pouyat and associates established a prosperous pottery primarily for export wares in the Limoges district of France in the 1840s. The firm competed for the American market against other reputable Limoges companies, including Haviland & Co. Their porcelains met with success and the name Pouyat became respected in America during the second half of the nineteenth century. Antique porcelain bearing the mark Pouyat in various designs including the *J. P.* over *L.* originated at this factory. The word France was added to the factory mark in 1891. Pouyat values: Cake plate, white and pink flowers, $9; Creamer, blue flowers, 5″ high, $14.

POWDER FLASKS

Gun powder flasks were first manufactured in the United States around the 1830s, although they had been made abroad earlier in the century. Die-stamped metal flasks quickly began replacing all other types and flasks of brass, copper or a combination of the two, or of pewter and zinc dominated the market. The American firms copied many of the English designs, although often they were not as detailed as those made abroad. There are pocket pistol, military and sporting flasks and the collector may specialize within a particular category. Patriotic designs and hunting scenes form interesting groups as do the Army and Navy flasks. Metal flasks continued being made until the 1890s. The one of a kind flasks of carved ivory, mother-of-pearl, tortoise shell and silver or hand painted metal are other possibilities in the field of powder horns or flasks. Powder Flask values: Copper Flask with brass trim hunting dog and game bird design, 8″ long, $45; Pewter and brass flask, 9″ long, $54.

PRANG, LOUIS

America's foremost maker of chromo lithographs is the title deservedly acquired by Louis Prang of Boston, Massachusetts. Prang's in-

tention was to bring fine works of art to the masses. He employed excellent artists to create the wide and varied subjects used on his chromolithographs, greeting cards, calendars and art books. His chromolithographs covered every possible theme from landscapes to animal groups. The firm became known for its Valentine, Christmas, Easter, New Year and birthday cards and competitions were held for the card designs. The designs were exhibited at the Boston Fine Arts Gallery and the Chicago Art Institute. Prang cards were outstanding and one of the best sources for locating them would be in a Victorian scrapbook. The firm name usually appears on each card directly under the picture. Some are marked on the reverse side as prize winning designs, stating the amount of the reward and the date. Prang values: Christmas Greeting Card with Santa Claus, $4; Framed Chromolithograph Print of game birds, 12" x 14", $35.

PRESSED AMBERINA

Hobbs and Brockunier of Wheeling, West Virginia, were granted permission from the New England Glass Company of Massachusetts in 1886 to produce pressed Amberina. Daisy and Button pattern Amberina was listed in the company catalog as Hobnail-Diamond pattern and was manufactured in a complete line of tableware and ornamental items. The Daisy and Button pattern pressed Amberina was also made by Scotney and Earnshaw of London between 1884 and 1901. The English registry mark may be noted on their pressed Amberina pieces. The French Baccarat factory also made pressed Amberina bearing a factory trademark or the word *depose*. Their wares date from the twentieth century. Pressed Amberina values: Butter Pat, Daisy and Button pattern, $62; Boat-shaped Dish, Daisy and Button pattern, 14" long, $210; Toothpick Holder, $150.

PRESSED FLOWERS

The ancient art of skeletonizing leaves was revived in the 1860s and combined with pressed flowers to create gossamer-like bouquets. The arrangement when completed was often set in a deep-recessed frame or placed under a glass dome. Pressed flower pictures appealed to the Victorians love for botany and many were pressed carefully into albums. Pressed Flower Picture value: Framed Shadow Box, flowers on black velvet, 14" x 16", $60.

PRIMITIVE PAINTINGS

Very few families could afford professional oil paintings or water colors in the nineteenth century. The average household had to depend upon the lesser talents of an amateur, local or journeyman artist for its paintings. These artists painted in a rather flat, crude style and the quality of work depended often upon the amount of money being paid. There were many family portraits, consisting of a group or a child at play, which tend to appear a trifle distorted. In reality, they were probably never really fine likenesses of their subjects. Religious paintings, flower groups, still-life centerpieces, ships, local buildings and mourning paintings were among the subject matter favored by these would-be artists. These paintings are known as "primitive" paintings and are being collected by forward-thinking individuals interested in preserving and with an appreciation for this nineteenth century art. Primitive Painting values: Boy with Goat, gold leaf frame, 26" x 30", $950; Farm Scene, detailed, medium size, $350.

PRIMROSE PATTERN

The Canton Glass Company of Canton, Ohio, created many bestselling tableware patterns during the 1880s including the Primrose design. Large panels have a background consisting of tiny raised beads arranged crosswise, providing a screened effect for the low relief spray of flowers, leaves and foliage. Primrose adapted itself well to both clear and colored glass and was made in vaseline, amber and blue. Collectors beat a path to Primrose pattern glass and colored pieces range slightly higher than the clear glass examples. Primrose Glass values: Cake Stand: Clear, $23; Cake Stand, Vaseline, $34; Celery, Blue, $40; Cordial: Clear, $15; Egg Cup, Vaseline, $22; Spooner, amber, $20.

PUPPETS

The most cantankerous youngster could be brought under control when mother or a female relative handy with needle and thread fashioned a hand puppet. Fairy tales and nursery rhymes provided the characters or animal subjects for a puppet project. Traveling puppet shows touring the countryside gave puppetry an added boost when children visited the fairs and carnivals. Children were often given puppets as gifts and Punch and Judy and all the other members of the puppet family tree were called

Parian

Rogers Group

Terra Cotta

Bisque

upon to withstand the vigors of heavy wear and tear. *Tip:* Finding one in excellent condition is next to impossible and even those a bit worn about the edges should prove salable. Puppet values: Hand-made German Puppets, hand-carved wooden head, rough condition, circa 1870, pair, $90.

Q

QUILLWORK

Paper filigree work known as Quillwork was a seventeenth century craft which was still being practiced by skillful artists during the 1800s. Tiny strips of paper, white and colored, were rolled into spirals and glued by one edge to the selected article of wood, paper, fabric or other background. The edges of the spirals were painted or gilded and arranged in a mosaic-like manner. This rolled paper art was attempted on screens, tea caddies, boxes, picture frames, sconces and other objects. The design often incorporated shells, seeds, beads, threads, needlework and other forms along with the rolled paper for further dramatic effects. Unlimited patience was required; a similar amount may be exercised by the anxious collector searching for a prized specimen of paper filigree or Quillwork art. Quillwork values: Box 4" x 5", maker unknown, circa 1850, $48; Tea Caddie, dated 1860, $120.

R

RAG DOLLS

Cuddly home-made rag dolls were made as early as the 1700s and although the examples that exist today are probably from the nineteenth century, they are always received warmly by a doll enthusiast. The first to be produced on a commercial scale in this country were those made in Rhode Island by Mrs. Izannah Walker in the 1870s. By the 1890s

Mrs. Martha Chase, another resident of Rhode Island, began making her now famous Chase Stockinette rag doll. The lifelike appearance of these early commercially made dolls was achieved by the use of oil paints in the delicate hand painting of the features. The 1890s saw patents issued for such perennial favorites as Tabby the Cat, Palmer Cox Brownies and Uncle Sam, who were joined quickly by Little Red Riding Hood, Jocko the Monkey and the Columbian Sailor Boy. The manufactured cloth dolls of the 1890s were stamped on a piece of cloth showing the complete doll both front and back for easy sewing at home. *Tip:* Beware of the reissues of old cloth dolls; most antique dolls will show signs of wear and have faded colors and probably be stained somewhat as they were dearly loved by the children and received hard wear. Rag Doll values: Palmer Cox Brownie Doll, 4" cloth, $28; Rag Doll, painted features and underclothes, circa 1865, 5" high, $45; Rag Doll, dressed, circa 1890, 25" tall, $72.

RAILROAD PRINTS

The largest number of railroad-related prints were executed as lithographs. The development of the American Railway system has been accurately and vividly preserved on these fine Victorian prints. Locomotive prints form one interesting category as they picture the engines themselves and are very detailed and brightly colored, although the engines are not shown in motion. Builders used them to circulate among railroad companies as advertisements. These are scarce although they hung in numerous railroad stations and ticket offices, framed and unframed. Other railroad-related prints picture viaducts and bridges, horse-drawn railway coaches, steam locomotives and accident prints. Railroad scenes of the Civil War are wanted for their social significance. Currier and Ives issued approximately thirty different railroad prints and other print makers also contributed to the important category of railroad prints with their endeavors. Railroad Print values: Atlantic, Mississippi & Ohio Railway, Currier and Ives, 1864, large folio, $2,350; The Railroad Suspension Bridge Near Niagara Falls, Currier and Ives 1856, medium folio, $245.

RAYO LAMP

Popular during the 1880s and 1890s the Rayo lamp was actually a kerosene-burning table lamp with a brass base supporting a fluted

shade. They were practically all vase-shaped with the font supported by the metal base. The glass shades rested on three metal arms which provided them with sufficient support. Some of the earlier examples had only a glass chimney, while the later types were complete with the metal holder for the flaring or circular glass shades. Those with two knobs on the side indicate a double wick. *Tip:* The shades have been reproduced. Run your hand along the bottom rim. The antique shades will be rough to the touch, the new shades are smooth along the rim. Rayo Lamp values: Brass burnished, no shade, $35; Lamp with painted shade, electrified, $65.

REBECCA AT THE WELL TEAPOT

The renowned Edwin Bennett firm of Baltimore, Maryland, made this brown- or Rockingham-glazed teapot in the early 1850s. It was adapted from an earlier parian jug design made by Samuel Alcock and Company of England. The American teapot design is credited to Charles Coxson, associated with the Bennett firm. A Rockingham glaze covered the teapot, which depicted a design carved in the surface of Rebecca at the Well. The teapot became legendary in American ceramics as potters in England and America added it to their list of accomplishments. Unmarked specimens are difficult to attribute to a particular maker due to the similarity in design. The original spelling of the name was Rebekah. *Tip:* The Rebecca at the Well teapot did not originate at the Bennington Potteries. Rebecca at the Well Teapot values: Bennington Teapot, $82; Rockingham, $55.

RECTANGULAR MIRROR

The standard Victorian mirror had a simple rectangular OG frame and a single pane of glass. The frames were of pine, coated with gesso and painted to resemble black walnut or rosewood or gilded with gold leaf. Heavily made by the frame makers, some were of black lacquer with gilt, or mahogany veneer, while in the late 1800s walnut and oak became popular woods. They were made in innumerable sizes and could be hung vertically or horizontally. The better quality rectangular mirrors were the work of cabinetmakers or small furniture factories. *Tip:* Leave the original mirror glass intact for highest returns. Rectangular Mirror values: O.G. mirror, 26" x 38", $74; Pine Mirror, good condition, 24" x 36", $78.

RED BLOCK PATTERN

This crystal glass with red-stained blocks found public acceptance during the period when ruby-stained glass reached the peak of popularity. Doyle and Company of Pennsylvania, Fostoria Glass Company of Ohio, and the Model Flint Glass Company of Ohio all realized the potential of red block and issued the design with minor alterations. The pattern was also available in clear glass without the ruby-stained effect. This pressed-glass pattern of the 1880s and 1890s is well known to collectors. Red Block Pattern values: Berry Bowl, $35; Celery, $41; Creamer, large, $44.

REGISTRY MARK

A lozenge-shaped mark was in use between 1842 and 1883 on English wares denoting that the design had been registered at the British Patent Office. The abbreviation "Rd" appears within the mark and surrounding numbers and letters can provide the exact year, month and day a design was registered by a manufacturer. Beginning in 1884, the diamond-shaped form was eliminated and a simple consecutive dating system was inaugurated. The prefix "Rd" or "Rd No" appears on wares after this date and they started with the number 1 in 1884. By 1900 there were some 368,000 designs registered at the patent office and these numbers provide a clue to dating wares of English origin.

RENAISSANCE REVIVAL

The Renaissance Revival furniture was based on Renaissance architecture and was successfully launched following showings at the London Crystal Palace Exhibition in 1851 and the New York Exhibition in 1853. Renaissance furniture was heavy and straight of line, finding public acceptance between about 1860 and 1880. Characteristics included tall arched pediments, carved cartouches, bold moldings, raised and shaped panels and applied carving in fruit, floral and medallion forms. The furniture was generally oversize and many pieces were heavy and stiff. Renaissance furniture enjoyed its greatest popularity in America in bedroom, dining room and library areas. Renaissance furniture often had Eastlake details around the 1870s and some pieces originated at the furniture factories centered about the Grand Rapids region. The American pieces were scaled down in size and plainer in ornamentation than on

Renaissance furniture made abroad. Renaissance values: Bed, tall head-board, foot board, 39" tall, 9', circa 1870, $650; Commode, walnut, marble top, circa 1870, $230; Table, oval, marble top, fancy, good condition, 24" x 38", $280. Illustrations on page 31.

REVERSE PAINTING

Reverse paintings on glass became a homecraft art project during the Victorian years and they are almost always found fitted into their original frames. The technique was an age-old method of painting popular in Europe and revived in the 1800s by leading periodicals, which suggested the art form as a pleasant way to pass a summer afternoon. The method suggested for home projects was very simplified and these can be easily recognized by the subject matter. On the finer examples mother-of-pearl inlay was employed. American artists of note also used the reverse painting on glass technique, favoring portraits of Presidents, including many of George Washington, religious and still life subjects. Value is determined by the skill of the artist, subject matter and overall condition. Reverse Painting values: Child's Portrait, good condition, circa 1850, $150; Landscape, oval frame, late, $36.

RIDDLE BOOKS

Knowledge acquired through riddles and puzzles was a repeated method of instruction by the 1840s. Collectors are puzzled by the scarcity of pre-Victorian puzzle books and have turned their attention on those of nineteenth century origin. *The Child's Token* in 1841 had steel engravings, wood cuts and six riddles in verse by Samuel Coleman. Lewis Carroll of *Alice in Wonderland* fame fared well with mathematical puzzles for adults, rather than children. *Riddles for the Nursery,* published in the 1850s by Kiggins and Kellogg, and all other Victorian puzzle and riddle books, complete or incomplete, are wanted. Riddle Book values: Black and white engravings, circa 1840, $12.

RING HOLDER

A bureau top oddity, the ring holder is absolutely unmistakable. Picture a hand in an upright position, fingers slightly spread apart, rising from a saucer like base. Rings were placed upon the outstretched fingers on this clever piece of Victorian ingenuity. Ring holders of porcelain, pottery, silver, parian, wood or other suitable materials adorned a lady's

dressing table or bureau. The delicate floral Dresden type holders or those bearing factory marks of known firms are choice acquisitions. Ring Holder values: Bavarian china, floral decor, $18; Cut-glass Ring Tree, $55; Parian hand, $27.

ROCKINGHAM

The term Rockingham is associated with ceramics manufactured in America between 1840 and 1900, which possess a solid brown, mottled brown or streaked glaze. This Rockingham glaze was used by many potters on numerous household articles; a mottled tortoise shell glaze was more popular than the solid brown glaze. The wares are frequently unmarked and are erroneously referred to as Bennington. The Rockingham glaze was used on Bennington wares, but the principal center in the United States was the area of East Liverpool, Ohio. The term Rockingham is also applied to certain English ceramics which were manufactured on the estate of the Marquis of Rockingham, Swinton, Yorkshire, between 1754 and 1842. This pottery became known as Rockingham in 1826. Rockingham pottery earned a fine reputation in England. Rockingham values: Cow Creamer, $52; Cuspidor, rectangular, 7" x 9", $35; Pie Plate, 11" diameter, $34.

ROGERS, JOHN (1829–1904)

The life and times of the Victorian Age were vividly and accurately portrayed in the sculpture groups of John Rogers. There were over one hundred thousand groups sold between 1859 and 1892 in over eighty different subjects. They sold for between five and twenty-five dollars each. The middle class homes of America displayed his putty-colored plaster groups, strengthened by metal supports, on marble top tables and mantels and they proved popular because they related a story in a sentimental manner and expressed the spirit of the people. They were a commentary on the literary and social events of the day and the realistic domestic subjects were among the best selling groups. The Civil War inspired such groups as "Council of War," "The Wounded Scout," "Camp Life" and other subjects dear to the hearts of the people. Each group had a title which was impressed in the front of the group on the base. They also bore a patent date and the name John Rogers, New York. The titles relate the scope of these plaster art works, such as Coming to the Parson, Fetching the Doctor, Neighboring Pews, School

Days and Slave Auction. John Rogers was a master in the art of the story-telling sculptures. John Rogers values: Council of War, $750; Coming to the Parson, $350; Rip Van Winkle at Home, $270. Illustration on page 181.

ROLLING PINS

During the Napoleonic Wars glass rolling-pins were made to hold salt when first produced. Victorian glass rolling-pins were extremely colorful with striped and swirled effects or in a solid color often embellished with gilt decoration. Superstition surrounding the rolling pin during the 1800s suggested that it was thought to ward off misfortune. They were often presented as gifts by sailors to their sweethearts or wives and by hanging them on the wall they became lucky tokens. They have been reproduced; however, an antique rolling pin is likely to show signs of wear. Rolling Pin value: Nailsea glass, clear with white loops, $62.

ROSE AMBER

Introduced by the Mt. Washington Glass Works of New Bedford, Massachusetts, during the 1880s, this version of Amberina glass shaded from yellow to amber. Trademark papers were granted to Frederick Shirley for Rose Amber in 1886, although the factory claimed the wares had been marketed as early as 1884. A court suit instigated against the factory by the makers of Amberina, the New England Glass Company, prevented the New Bedford firm from producing Rose Amber. Extensive study is required to differentiate between Rose Amber and Amberina, both popular during the 1880s. Rose Amber values: Goblet, $160; Tumbler, $95.

ROSE BOWLS

The pleasant scent of rose drifted across a room from the small rose bowls containing real rose petals. The rose bowls were attractive enough to remain on view even when roses were not available. These small crimped and pinched-edge bowls, ranging from two to six inches in diameter, were made in a rainbow of colors. Satin glass rose bowls in pastel shades were embellished with enamel or painted decoration, or with clear or colored applied-glass leaves and flowers. The colors shaded softly from top to base and some rose bowls were multi-colored or striped for pleasing effects. Rose Bowl values: Amberina, $185; Cranberry,

crimped top, $70; Satin, diamond quilted, rose and white, $87; Vaseline, circa 1885, $64.

ROSE IN SNOW PATTERN

A coveted American pressed-glass pattern is Rose in Snow, made during the 1870s in a square shape by Bryce McKee of Pittsburgh, Pennsylvania. The graceful design had an open rose with foliage against a stippled background and was made in clear and colored glass and in a variety of table-top items. Rose in Snow pattern was also made in a round shape and has been heavily reproduced in this shape. The colored pieces bring higher prices than those of clear glass on this cherished American glass. Rose in Snow values: Butter Dish, round, clear, $40; Cake Stand, amber, $46; Creamer, round, blue, $45; Tumbler, vaseline, $48.

ROSE MEDALLION

Shipped from the port of Canton, China, was the green enameled ware made in ornamental and utilitarian objects called Rose Medallion. The ceramic decoration on Rose Medallion consisted of medallions with figures of people, alternating with medallions of pink flowers, butterflies and birds. "Rose Canton" is the term used in connection with the pieces which had all medallions filled with flowers. There are minor variations in the design, which remained continually popular throughout the nineteenth century. Rose Medallion wares usually had four panels, except on the larger platters which often had six. Rose Medallion values: Bowl, 6" diameter, $55; Demitasse Cup and Saucer, $30; Powder Box, $32; Tea Pot, circa 1870, $92.

ROSENTHAL

The nineteenth century porcelains of the still-existing Rosenthal factory of Selb, Bavaria, are now being collected. The firm, founded in 1769, signed their products with the family name Rosenthal. They became noted for their excellent quality and table wares and figure subjects were exported to the United States. The company broke with tradition and in the early 1900s, table services in the modern style in ceramics were marketed by the progressive Rosenthal firm. Rosenthal values: Cake Plate, hand-painted, 12" diameter, $36; Cup and Saucer, red and gold, $16; Vase, hand-painted roses, 10" high, $48.

ROSEVILLE

The Roseville Factory was founded in 1892 in Roseville, Ohio, and a second factory was established in 1898 in Zanesville, Ohio. George Young, ambitious manager of the factory, impressed by the success of Weller and Owens, developed a similar ware called "Rozanne." The line, which was made in the underglaze decoration associated with Rookwood, met with excellent public response. Marked examples have an incised "Rozanne" along with a circle enclosing a rose. Roseville continued making art pottery and many other new lines. Rozanne Woodland, Rozanne Egypto and Rozanne Mongal were added to the firm's output in the early 1900s. The names of the individual lines were not marked on the wares, but are identified by their separate distinguishing features. The firm remained active until the 1950s and even the late production is beginning to attract attention as a "now collectible." Roseville values: Rozanne Vase, orange and green, 10″ high, $120; Two-handled Vase, orange and green, 4½″ high, $62.

ROYAL BAYREUTH

Anyone who has ever inherited a pitcher collection has found the mark of the Royal Bayreuth firm on one or more pitchers. Their tomato, alligator, lobster, moose head, poppy, strawberry and other novelty shapes, such as the handsome Card and Devil creamers and pitchers, were sold and given as souvenir items around the late 1890s and early 1900s. Highly respected are the Bayreuth tapestry pieces in rose and scenic designs, made to resemble woven tapestry. They made china featuring the Sunbonnet Babies, based on the drawings of Bertha L. Corbett that are sought after. The Royal Bayreuth firm of Germany made a wide variety of diversified china wares during the late 1800s. On wares made after 1891 the word "Bavaria" appears below the standard factory mark. *Tip:* The firm incorporated the founding date of the company, 1784, in their mark and this should not be mistaken as a date of production. Royal Bayreuth values: Moose Head Creamer, $52; Cup and Saucer, Rose Tapestry, $100; Tomato, covered on lettuce plate, small, $45.

ROYAL BONN

Check the mark on an antique china mantel clock with rococo designs and chances are it may bear the trademark of the Royal Bonn

 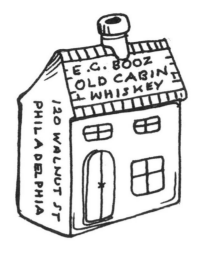

Flasks and Bottles

Knife Rests

Inkstand Dolphin Candlestick

Factory of Germany. The clocks were made by the Bonn factory and exported to the United States where they were fitted with Ansonia works. The factory mark incorporates the founding date of the firm, 1755, which should not be accepted as a date of manufacture since the majority of wares found in Royal Bonn are from the late nineteenth century. The china originating at the Bonn factory was hand-painted and often the wares were decorated with roses or floral motifs and enriched with gold. Royal Bonn values: Clock, floral decor, Ansonia works, medium size, $150; Cracker Jar, pink roses, gold decor, $54; Vase, portrait with flowers, 16" high, $77.

ROYAL COPENHAGEN

Collectors are familiar with the three wavy lines in underglaze blue signifying the three waterways through Denmark, the factory mark on wares from the Royal Copenhagen firm. The firm was established in the 1770s by F. H. Muller and enjoyed world wide recognition during the 1800s. The company was noted for its magnificent figures and the Far Eastern influence may be found in their late nineteenth century wares. The first limited-edition Christmas plate from the Royal Copenhagen Company was issued in 1908. Royal Copenhagen values: Chocolate Pot, blue and white, circa 1880, $72; Cup and Saucer, blue floral, $33; Teapot, blue and white, $69.

ROYAL FLEMISH

The Mt. Washington Glass Company of New Bedford, Massachusetts, advertised this distinctive satin glass in 1889. A patent was not granted to the firm for Royal Flemish until 1894. A beige or brown enamel was applied to the matte finish surface of each piece, the design being formed in raised gold outlines. Oriental motifs were favored as were gold dragons and medallions on beige, brown and gold grounds. The trademark of an *RF* monogram within a diamond-shaped figure appeared on this satin glass of the 1880s and 1890s. Royal Flemish values: Cookie Jar, Mt. Washington Gold coin medallion, silver top and handles, $1,000; Pitcher, $1,050.

ROYAL RUDOLSTADT

Lovely egg-shell porcelains were imported to the United States from Rudolstadt, Germany, in the closing decades of the nineteenth century.

Rudolstadt had been the site of an important faience factory since the eighteenth century. L. Straus and Sons began operating a porcelain factory primarily for export wares in the 1880s. Vases, pitchers, figurines, trays, lamps and other decorative accessories in pastel colors and floral motifs were embellished with liberal amounts of gold trim. The varying marks often incorporated the Schwarzburg Coat of Arms and the initials *RW* enclosed within a diamond. *Tip:* The initials *RW* on Royal Rudolstadt wares should not be mistaken for wares from the Royal Worcester firm. Royal Rudolstadt values: Hatpin Holder, pastel florals, $28; Pitcher, flower sprigs, roses, $72; Vase, floral motif with gold, cream ground, 12″, $140.

R. S. PRUSSIA

Beautiful porcelains by the Brothers Erdmann and Reinholdt Schlegemilch were exported from Germany in the latter part of the 1800s. The factory mark was a wreath enclosing the letters *R.S.* and the word *Prussia* below. A red star on a piece of R.S. Prussia is thought to denote a piece of superior quality. Floral motifs dominate the designs. Hand-painted R.S. Prussia wares have skyrocketed in price as dealer and collector activity has been brisk on all marked pieces. *Tip:* The ware is currently being reproduced and therefore caution is advised. R.S. Prussia values: Bowl, green and white florals, 10″ diameter, $72; Cake plate, handled, floral motif, $95; Chocolate Pot, floral, $85; Hat Pin Holder, green and white floral, $74.

RUBINA GLASS

This type of transparent shaded glassware was made by George Duncan & Sons of Pittsburgh, Pennsylvania during the 1880s. Rubina crystal shades from clear to ruby and some pieces were given a frosted effect to enhance the overall appearance. The ware was made in patterns including hobnail, inverted thumbprint and diamond-quilted designs, with some pieces having enameled decoration. Rubina Verde was a similar ware shading from yellow at the base to red at the top. Rubina and Rubina Verde are two of the lesser known types of American art glass, attracting the attention of glass connoisseurs. Rubina Glass values: Cruet, 7″ high, $88; Vase, Rubina, 7″ high, $60; Vase, Rubina Verde, 8″ high, $100; Water Pitcher, Rubina Verde, $220.

RUSSIAN PATTERN

Philip MacDonald patented this cut-glass pattern in 1892 for T. G. Hawkes Glass Company, Corning, New York. Based on the earlier star and hobnail pattern, the deeply-cut design features various size stars alternating with hobnails and a large center star. The pattern was ordered for the opening of the Russian Embassy in Washington in 1882, resulting in its being named Russian Pattern. President Grover Cleveland in 1886 requested a complete set of cut glass in the Russian pattern made for the White House. C. F. Dorflinger, another glasshouse, also produced the Russian cut-glass pattern. Russian Pattern values: Butter Dish, dome covered, 5″ round base, $130; Compote, 12″ high, $220; Perfume Bottle, silver top, $62.

RUSTIC CAST IRON

Since cast-iron furniture styles were becoming increasingly important between 1850 and 1900, most prominent cast-iron furniture makers added the rustic line to the endeavors. Realistic oak branches and leaves in irregular shapes adorned the backs and seats of chairs and settees. The rustic cast-iron leaves and branches blended with Nature's own leaves and branches and Victorian gardens flourished with this combination. *Tip:* Rusty rustic cast-iron furniture can often be acquired for substantially lower prices than pieces in excellent condition. Rustic Cast Iron values: Chair, $185; Settee, good condition, $240.

S

ST. NICHOLAS MAGAZINE

Mary Mapes Dodge was the capable editor of the dearly loved magazine for children, *St. Nicholas.* Under her guidance American children were able to read and become acquainted with some of the finest storytellers, poets, and illustrators. Some of these included Kipling, Burnett, Frances Hodgson, Palmer Cox and Arthur Rackham. They were a few of the talented people contributing their efforts to *St. Nicholas,* from 1873 and continuing into the 1920s, after the death of Mrs. Mapes in 1905. Eye catching woodcuts and the riddle section with hidden words,

charades and anagrams captivated the young subscribers. Bound volumes of *St. Nicholas* were presented as Christmas gifts to children. *St. Nicholas* value: Two bound volumes, 1882, $17.

SALEM ROCKER

The Salem Rocker is a variation of the Boston Rocker and originated in New England dating from the 1800s. The Salem rockers of the 1840s were smaller than the close-resembling Boston rockers, with flat seats and lower backs. Light straight spindles and a heavy top rail are two other distinguishing features of the Salem rocker. The arms and seat often had heavy scrolling and many had cane seats. The Salem rocker never received the popularity attended the Boston rocker. Salem Rocker values: Maple, refinished, circa 1840, $130; Rough condition, $68.

SALTGLAZE

This type of stoneware, having a thin glaze, dates from the 1700s. The glaze was accomplished by salt being placed in the kiln at the point of highest temperature. The vaporizing of the salt resulted in the surface of the finished piece becoming slightly pitted or bumpy. Potters gradually improved on earlier techniques and the saltglaze wares remained popular throughout the 1800s. It was made in a limited quantity in the United States after 1840. Various surface designs formed in the molds included basketweave, geometric, rope patterns and naturalistic motifs such as leaves, vines, stems, flowers and fruit. The majority of the wares were then left undecorated, relying solely on the surface design and shape for appeal. Saltglaze values: Jug, Julius Caesar, circa 1840, $95; Syrup Jug, basketweave design, pewter top, $72; Teapot, geometric design, circa 1870, $84.

SALTS

Salt dips, salt cellars, salt dishes, and eventually salt shakers around the 1860s, were tabletop indispensables. Pressed-glass salt dishes in both standard and whimsical shapes and in numerous patterns were made by many glasshouses. The salt dishes, footed or flat, round, rectangular or oval were made in clear, colored, opalescent and art glass and, during the 1880s and 1890s, in cut glass. Some porcelain china services came complete with twelve individual salt dishes as part of the set. Matching sets of salt and pepper shakers started replacing open salt dishes during

the 1870s. Salt Dish values: Art Glass Salt, footed and signed, $105; Cut glass, individual salt, $8.50; Camphor glass, duckling shape, $12.

SAMPLERS

A completed sampler is a tribute to the stitching skills and the perseverance of the maker, as young ladies rich and poor were encouraged to try their hand at a sampler project. Little girls of the Victorian Age were still using the alphabet, numerals and decorative borders found on earlier samplers. Later they became quite bold, attempting family portraits, depicting historical events, military campaigns, hobbies and other eye-catching motifs. The cross stitch was employed during the 1800s and colored wools combined to make samplers that displayed more individuality. A child's own home, school, or church was often pictured. No one ever allows a crooked row of alphabet letters or a miscalculation which might cause the letters to be bunched together at the end of a row to deter them from buying a sampler. The maker usually signed and dated the work and many samplers will also have the age of the child incorporated into the design. Prices are generally higher on the earlier samplers; however, those created by children during the Victorian period should not be neglected. *Tip:* An unfinished sampler may be the work of a young child who didn't live long enough to complete the piece. Sampler values: Alphabet with numbers trimmed with animals and flowers, 12″ x 13″, dated 1848, framed, $140; Religious theme 17″ x 18″ dated 1842, framed, $175.

SAND PICTURES

Georgian artists excelled in sand pictures and in the Victorian period it was practiced as a home art. Sand pictures were made from various colored sands procured from the Alum Bay on the Isle of Wight. The subject matter varied from primitive local subjects to copies of famous paintings. The colored sand permanently fixed to the canvas resembled a water color picture. There was a revival in Germany of this lost art during the 1880s and there is always the possibility of uncovering a sand picture signed by the artist and even dated. Sand Picture values: Framed, Pastoral scene, circa 1880, $125.

SANDWICH GLASS

The Boston and Sandwich Glass Factory of Sandwich, Massachusetts, was established in the 1820s and under the guidance of Deming

Jarves became one of the most notable glasshouses of the nineteenth century. During its long life the factory was responsible for a long list of distinguished wares and was a pioneer in mold blown and pressed glass as well as cut glass. The factory experimented with numerous types of glass throughout the years, and although relatively few marked specimens exist, attribution is possible as a result of intensive study and research. A partial list of the firm's diversified wares would include cup plates, pattern glass, lamps, dolphin candlesticks, art glass and the highly regarded Mary Gregory pieces. The factory operated between 1826 and 1888. Sandwich Glass values: Candlesticks, canary yellow, pair, $130; Pitcher, large, overshot, ruffled top, $180. Illustration on page 201.

SARGENT BELLS

The next time you attend a country auction, inspect that old cow bell for a label reading "Kentucky Cow Bell." When the bidding starts, be willing to go a bit higher as this is a prized bell from the Sargent Hardware Company of New Haven, Connecticut. Dating from the 1850s, this company concentrated on producing bells and cabinet hardware, and bell buffs barter briskly for their bell treasures. Sargent Bell value: Cow bell, $18.

SATIN GLASS

Satin glass is any opaque glass with a dull matte finish achieved by means of hydrofluoric acid vapor treatment. The usual white lining was given a pastel overlay in either a solid color or shaded effect and had a velvety finish. The quality varies and depends in part on the color, matte finish and decoration. The public responded to satin glass during the 1880s as it offered texture and coloring which had mass appeal and was made in tableware and ornamental items. Satin glass was often left undecorated, although some pieces were subject to painted, enameled or applied decoration. Mother-of-pearl, or Pearl Satin glass, Coralene, Crown Milano and Royal Flemish are among the different types of satin glass developed during the 1880s and 1890s with specific names. Satin Glass values: Bowl, deep rose, 6″ diameter, $145; Cracker Jar, deep rose, melon ribbed, $240; Rose Bowl, pink enamel decor, $90.

SAWTOOTH PATTERN

American glasshouses kept family dining tables well supplied with Sawtooth pressed-pattern glass during the 1800s. The earlier Sawtooth

pieces were heavier in weight and have a resonance when struck. They were made with applied handles. The wares made after the 1860s of the less expensive soda lime glass were somewhat inferior in quality; however, this never deters a collector who appreciates this fine pattern of pressed glass. The overall design of short points, or teeth, covering the entire surface is easy to recognize and was also known as Diamond, Mitre Diamond and Pineapple. The Sawtooth pattern has been extensively reproduced in both clear and milk glass. Sawtooth Pattern values: Celery, $34; Covered compote, 10″, $42; Tumbler, $17.

SCENIC PAPERWEIGHT

Affordable paperweights for the beginner collector are these mid and late Victorian paperweights featuring small prints. Between 1850 and 1870 the weights were usually circular and the clear glass domes acted as a magnifying glass to show the lovely colored scenes of everyday Victorian life. Equally desirable are those weights picturing exhibitions, buildings, animals and commemorative or souvenir scenes and often incorporating a bit of verse. Later scenic weights were made in a variety of shapes and by the 1890s the simple photograph type similar to postcard views became popular. Scenic Weight values: Centennial building, circa 1876, $40; Prudential Building, late, $22.50.

SCHOOLMASTER'S DESK

Rarely made by city cabinetmakers, this type of desk enjoyed popularity in schools and offices and was usually made of pine or other soft woods. There was a concealed storage area under the lift top lid. Schoolmasters' desks usually had only one drawer and those designated for school use can be identified by the series of grooves in the desk for writing necessities. The overall dimensions are somewhat larger than that of a standard child's desk and the longer legs enable you to differentiate between the two. Schoolmaster's Desk values: Kneehole-type, side compartments, walnut, rough condition, $200; Pine, refinished, circa 1870, $240; Pine, rough condition, $150. Illustration on page 21.

SCHOOL READERS

The leading school reader of the 1800s was the *McGuffey Reader*. Next was the *Goodrich School Reader* published by Peter Parley and

well received by eager school youngsters in the pre-Civil War days. George Saudres published five readers between 1838 and 1860 containing instructional material and stories that remained popular until the end of the century. During the second half of the 1800s, the *Lyman Cobb Juvenile Reader* appeared and this has been gathering attention from antique buffs. School readers differed from purely instructional manuals as their content included poems, stories, pictures and other childhood lure. School Reader value: Early School Reader, circa 1845, $10.

SCRAPBOOKS

Pasted patchwork quilts, Victorian scrapbooks are really memory books from a century ago. The scrapbook was an important part of Victorian life and concealed between the often bulging pages were chronicled the life and times of the era. Holiday greeting cards were intermingled with scrap pictures imported from Germany and trade cards from the shop around the corner. Valentines and love tokens, friendship cards, and visiting cards, were not placed, but rather artistically arranged in a pleasing manner on every page. Proudly pasted in a scrapbook were the Reward of Merit cards, and surprises await you when you find a hidden name card. Toward the latter part of the 1800s the postcard covered precious scrapbook space along with cigar bands and cigar box labels. You can expect to find the unexpected when you leaf through the pages of a Victorian scrapbook. Scrapbook values: Scrapbook, assorted trade cards, valentines and scrap pictures, 16 pages, $45.

SCRATCH BLUE

This is a version of the age-old sgraffito technique employed during the seventeenth century on blue and other colors. The method of decoration was achieved by incising the design into the soft clay after which blue pigment was applied to the incised areas. The technique was revived with notable success by the talented artists employed by the Doulton firm, such as Hannah Barlow, in the 1870s. The Doulton artists followed the same methods used on the earlier stoneware, except they favored brown or black pigments rather than blue. The Barlow animal studies are excellent examples of the scratch work technique and bear the artist's monogram along with Doulton trademarks. Scratch Blue values: Barlow Vase, stoneware, Doulton, 10″, circa 1885, $170.

SCREENS

Ornamental screens of various sizes graced the rooms of most Victorian dwellings. They served several purposes aside from being conversation pieces as they helped to eliminate drafts as well as protect against the heat of the fire. The seeker may encounter floor screens, chair screens as well as hand screens. A round, oval or rectangular screen was available on a pole that could be adjusted for height. The screens from a century ago are strikingly attractive, as many had beautiful Japanned panels as well as needlework designs and effects in brilliant rich silks. Those in good condition find immediate buyers. Those requiring minor restoration, priced accordingly, are also promptly purchased as the demand for Victorian vintage screens never decreases. Screen values: Fire Screen, carved oak, needlepoint design, $350; Three-fold Regency, nineteenth century, 6' high, $300.

SEAWEED CRAFTS

Queen Victoria was said to have created a complete seaweed album. Needless to say, other young ladies swiftly responded and soggy seaweed was carefully preserved into lasting craft endeavors. Dried seaweed was pasted in intricate and interesting designs on sheets of thin paper. The individual sheets were then joined together to form an album. The fancy front and back covers were skillfully cut out in a manner to simulate two fan-shaped seashells. Seaweed pictures having lithographed harbor, seaside or water scenes were accomplished by having the subject matter encircled with a wreath of seaweed rising majestically from a basket or vase. The picture was then placed in an appropriate frame. Seaweed values: Album, six pages, circa 1845, $37; Framed picture, lighthouse coastal scene, above basket, shadow box frame, 14" x 18", good condition, $75.

SETTEES

Wooden settees of the 1800s closely followed painted chair styles and ranged in size from three to seven feet in length. They were made by chair shops and furniture factories and the underside of the seat may have the maker's name. Those with seats of wood were always made from one single piece of wood. Rush seats were also popular on settees. They were painted brown, black or dark green and fancier versions had

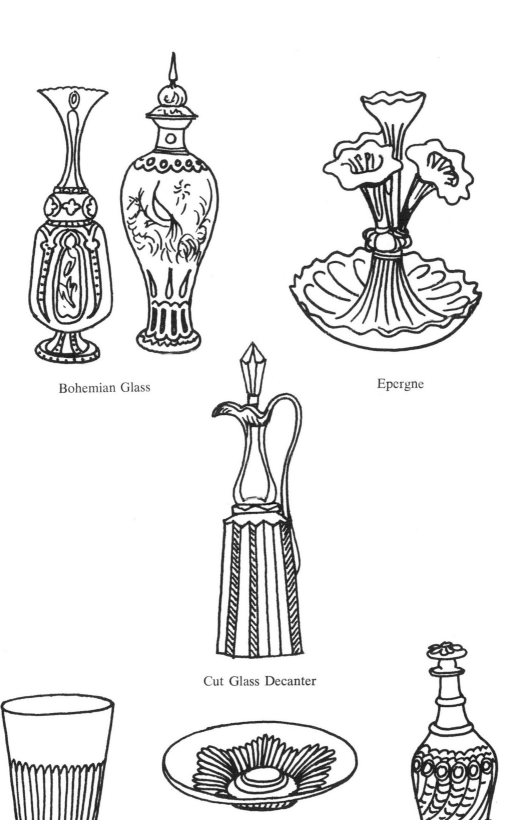

Bohemian Glass

Epcrgne

Cut Glass Decanter

Sandwich Glass

the addition of stencil decoration on the crest rail in fruit or floral motifs. The base paint and other decoration varied with the maker. However, gilt and bronze trim on turnings of legs and stretchers was prevalent. An improbable but not impossible find would be a settee on rockers or with one front end fenced off for use as a cradle. Settee values: Maple, painted brown, good stencil decoration, circa 1860, 6' long, $365; Settee, pine seat, rough condition, circa 1880, $250.

SEWING BIRDS

Metal bird forms with the necessary attachments to clamp to a table or stand were introduced in the eighteenth century. Victorian sewers found them indispensable as their spring mechanism kept one end of the fabric being sewn taut. Sewing birds were usually made of brass. plated silver, iron and other metals and many types came with a bright velvet covered pincushion nested on their back. Rarer examples may be found in scrimshaw and these sewing aids were perched upon work tables and sewing machines to aid in the sewing chores. Sewing Bird values: Brass sewing bird, $40; Iron bird, $32.

SEWING BOX

Victorian women were indefatigable sewers and the sewing box was never out of reach. The majority were wood, although some were made of tin. Most were brightly decorated. The interior was lined with paper or fabric and fitted with a small shallow tray which held the sewing necessities. This removeable tray concealed a storage area below for bulkier materials and was divided into various compartments. The sewing or work box was generally of a hard wood with inlay of veneer. Simpler ones were made from available woods and all were portable. Sewing Box values: Mahogany inlay work, circa 1865, $75.

SEWING DOLLS

Designed to hold various sewing paraphernalia these sewing dolls were featured in *Godey's Lady's Magazine* and *Peterson's Magazine,* both of which gave instructions for making your own sewing companion. The pockets of the doll's dress were made to hold scissors, buttons, thimbles, thread and other sewing tidbits. They were sometimes used as a sewing pincushion acting as a holder for easily misplaced accessories. Young ladies of the day were tempted to try a sewing project by the

presentation of a sewing doll. The sewing dolls were dressed in the prevailing fashions and this may be a guide to dating. Sewing Doll value: All original, 12″ tall, circa 1865, $65.

SEWING TABLE

The work table evolved around the 1700s and became a standard piece of furniture in a lady's sitting room. The basic style had a lift top and a lower compartment or suspended pouch to hold sewing necessities and was adapted to various Victorian furniture styles. Some work tables were made with one or more drawers and a suspended work bag. They were made in a variety of woods and tended to follow existing furniture forms. They were generally fitted with a lock. The Martha Washington sewing table was so named because she supposedly owned one of this type. This oval-shaped sewing table, mounted either on four legs or on a pedestal tripod and reeded to resemble tambour, was usually covered with pleated silk and proved to be continually popular. Sewing Table values: Victorian rosewood, good condition, circa 1850, $220; Victorian pedestal base sewing table, circa 1860, mahogany, good condition, $200.

SHAKER FURNITURE

The Shakers exhibited an individuality in their furniture of the nineteenth century when their pieces are viewed alongside the elegant ornamentation found on most Victorian furniture. Their plain, simple, functional designs are easily recognized by fine quality workmanship in evidence on every piece. The lightweight furniture was made of light colored woods such as pine, maple, birch, cherry and others. The earliest chairs were painted red, while later they were given a light stain. The seats were rush or cane and later woven tape seats were favored. A complete line of furniture was made by Shakers in their self-supporting communities and sold to people outside their settlements. During the 1870s illustrated catalogs appeared showing Shaker furniture designs. There were slight changes noticeable in this later output of commercially made furniture. Shaker Furniture values: Chair, ladderback, rock maple with caned seat, refinished, $140; Slant Top Desk, $375.

SHAVING MUGS

Gentlemen of the late Victorian period had their own personalized shaving mugs kept on hand for them at the local tonsorial. They were

custom designed for the individual with name or initials and pictures showing the occupation or fraternal organization of the owner. Everyone from hardware clerk to harness maker participated in this shaving mug status symbol game. Cherished are the mugs depicting such occupations as dentist, prize fighter, undertaker, baseball player or any occupation no longer in existence, including marble cutter, blacksmith or horse-and-buggy driver. There were also glass shaving mugs and, of course, just plain china mugs with typical floral motifs. The shaving mugs found in antique shops today date from the mug mania of the 1870–1900 period. Shaving Mug values: Baseball Player, $145; Butcher Store, $84; Locomotive, $92. Illustration on page 141.

SHAVING STAND

The shaving stand was designed expressly for the gentleman of the house to stand in front of while shaving and ranged in size up to six feet in height. The standing shaving stand had an oval or rectangular mirror fitted into a cabinet base. It had one or more drawers and was supported by either long legs or a pedestal. The mirrors were often adjustable and the overall style varied in an effort to blend with existing furniture. Small marble tops covered the cabinet portion on shaving stands made later in the century. Bureau top shaving stands were also made with a mirror mounted on a shallow one drawer chest. By placing the small stand on a bureau or high chest, it was the perfect height for a gentleman to stand in front of while shaving. Shaving Stand values: Walnut, 6′, adjustable mirror, good condition, circa 1860, $260; Dresser type, oak, oval mirror, one drawer, circa 1870, $135.

SHEFFIELD SILVER

The making of Sheffield silver declined during the 1840s and within a few short years it became a collector's item. Thomas Boulsover discovered the method for producing this hand-rolled silver on copper about 1742. Sheffield silver consists of two pieces of silver bounded to one of copper; the edges also bound in silver. Silver pieces were duplicated in Sheffield and it was a thriving industry for about one hundred years. Sheffield was heavily used and often the reddish copper base will show. This patina or worn effect is appreciated by collectors. *Tip:* Never resilver any piece of antique Sheffield. Sheffield values: Coffee Pot, circa

1840, large size, $195; Gravy Boat, circa 1845, $120; Tea Urn, ornate, circa 1840, $355.

SHELL AND TASSEL PATTERN

The Shell and Tassel pattern of pressed glass is available in both a square and round shape. The square shape is the earliest, being registered by George Duncan and Sons of Pittsburgh, Pennsylvania in the early 1880s. The square shape has frosted effects with shells and ornaments covering most of the body. Finials on the covered pieces have a double scallop shell. The round version appeared later by the same firm in clear glass with gilt or silver shells or in reverse with the body in gilt and the shells clear. The finials on the round shell and tassel have a reclining dog figure. This version pictures the Tree of Life pattern on the shells and most pieces have four shells. Shell and Tassel Pattern values: Butter Dish, round, $36; Square, $48; Celery, round, $30; Square, $38; Creamer, round $23; Square, $27.

SHELLWORK

Shells gathered on a family outing to the seashore were transformed with skill and patience into a variety of fancy handiwork items. The collected shells were further enhanced by exotic store-bought shells to create lasting ornaments. Pictures were framed, usually in a shadowbox frame, and were combined with a bit of dried seaweed for a truly nautical look. Handsome mantel and table pieces were made by assembling tall bouquets of shell flowers in vases. These were then protected from the elements and tiny fingers by encasing them in glass domes. Small trinket boxes were made as well as hair ornaments using tiny rice shells that came from the West Indies. Shellwork values: Hand mirror with shell design, $24; Jewel box, 6" x 9", $20; Large intricate floral arrangement under glass dome, 24" high, $150.

SIDEBOARD

The sideboard was a dining room piece for storage and serving, introduced in America during the 1780s in the Hepplewhite style. By the 1840s sideboards were generally the work of small cabinetmakers and early examples were the continuation of the short American Empire sideboard, but possessed Victorian details. The Gothic sideboard, with pronounced Gothic details, graced dining rooms between 1840 and 1855.

The elaborate arched pediment over the completely closed base was developed in the Renaissance Revival sideboards of the 1860s, often with a marble top. Elizabethan sideboards resembling buffets of carved oak appeared in the 1860s and 1870s. Other sideboards reflected the French Revival styles. By the Eastlake period the sideboard became more compact and was made with limited decorative details. Backs and mirrors on sideboards came into fashion with the reign of Queen Victoria and the sideboards of the period reign as magnificent architectural wonders. Sideboard values: Eastlake Sideboard, black walnut, refinished, circa 1875, $575; Gothic Sideboard, rosewood, circa 1850, $600; Renaissance Break Front Sideboard, black walnut, fair condition, $500.

SIDE CHAIRS

Victorian side chairs are in demand and sell quickly whenever they are offered for sale. The range of styles is wide and varied and in general this term refers to the fancy chairs of all types without arms. They are light and portable and some reflect excellent workmanship. Treasured are the side chairs in the Rococo Revival styles with naturalistic carvings of flowers, fruit and foliage. They are comfortable and sturdy with upholstered or needlepoint covered seats and may be found in a variety of woods. The side chairs with caned or solid seats, usually considered country pieces, are very saleable. Side chairs may be found singly or in pairs and less often in sets of four and six. Side Chair values: Rococo design, upholstered seat, circa 1865, $140; Spool-turned Gothic Side Chair, walnut, upholstered seat, circa 1855, $180.

SILVER

The silver industry flourished in America during the Victorian era and the designs followed the currently prevailing furniture styles. Both bore French and English revival characteristics. Repoussé decoration was prevalent during the Rococo Revival of the middle 1800s and the Elizabethan influence dominated silver designs in the 1860s. Silver became more ornate and elaborate as the century progressed and storytelling silver captivated visitors to the Philadelphia Centennial in 1876 by depicting the history of the United States in silver forms. Silver holloware pieces were treated to the latest techniques developed by their illustrious makers, such as cast reliefs, matting, burnishing and chased and engraved methods of decoration, along with oxidation and parcel

gilt, embellished the surface of silver. The Japanese influence, with its naturalistic styling, remained enduringly popular. Silver flatware gained momentum during the second half of the nineteenth century and a patent date indicates when the pattern was first produced. American silver was clearly marked with the maker's trademark and the quality of the silver, which provides accurate and reliable identification. Silver values: Demitasse Spoons, sterling embossed gilt bowls, set of six, $85; Place Setting, four pieces sterling, ornate pattern, $55. Illustrations on page 171.

SILVER DEPOSIT

This silver overlay technique which could be employed on clear and colored glass was accomplished by the silver being deposited by means of electroplating to a previously applied design. Naturalistic openwork motifs were effective against the clear or colored ground; dark green, red and blue were favored. The Alvin Manufacturing Company of Rhode Island, and other American glasshouses made silver-deposit glass during the 1880s and for several decades thereafter. Silver-deposit glass articles of the 1890s were dominated by free form naturalistic Art Nouveau forms. Silver Deposit Glass values: Bon Bon Dish, 5" diameter, $55; Plate, floral, 7" diameter, $28; Vase, 7" high, $32.

SILVER PLATE

The process of electroplating silver was widely adapted in the United States after 1840. This method of depositing silver on a base metal such as Britannia, copper or white metal was relatively inexpensive and manufacturers could duplicate solid silver pieces for a fraction of the cost. Plated silver was within the means of the masses and became closely associated with the Victorian Age. The same firms engaged in producing sterling silver made silverplated wares and tableware items of every type were marketed. Most Victorian silverplate was marked with the maker's trademark and a clue to the quality such as triple or quadruple plate. Prior to 1860 the mark appeared on a disk soldered on the base of the piece. After this date it was placed directly on the base. Victorian silverplate values are determined by the condition and the base metal and any piece in poor condition can be resilvered. Silverplate values: Basket, resilvered, 12", $48; Teapot, some ornamentation, 14" high, $100.

SKATES

Importers of ice skates became concerned around the 1840s when American firms pursued a piece of this lucrative market. Dutch children had introduced ice skating to America in the seventeenth century and large quantities of ice skates were imported from Holland. T. A. Williams, Winslow Skate Company, Union Hardware, and Coe and Shiffin were American-based firms trying to cut a figure, financially, in the ice skate business. There were many name skates and many companies made both ice and roller skates. Among the leading roller skate firms were Plimton of Brooklyn and the Crown Roller Skate Company, who kept their skates rolling out of their plants into roller rinks the country over. Skate values: Child's ice skates, circa 1880, four short blades, some rust, original leather straps, $12.

SKELETON CLOCKS

The public viewed these masterpieces encased in glass domes at the London Exhibition in 1851 and immediately skeleton clocks were gracing marble tops and mantels everywhere. The clock mechanism was clearly visible at all times, protected from the elements by being fitted under a glass dome. Skeleton clocks were soon pictured in clockmakers' catalogs during the 1850s and 1860s. Future generations of clockmakers received their initial apprenticeship with an explanation of the exposed movements by an ever-patient father. Skeleton Clock values: 14″ high, under dome, circa 1860, $330.

SLEDS

Early in the nineteenth century sleds were generally homemade, but by the 1840s they were being produced by Crandall's and other manufacturers. Trade names such as Teaser, Boston Clipper, Snow King and Maine Clipper were given to various sleds by their makers. Hand-painted wooden sleds with wooden runners were gradually replaced by fancier types having slender runners, handsomely decorated. Horses, flowers, landscapes, the name of the owner and a date were often painted on a sled. Children's magazines of the 1880s and 1890s offered sleds as premiums for subscriptions. The first steering sled, "The Flexible Flyer," appeared in 1889. The original paint should always be left untouched to retain the value of an antique sled. Sled values: Early 1840, original

paint, fair condition, $95; Fancy type, large, painted, floral decor, dated 1864, good condition, $170. Illustration on page 211.

SLEEPY HOLLOW CHAIR

This upholstered version of the European Gondola chair became popular in America between 1850 and 1870. The American name was derived from the chair being a particular favorite with Washington Irving, author of "The Legend of Sleepy Hollow." The chair followed the lines of the earlier side chair of the Empire period having a semi-circular arched, boldly concaved back, and conforming finger molded frame. The deep upholstered seat was U-shaped and black horsehair was the typical upholstery. The Sleepy Hollow chair was also made as a rocking chair with slightly shorter legs mounted on curved rockers. *Tip:* The chairs were fitted with socket casters and although the casters may be missing the holes should be apparent. Sleepy Hollow Chair values: Black horsehair upholstery, rosewood, good condition, circa 1860, $430.

SLEIGH BED

This descriptive term was used for an Empire-style bed with head and footboard of equal height and the outward curvature being similar to a sleigh. Sleigh beds were small in size and were placed with the long side against the wall and a draped canopy hung over the piece, frequently very elaborate. Cabinetmakers and early furniture factories produced sleigh beds, generally using mahogany, rosewood or pine. Beds resembling sleighs or horse drawn cutters continued being popular into the 1840s. Sleigh Bed values: Rosewood, refinished, circa 1845, $425; Rosewood, rough condition, circa 1845, $250. Illustration on page 83.

SLEIGH BELLS

Sleigh bells ring and collectors listen for the superior sound of the brass bells which are preferred over the iron examples. The bells were attached to the harness for precautionary measures and enjoyment during a winter sleigh ride. The sound of the bells warned other travelers of an approaching sleigh. The majority of bells were ball-shaped although some were bell-shaped. Some firms made them in up to twenty different sizes ranging from just under an inch in diameter to three-and-a-half inches or more. The bells were usually attached to a leather strap by means of staples or cotter pins. The quality of the bells and the quality

of the leather strap determined the value then just as it does today. Sleigh Bell values: 30 bells graduated sizes in brass riveted on leather strap, $130; 36 bells in iron on strap, $95.

SLIPPER CHAIR

A small upholstered chair, the Slipper Chair was introduced in the Queen Anne period primarily as a bedroom piece. Aptly named, the chair was in constant use by the lady of the house to facilitate the operation of getting in and out of footwear. The low straight back chair without arms had an upholstered seat and back and the style varied slightly, being influenced by prevailing furniture trends throughout the 1800s. The finer slipper chairs were the work of cabinetmakers and those with rococo styling may have finger rolled carving. Slipper Chair values: Rococo style, upholstered with finger-carved molding, original, good condition, circa 1860, $245; Upholstered back and seat, Burgundy velvet, circa 1870, $200.

SLIPPERS

Boots, shoes and slippers walked out of American glasshouses onto what-not shelves with amazing regularity between 1850 and 1900. A number were made as end-of-day pieces by factory workers and some were intended for use as toothpick holders, perfume bottles, shakers and jiggers. The majority of slippers and shoes were made of pressed glass with the Daisy and Button design being the frontrunner. They were also hand blown and over the years were made in clear and colored glass of every description. A collector would never walk away from a lady's highbutton shoe, baby's shoe, man's boot, or even those shoes and slippers on skates. The variety of glass shoes and slippers made in the nineteenth century would certainly stock a bootery. Slipper values: Blue Glass Slipper, turned up toe, 7″ long, $14; Daisy and Button Green Glass Slipper, $12.

SLIPPER STOOLS

Small stools approximately sixteen inches high on legs, the slipper stool had a top compartment under the lid for storing slippers. The stools were usually upholstered and the storage area beneath the lid was large enough to accommodate footwear. Fancy needlework designs in floral and fruit motifs were popular and changes in style occurred to reflect the

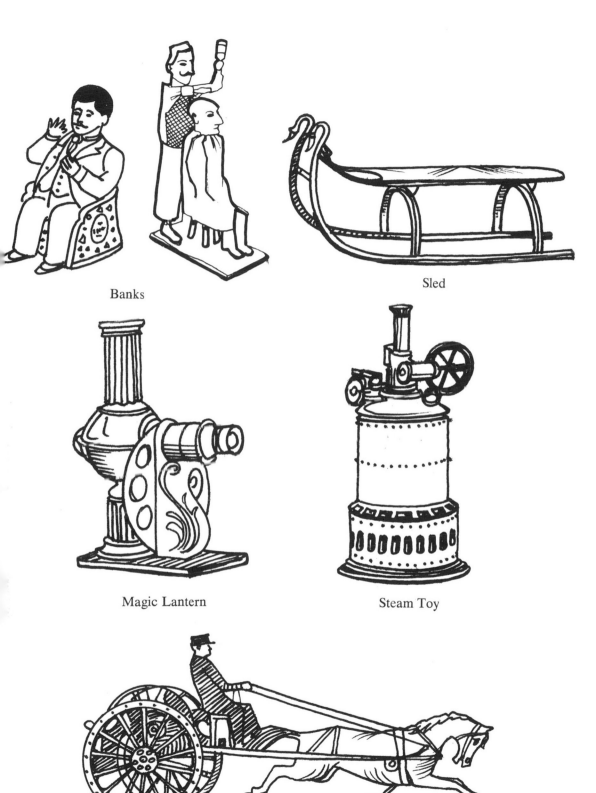

Banks

Sled

Magic Lantern

Steam Toy

Iron Toy

currently prevailing furniture innovations. The Eastlake slipper stool of the 1870s was factory produced of black walnut or ebonized maple, usually with trestle shaped legs. The slipper stool served a dual purpose, being both a stool and a slipper holder. Slipper Stool values: Eastlake Slipper Stool, black walnut, tapestry top, circa 1875, $80; Empire Footstool, needlework top, mahogany, circa 1840, $90.

SNAIL PATTERN

George Duncan and Sons of Pennsylvania marketed the Snail pattern of pressed glass in the 1880s. The pattern was almost plain with large areas left open for engraved or etched decoration. A number of pieces have an engraved floral spray on this portion of the piece. The pattern name is derived from the embossed band of uniformly tight spirals running around each piece, suggestive of a group of slow moving snails. Collectors move at a brisker pace when a Snail glass treasure moves into view. Snail Glass values: Creamer, small, $18; Celery, $27; Finger Bowl, $18; Syrup jug, $34; Tumbler, $9.

SNOW WEIGHT

Tilting the weight caused a shower of snow to fall on the scene enclosed within the glass. Snow weights were developed in France around the 1850s and were originally sold as toys for children. Antique snow weights dating from the Victorian era had bases of china or marble. The new weights usually have plastic or wooden bases. Snowstorm after snowstorm swirled up in the old weights and their heavy usage should result in some signs of wear. Snow Weight value: Early weight with pottery base, $35.

SOAPSTONE

This easily-carved mineral called steatite is more commonly known as potstone. The stone is greasy to the touch and available in a variety of colors such as green, reddish brown, yellow and light grey, alone and in combinations. Soapstone was extremely versatile and figurines, cooking vessels, vases, griddles, table tops and even parlor stoves were made from it during the 1800s. Carved soapstone figures and ornaments marked "China" indicate a date of production subsequent to 1891. Soapstone values: Chicken, 6″ high, $32; Match Holder, birds, $24; Vase, high vines and leaves, 10″ high, $34.

SOLAR LAMP

Cornelius and Company of Philadelphia, one of America's foremost lamp manufacturing concerns, patented this lard oil burning lamp in 1843. The typical type had a brass standard on a marble base with white or colored shades and cut prisms. The shades were often cut in a floral motif. The Solar lamp eliminated the smoke and smell prevalent on earlier lamps which burned coarse oils. Other lamp firms improved upon the basic design of the Solar lamp as the century progressed. The Cornelius factory mark and the patent date may be found on prized examples. Solar Lamp values: Brass, marble base, cut shade, prisms, 18″ high, good condition, $245.

SONG SHEETS

Attack the attic and perhaps you will discover a pile of dusty old song sheets from the 1800s. Totally worthless? Totally wrong! Song sheets dating prior to 1900 are in demand particularly those featuring famous theatrical personalities, military, political or sport subjects, early modes of transportation or Gibson girls. The style of printing, subject matter, rarity of the song are the contributing factors in determining value. Song sheets related to the Civil War bring attractive prices with Confederate material slightly rarer than the Northern subjects. The early lithographed song sheets with engaging covers stir both musical memories and moderate monetary rewards. Song Sheet values: "Give This to Mother," H. Waters, New York, 1864, $10; "Old Folks at Home," Firth, Pond and Co., N.Y., 1853, $15; "The Soldiers Home," St. Gordon, N.Y. 1863, $6.

SOUVENIR SPOONS

Souvenir-loving Victorians of the 1880s and 1890s satisfied their collecting urges by acquiring various spoons, decorated as mementos of famous people, places and events. The spoons were usually sterling silver rather than silver plate and fancier ones had handles enriched with enamels and bowls of vermeil. There are many interesting categories and the field is broad enough to permit a collector to specialize. Fair and exposition spoons offer exciting rewards. There are city and state spoons, Presidential and historical spoons, personality and landmark spoons to mention a few. Souvenir spoons are ideal for collectors working with

both limited space and capital. Souvenir Spoon values: Return of Columbus, 1893, $12; Queen Victoria, Canada, 1891, $14; Zodiac, February, Sterling, $11.

SPANGLE GLASS

This type of glass is multi-colored, similar to spatter glass, but with an addition of flakes or spangles obtained from a lustrous metal. The streaks or spangles of mica or silver or gold and colored bits of glass combine to give this ware a striking appearance. Spangle is usually cased with a clear or white lining of glass which may vary depending on the particular glasshouse involved. The effect was achieved against both dark and light colored backgrounds and was often accompanied by the addition of applied decoration. Clear glass handles are a characteristic of spangle glass. It was made in America and Europe mainly between 1880 and 1900. Spangle Glass values: Barber Bottle, multi-colored, $64; Finger Bowl, circa 1890, $32; Tumbler, multi-colored, $34.

SPATTER GLASS

A multi-colored art glass, Spatter glass was made in America and Europe between 1880 and 1900. This glass is also known as End of Day glass, a term originating from workmen mixing bits of leftover colored glass from the day's production into various decorative objects. The glass was a commercial product in some glasshouses and a patent was granted to produce Spatter in the 1880s. Spatter also resembles spangle glass but is made without the metallic flakes. Spatter Glass values: Slipper, multi-colored, $37; Syrup jug, multi-colored, $72; Vase, multicolored, 10" high, $70.

SPATTERWORK

Every Sunday parlor was certain to boast at least one accomplishment in the art of spatterwork. Pressed leaves, flowers and ferns along with appropriate cutout paper shapes were carefully arranged in a graceful composition. The completed arrangement was then given a fine spray of India ink which was applied to a toothbrush and brushed over a wire screen which covered the prearranged design. When the ink had dried the pinned pieces were then lifted from their base and this resulted in a clearly defined silhouette on a shaded background. Spatterwork pictures became wall adornments and the technique proved interesting on lam-

brequins, screens, curtains, lampshades and other decorative objects. Spatterwork value: Pine frame, 10″ x 12″ spatterwork example, circa 1865, $45.

SPICE BOX

Kitchen shelves supported spice boxes and chests ranging in size from six to twenty-six inches in height. Any spice container with anywhere from six to twelve drawers was known as a spice chest. Occasionally a spice chest was a custom-made replica of a larger household chest. The finest examples may be dated or initialed and prized are those with painted or carved details. A spice chest is often distinctly regional in design, making attribution to a particular area possible. Spice chests were made from a variety of woods including oak, maple, cherry and walnut. The tin spice containers made for home or store use are also collectible. Spice Box values: Walnut, twelve drawers, porcelain knobs, circa 1870, $135; Oak, eight drawers, refinished, $85.

SPINET PIANO

The spinet piano pre-dates the square piano and was fashionable in the United States from the 1820s through until the 1850s. Details after 1840 include the lyre shaped pedestal frame as well as the open work scrolled music rack, along with wavy bands of molding. The over-all design resembled the melodeon, except that the spinet piano keyboard flap was deeper. They were made with five octave keyboards, usually of mahogany or rosewood, veneered on pine. Early spinet pianos are scarce, despite the fact that parlors of music-loving Victorians were incomplete without a piano. Spinet Piano values: Rosewood veneered, good condition, circa 1850, $750.

SPINNING WHEELS

Rural homemakers found the spinning wheel an indispensable item throughout the nineteenth century. Those out of touch with the latest Victorian commodities could make yarn or thread on these hand- or foot-powered necessities. The construction when intended for home use usually featured turned parts. Simplicity of style is generally found on American examples of spinning wheels. Spinning Wheel values: Complete and refinished, $160; Smaller size complete, but in rough condition, $120.

SPODES TOWER

A dinnerware pattern dating from the late eighteenth century, the design based on a drawing of the estate of Josiah Spode. The central picture of an English pastoral scene was first issued by the Spode factory, printed in blue and maroon. There were numerous revivals during the 1800s and by the 1890s advertisements proclaimed that Spodes Tower was having a "centennary revival." All antique pieces made prior to 1900 have the greatest worth. The factory mark on the underside should settle any dispute pertaining to the age and origin of the enduringly popular Spode's Tower. Spode's Tower values: Bowl, blue, circa 1840, 9″, $42; Cup and Saucer, circa 1895, $12; Soup Plate, circa 1845, $15.

SPONGE WARE

Staffordshire potters produced this inexpensive Sponge ware for the American trade between 1820 and 1850. It is also known as spatter-ware. Tableware items and other utilitarian pieces were daubed with a sponge covered with paint. The sponged borders were usually of red, brown, yellow, black or green. The center designs included tulip, school-house, peafowl, eagle, flower, star and other motifs. Later in the century printed designs were used on spongeware pieces and early examples often show the three kiln marks on the underside. *Tip:* Reproductions exist without the presence of the kiln marks. Sponge Ware values: Cup and Saucer, green peafowl, $137; Pitcher, Tulip, blue border, $210; Plate, Star, yellow border, 8″ diameter, $165.

SPOOL FURNITURE

Spool furniture was developed in the early 1800s when new machinery enabled cabinetmakers to make elaborate turnings on wood. Long straight lengths of turnings in a manner resembling a string of spools was applied to various household furniture. Spool furniture reached its height of popularity between 1840 and 1880, when furniture factories mass produced this country-furniture style. After 1850 rounded corners appeared on spool furniture pieces adding to its overall attractiveness. The Elizabethan influence dominated spool furniture, which was known for its durability and light weight. An assortment of woods were employed in the making of spool furniture with many pieces being stained or painted. Spool Furniture values: Armchair, black walnut,

leather seat, circa 1850, $240; Side table, refinished, maple, circa 1860, $125.

SPOONER

A receptacle for holding spoons, the spooner was popular during the 1800s. Spooners were made in numerous pressed glass patterns of the nineteenth century and bargains exist as they are overlooked by the majority of collectors. They have not been reproduced and a novice should consider their acquisition as a possible field for researching antique glass, thereby avoiding the confusion surrounding reproductions. Silver company catalogs featured ornate and intricate spooners of silver plate in the closing decades of the century. There were many variations including the sugar bowl/spooner combination, where the spoons hung from grooves or clips around the outer rim. Flat pressed and cut-glass spooners adorned tables by the 1890s. Spooner values: Fuchsia pattern glass, $20; Purple slag, footed spooner, $52; Silver plated, quadruple plate, resilvered, circa 1880, $27; Tray type, cut glass, circa 1890, $42.

SPRINGERLE BOARDS

Holiday cookies, particularly those of Swiss or German origin, received their fancy taste-tempting designs from carved springerle boards. One board was capable of pressing anywhere from six to twenty-four cookies at a time. The wood was finely grained and the carving sharp and decisive. The squares had different subjects with fruit, flowers, toys, animals, figures, houses and pagodas being enduringly popular. Springerle Board values: Large size, good condition, different subjects each square, $45; Small size, twelve squares, circa 1860, $24.

SQUARE PIANO

Prominent American piano manufacturers were busy supplying square pianos to musically inclined families between 1850 and 1880. Most were clearly marked with the maker's name, which provides quick and accurate identification. The square piano post dates the spinet piano and had a rectangular fold-over top, the front corners were square or rounded, and there was a deep keyboard flap. The heavier legs were a necessity due to the cast iron frame in the movement, which increased the weight of the case considerably. A typical case was of rosewood or mahogany, veneered on pine. Many square pianos were made with six octave keyboards from piano firms such as Jonas Chickering of Boston.

Abraham Lincoln played a square piano while a resident of the White House. Square Piano values: Chickering, rosewood, $1,000.

SQUEAK TOYS

Shrieks of approval greeted tiny squeaks emitted from squeak toys of the nineteenth century. The American-made squeak toys were usually of Pennsylvania origin and the majority of imported toys came from Germany. They were simply constructed of papier-mâché, wood, plaster of Paris or other suitable substance and attached to a small strip of wood. A bellows beneath the wooden strip produced a squeak with the application of pressure. Squeak toys are scarce as they were usually hand-made and never produced in large quantities. Birds, cats, dogs, roosters, rabbits, bears and peacocks led the list of squeak toy subjects. The selected subjects had hand-painted features, and often birds stood on twisted wire legs. *Tip:* A squeak toy with more than one figure is worth double the value, as they are rare. Squeak Toy values: Bird in Cage, American, circa 1860, $50.

STAFFORDSHIRE FIGURES

The Victorian Staffordshire figures represent a rewarding field for the collector with their simple modeling and tremendous appeal. Known in the nineteenth century as Toys or Images, thousands of charming groups and figures were made at a relatively low cost and possessed great charm and diversity of subject. They are also known as Cottage or Chimney ornaments and were made for the masses between 1840 and 1900. Sold at fairs and other gathering places as well as the china emporiums everywhere, the named subjects are most interesting. Queen Victoria, Prince Albert and the royal family as well as heroes and political figures of the day are just some of the pieces available. The named figures have somewhat higher value than some of the unnamed figures, although all have appeal. Associated also with this group are the animal figures including the famous Staffordshire spaniels, usually sold in pairs, the poodles and other animal subjects. Very rarely marked in any way by the maker, their production continued into the twentieth century. These pieces tend to develop a crackling in the glaze with age and this helps in determining the antique Staffordshire from the currently-produced pieces. Staffordshire Figure values: Man with Dog, 13" high, $75; Man and Woman Highland garb, 15" tall, $82; Shakespeare standing, $110.

STEAM TOYS

Childhood dreams were realized when Christmas morning brought a new toy steam engine, steamboat, locomotive or fire engine to a happy youngster. Beggs and Carlick and the Weeden Manufacturing Company of New Bedford, Massachusetts were two of the prominent steam toy makers. They competed for sales with the Buckman Manufacturing Company of New York and Branhall, Smith and Company for a share of the market. The Weeden Steam Engine is considered to be one of the finest ever made in America and the firm's catalog listed a variety of toys to be set in motion from the belt attached to the steam engine. *Tip:* Steam toys are better to admire than to operate, as both the toy and the owner are best preserved in this manner. Steam Toy values: Steam engine, Weeden, horizontal, $62; Steamboat, circa 1875, good condition, original paint, $130. Illustration on page 211.

STENCILED CLOCKS

American shelf clocks of the middle nineteenth century had painted or stenciled decoration similar to Hitchcock chairs. Painted or stenciled columns and spats gave them a look that resulted in them also being called "Hitchcock" clocks. The majority had wooden movements and painted tablets. It is best not to attempt restoration work, even when the painted areas show deterioration. The clocks, like the Hitchcock chairs, are best left untouched. New England clockmakers were actively producing stenciled clocks between 1820 and 1850. Stenciled Clock values: Good condition, circa 1860, $190; Terry, heavily stenciled columns, 30 hour movement, $350.

STERLING SILVER

The mark "sterling" began appearing on American silver during the 1860s. The mark was placed on articles with a 92.5 content of silver. English silver of American sterling quality was marked with a group of small hallmarks. A lion pictured within a hallmark denotes English silver of sterling silver quality. *Tip:* The heavier the piece of silver, the finer the quality. Sterling Silver values: Bread Tray, marked Kirk, circa 1870, $53; Serving Spoon, Chantilly, Gorham, $22; Sugar and Creamer, Rococo style, circa 1860, $80.

STEVENSGRAPHS

Thomas Stevens established a factory in 1854 in Coventry, England, for producing "Stevensgraph Silk Pictures." Beautiful silk pictures were woven into ribbons, using the Jacquard loom, and sold for a modest sum. They became favorite wall ornaments when framed. A trade label appeared on the woven silk pictures which read "woven in silk by Thomas Stevens." There were many interesting designs and Lady Godiva led the procession of popular silk picture subjects. Prized are the woven silk bookmarks covering a wide range of titles. The public eagerly purchased silk pictures when they were shown at the New York Crystal Palace Exhibition in 1853 and the Philadelphia Centennial in 1876. Stevensgraphs values: Bookmark "Landing of Columbus" framed, $90; "Crystal Palace Interior," framed, $110.

STOCKTON ART POTTERY

The Stockton Terra Cotta Company, organized in Stockton, California, in 1891, is best known for its Rekston art line marketed in 1897. Rekston ware had a heavy opaque glaze in various colors including dark green, deep blue and golden brown. Umbrella stands, vases, teapots, pitchers, bowls and other articles were decorated with raised patterns including grapes, grape leaves and ivy leaves. The wares were marked with the firm's name or initials and the word "Rekston." Despite serious attempts on the part of management to successfully market their art lines, the pottery was never a financial success and following a series of fires, the company closed in 1902. Stockton Pottery values: Vase, Rekston, grape leaves decor, 10" high, $67.

STONEWARE

The colored glazes often applied to nineteenth century stoneware articles gave them a different appearance than the earlier stoneware produced a century or two earlier. The gray and buff pieces with slip decoration, usually in cobalt blue, are eagerly collected. Birds, farm animals, flowers, foliage and country scenes dominated the numerous motifs on stoneware crocks, jugs and other utilitarian items. After 1850, the motifs were frequently stenciled and many pieces were enhanced with molded designs. Salt-glazed stonewares continued being made into the nineteenth century and stoneware indispensables invariably found a rest-

Papier-mâché Tea Tray

Mottoes

Wall Pocket

Wax Work

ing place in the kitchen area. Stoneware values: Crock, Blue Tree design, 1½ gallon, $42; Jug, Bluebird, two gallon, $58; Milk Pitcher, Doulton, Lambeth, beige and brown, circa 1870, $78.

STONEWARE BOTTLES

The English stoneware bottles of the early nineteenth century provide a lucrative field for the bottle buff. Hundreds of different sizes and shapes were made by such makers as Doulton, Stephen Green and James Stiff, all of Lambeth. Marked bottles from these and other potters are exceptional finds. There are pistol, figural, fish and portrait shapes. Commemorative bottles of the Reform Bill and the accession of Queen Victoria are available to the persistent pursuer of molded stoneware bottles. London potters were particularly prolific in the production of stoneware bottles, which have unfortunately staged a disappearing act of late. Stoneware Bottle value: Round bottom, mottled brown glaze, 8½" long, $26.

STORE TINS

The tin containers used to package various nineteenth century products are very sought after, and early in the 1800s many were hand-painted or stencil-decorated directly on the metal container. The Somers Brothers of New York developed a lithography process around the 1850s and colorful lithographed tins brightened store shelves for the remainder of the century. The fascinating shapes and interesting subject matter made them appealing and collectible and despite the presence of a bit of advertising, they were, and still are, impossible to discard. Huntley Palmer biscuit tins caused a mild sensation with their unbelievable shapes including a set of leather bound books and a grandfather's clock among others. The firm urged buyers to try their biscuits and start a collection of their tin containers. Tobacco companies excelled in colorful tins as did numerous other firms which found that attractive tins meant increased sales. Store Tin values: Leather Bound Books, Huntley Palmer, $125; Walter Baker, ½ pound cocoa container, $7.

STRAWBERRY PATTERN

This pressed-glass pattern which was produced in both clear and milk glass is a favorite with collectors of American glass. Bryce Walker and Co. of Pennsylvania patented the design in 1870 and the pattern was well accepted, remaining in favor until the end of the century. A straw-

berry vine is shown encircling each piece and this is further enhanced by clusters of strawberries on long stems in low relief with stippled leaves. The maker wanted to capture the appearance of the natural berry and immediately the public picked this pattern as a natural winner. Variants include Stippled Strawberry, Strawberry with Fan and Paneled Strawberry, all made by various manufacturers. Strawberry Pattern values: Butter Dish in milk glass, $68; Pickle dish, $30; Water Pitcher, $120.

STRING HOLDERS

If they are of nineteenth century origin, silver, pewter, iron, tin, wood and all other types of string holders are wanted. The simple everyday examples bring lower prices than the fancier animal, fruit and floral shapes. A string holder may offer surprising versatility in design, with some being footed and elaborately carved. The better examples had their own cutting blade and those with advertisements from an old general store, rate as fun finds. Regardless of the size, shape or material, ever present is the opening through which the ball of string or twine is unraveled. String Holder values: Glass Beehive type, $12; Iron Beehive, $22; Store Counter, advertising holder, circa 1880, $23.

STUDENT LAMPS

Kerosene burning student lamps were made between 1870 and 1900 and many have been converted to electricity. The lamps were ideal for students laboring over their lessons, as they afforded a soft even light, with their brass reflector shades resting above the burners. The metal standard had a simple base and supported one or two burners which were often adjustable for height. The oil font was attached to the stand at a higher point than the burners. The chimneys were tall and narrow, differing in shape from other lamps of the era. All parts of a student lamp were of brass, except the chimney, and occasionally the shade. Student Lamp values: Double Brass, burnished, electrified, $350; Single shade, brass, electrified, $170. Illustration on page 11.

SUGAR CHESTS

Southern cabinetmakers and country craftsmen made the majority of sugar chests between about 1840 and 1870. Coffee, sugar, tea and spices were kept in the sugar chests. This was a period when such commodities were expensive and therefore all sugar chests were fitted with inset metal keyholes and both lid and compartment storage area could

be locked. The chest had a top compartment over a full-width drawer, and the compartment area contained sectional storage areas. Sugar chests were generally of walnut, cherry, butternut or southern woods and remained popular as dining room pieces until sugar and spice prices declined. Sugar Chest values: Butternut chest, custom made, good condition, circa 1860, $420.

SULPHIDE PAPERWEIGHTS

The sulphide paperweight enjoyed tremendous popularity in the Victorian era. Portraits, religious motifs, arms, crests and landscapes were favorite subjects. The sulphide technique was often employed along with millefiori decoration for added effects. There were many popular cameo portraits and some were cut with large stars on the base for added detail. Sulphide weights were made by leading glasshouses in France, England and America. The sulphide was often set on a colored ground of amber, blue, emerald green, crimson, turquoise or other suitable color. *Tip:* Study is required to differentiate between a contemporary sulphide paper weight and one of nineteenth century origin. Sulphide Paperweight value: Queen Victoria Sulphide, $220.

SUNDERLAND LUSTER

This term is applied to the splashed, marbelized or mauve pink luster wares made by several firms operating in the Sunderland district of England. The pink luster was often ornamented with black transfer-printed views or biblical texts, sporting events, drinking scenes, bridges and ships to name a few. The wares are distinct and easy to recognize even without the presence of a factory mark. Dawson and Company and Phillips and Company were two firms active in the Sunderland district during the first half of the nineteenth century. *Tip:* Pink luster wares were also made by potters in other areas of England and it is inaccurate to attribute all such luster to the Sunderland factories. Sunderland values: Cup and Saucer, late, $62; Pitcher transfer print, ships, 7″ high, $130; Teapot, mottled pink, circa 1845, $135.

SUMMERTIME PATTERN

Wheat and butterflies printed in brown against the cream colored semi-porcelain body created a pleasing effect on the Summertime dinnerware service. The T. R. Boote firm of Burslem, England, registered the

pattern in 1878. The firm trade mark and registry mark appear on the underside. American wholesalers found homemakers responded to Summertime, stocking their cupboards with complete sets, from butter pats to soup tureens. Summertime Pattern values: Cake Plate, $12; Covered Vegetable, $19; Tureen, $62.

SWAN PATTERN

Swans floated across American tabletops on a variety of glassware during the nineteenth century. One of the coveted patterns of Swan glass was issued by the Canton Glass Company of Canton, Ohio in the early 1880s. The stippled background had a center medallion with an ornamental border, inside of which there was pictured a swan with long neck preening its feathers. A complete line of tableware items appeared in the Swan pattern, although the original design was conceived for a pickle preserve jar. The body ornamentation may vary according to the piece and the covered pieces have swan finials. Swan Pattern values: Butter Dish, clear, $37; Goblet, Amber, $60; Sugar Bowl, Amber, $50.

SWIRL PATTERN

The Windsor Glass Company of Pittsburgh, Pennsylvania produced this late Victorian glass pattern in a full line of tableware items in both clear and colored glass. The pattern also known as Jersey Swirl is currently being reproduced including the much sought after fan shaped relish dish. The swirled design on this pattern was broken by a row of triple close-set blocks and is easy to recognize. Another swirl pattern was introduced by the Fostoria Glass Company during the 1890s and is known as Fostoria Swirl. Collectors whirl in the direction of Swirl pattern glass, carefully avoiding the reproductions. Swirl Pattern values: Creamer, clear, $25; Water Pitcher, Amber, $44; Tumbler, blue, $24.

T

TABERNACLE MIRROR

This American mirror style of the early 1800s was heavily favored and produced during the 1840s and 1850s. Half round pilasters intro-

duced in Sheraton mirrors formed the basis for the Tabernacle mirror design. This rectangular mirror with two pieces of glass joined by a narrow piece of framing had pilasters on all four sides, with square blocks or rosettes on all four corners. Carving and turning appeared on the round columns, separately and combined, and most examples were completely covered with gold leaf. Others were made of ebonized dark stained woods. The country types lacked the detail and were made from less expensive woods. A variation was made with a glass- or wood-painted panel above the mirror section and the Tabnernacle mirror varied according to the maker in size, shape and amount of added detail. Tabernacle Mirror values: Gold Leaf, good condition, circa 1850, painted panel above mirror, $190.

TARTAN MOTIF

Queen Victoria acquired Balmoral Castle in 1852 and shortly thereafter a tremendous tartan fad developed. Textiles, carpets, glassware, ceramics, upholstery and tartan bric-a-brac ornaments were suddenly in vogue. Gaily-decorated tartan items were produced for home and personal use and for a generation or more no one could escape this trend. Who could resist the temptation of a tempting tartan treasure. You may succumb to the urge when you spot one unexpectedly on your next antiquing venture. Tartan Motif values: Staffordshire Figure, Girl in Highland Garb, 6″ tall, $47; Work Box covered in Tartan material, 12″ x 10″, circa 1860, $45.

TEA LEAF IRONSTONE

Popular in the second half of the 1800s, this type of ironstone had a narrow band around the edge and a center tea leaf sprig, both decorated with gold or copper luster. Tea leaf ironstone was made in England and to a limited extent in America. Due to its durability, it was fashionable as a second set of dinnerware, or used as an auxiliary set for summer cottages. Children's tea sets in tea leaf ironstone are very desirable, as are the washstand sets. Attributing to the success of this pattern were innumerable pieces comprising a complete set and a wide variety of shapes. The majority of tea leaf ironstone was clearly marked by the maker, providing fast and accurate identification. Tea Leaf values: Gravy Boat, $30; Handleless Cup and Saucer, circa 1855, $22; Plate, 8″ diameter, $11; Washbowl and Pitcher, two-piece set, $130.

TERRA COTTA

The Italian words *terra cotta* mean "burnt earth." This unglazed earthenware which has been known since antiquity enjoyed a revival in the Victorian era. Prince Albert contributed to the terra cotta excitement when he purchased a pair of five-foot-high vases from the F. & R. Pratt firm in 1848. Magnificent garden ornaments of public figures, often approaching life size, were displayed in gardens and conservatories. Vases, pedestals, urns, candlesticks and wine coolers were among the terra cotta items which found mass appeal, due in part to their low selling price. Principle English makers included Coalbrookdale Iron Company, Doulton of Lambeth, and the Wattecombe Terra Cotta Clay Company, all active in the late 1800s. Terra Cotta values: "Beatrice" bust, good condition, 17" tall, circa 1880, $110. Illustration on page 181.

TESTER

The canopy covering a high poster bed is known as a "tester," the word being derived from an English word meaning helmet or head covering. The cornice tester and column tester beds were still made during the early Victorian period, particularly in the southern part of the United States. Tester beds with Louis XV Revival style details became popular around the middle of the century. Mansions in the south boasted these handsome beds, which were usually custom made by cabinet-makers. Tester Bed values: Birds-eye maple, circa 1840, 7' high, $600.

THEOREMS

Artistically-minded young ladies anxious to test their creative skills produced theorems, or stencil paintings. This art form was accomplished by arranging various shaped stencils in a manner to create a still life composition. Vases of flowers and simple fruit subjects were popular themes and were painted with water colors on paper or with oils on velvet. The stencils were prepared by an instructor and this technique of painting on velvet was preferred by young ladies unable to accomplish free hand art. The talented young ladies who could do their own sketching considered the "Theorem Technique" decidedly inferior. Theorem value: Fruit design in matted frame, 14" x 16", $90.

THISTLE PATTERN

According to the patent papers this pressed glass design was composed of Scotch thistle, leaves, stems and flowers which were connected

around the selected article in a wreath-like manner. Thistle blossom finials were conceived for the covered pieces and this simple pattern was devoid of any other decoration. Bryce Walker and Company of Pennsylvania made a complete line of tableware items in the Thistle pattern during the 1870s. Thistle Pattern values: Cordial, $13; Creamer, $17; Goblet, $14; Sauce, $7.

THOUSAND EYE PATTERN

A choice American pressed glass pattern, Thousand Eye was made in a multitude of different pieces in both clear and colored glass. Large flattened hobnails comprise the design and between each group of four there is a large high faceted diamond. This diamond form differentiates it from other patterns and on some pieces the hobnails vary in size gradually becoming smaller toward the base. Adams and Company produced the Thousand Eye pattern in clear and colored glass during the 1870s. Thousands of eyes search for Thousand Eye pattern glass in antique shops everywhere. *Tip:* The rare beehive twine holder was made by Richards and Hartley in Thousand Eye pattern, circa 1885. Thousand Eye Pattern values: Cordial, clear, $17; Tumbler, amber, $27; Wine, apple green, $35.

THREADED GLASS

Derived from an earlier Egyptian technique, Victorians witnessed a revival of threaded glass, accompanied by some improved manufacturing methods during the nineteenth century. The Boston and Sandwich Glass Factory made threaded glass and the pieces made prior to the latter part of the 1800s were generally hand threaded. A threading machine invention of the 1870s was patented and quickly copied by various glasshouses, as it dispensed with laborious hand work. Pearl satin and filigree, as well as other glass innovations, were thus enriched when threads of glass were applied to the body of the piece. Sophisticated designs were achieved by pattern-molding the glass before applying the threaded glass portions. Threaded Glass values: Bowl, pink, 8″ diameter, $82; Finger Bowl, amber, $30; Tumbler, blue, $48.

THREE FACE PATTERN

Frosted-glass patterns were among the new innovations introduced by American glasshouses during the 1870s. From the eminent George

Duncan glasshouse of Pittsburgh, Pennsylvania, came Three Face, also known as Three Graces or Three Sisters. A patent was granted for the pattern in 1878 and a complete line of tableware items was produced in clear glass with frosted faces. The frosted portions have a face full view, one in profile and the third in three quarter view. The same forms appear as ornamental finials or upon the stems or in any position deemed suitable to the individual piece. Excessive demand has resulted in an abundance of reproductions. Face the fact that you should do an about-face when confronted by a copy of Three Face. Three Face values: Butter Dish, $120; Celery, $70; Wine, $72.

THREE PANEL PATTERN

Richards and Hartley Flint Glass Company of Pittsburgh, Pennsylvania, made Three Panel pressed glass about 1880. It was made in clear and colored glass including amber, yellow and blue. The three large rectangular sections are separated from each other on the body portion by two narrow vertical bars. Inside the three panels are rows of raised circles with beveled edges and flat centers with alternating plain and eight-pointed star centers. There is a sharp point between each group of four circles. The same firm made Two Panel, often referred to as Daisy in Panel, and Daisy in Square in the 1880s in both clear and colored glass. Three Panel values: Butter Dish, clear, $30; Creamer, amber, $30; Pitcher, yellow, $45; Tumbler, blue, $28.

THUMBPRINT PATTERN

Bakewell Pears and Company made Thumbprint pattern pressed glass about 1870 calling it Argus pattern. The majority of the pieces were clear but colored specimens were also made. Challinor and Company referred to the pattern as Challinor's Thumbprint when they marketed their version about 1880. The pattern can be quickly recognized by the deep thumbprints, which over the years have been incorporated into numerous variants. The Thumbprint family tree includes Thumbprint and Block, Barreled Thumbprint, Ribbed Thumbprint, Inverted Thumbprint, Thumbprint with Diamond, Oval Thumbprint and English Pointed Thumbprint. The 1890s brought about the issuance of the highly collectible Ruby Thumbprint. This pattern has a ruby top suitable for etching or engraving with the thumbprint pattern in clear glass below. Thumbprint Pattern values: Celery, $98; Finger bowl, $24; Wine, $28.

TIFFANY, LOUIS COMFORT (1848–1933)

America's major contribution to Art Nouveau was in the fresh forms and imaginative work of the glass magician, Louis Comfort Tiffany. The Tiffany Favrile glass was an outgrowth of experiments conducted with stained glass windows and mosaics. This line of glass decorative accessories earned its maker international recognition. His Favrile glass, meaning hand made, was a triumph in iridescent glass and was marked "L.C.T." or "Tiffany" or "L.C.Tiffany" or the word "Favrile." The absence of any identifying mark would make attribution difficult, as the majority of pieces were marked by the maker. The Tiffany lamps should also bear a mark from the firm, either on the shade or on the base, which were usually of cast bronze. Louis Tiffany did not limit his designs to glass only; he developed innovative metal, enamels, jewelry, furniture and ceramics. His Favrile pottery was marketed in 1906, each piece signed with the initials LCT on the base. Louis Tiffany was widely copied and imitated but never equalled in the field of decorative arts. Tiffany values: Bon Bon Dish, 6″ diameter, $210; Goblet, clear and blue opalescent, signed, $350. Illustration on page 11.

TINSEL PICTURES

Prints of noted theatrical personalities and subjects of royalty were preferred by artistic young ladies devoted to tinsel work. This home craft involved the embellishment of a selected print with pieces of colorful material and tinsel. The tinsel provided the necessary glittering effect when cut into thin strips. Tinsel pictures showed actors and actresses of the day playing various roles and in certain postures from famous plays. A politician or other prominent person was also considered a suitable subject for a tinsel portrait. While a maker's name or date would certainly add to the rarity factor, any tinsel portrait of nineteenth century origin is of importance. Tinsel Portrait values: Framed portrait of Prince Albert, 12″ x 16″, $140.

TIN TOY

Any tin toy made during the 1800s has definite value to a toy collector. Age, condition and rarity will combine to establish their worth. The Philadelphia Tin Toy Manufacturing Company and the George W. Brown firm of Forrestville, Connecticut, were leaders in the tin toy field during the 1850s. Brightly-painted or stencil-decorated toys became

larger and more complicated as the century progressed. Animals doing a variety of tricks, toy tin kitchens, tin banks and doll house furnishings competed with fire engines, stagecoaches, trains, horse-drawn vehicles, and tin pull toys. Hot air tin toys of the 1860s had moveable parts. *Tip:* Never repaint a tin toy regardless of condition, as this will only lessen its worth to a collector. Tin Toy values: Grocery wagon with horse, good condition, circa 1880, $95; Tin Trolley, 8″ long, $65.

TINTYPES

During the 1860s this low-cost method of photography replaced the earlier daguerreotype and ambrotype efforts. The tintype was achieved by a collodion process producing a photograph on a thin black japanned iron plate. The method resulted in mass street and seaside picture taking by enterprising photographers and small photo studios. Like its closely related predecessors in the field of photography, the tintypes were fitted with gilt or leather cases lined with velvet or plush. The post-card size photos employing the tintype process caused Victorian albums to bulge beyond belief. Tintype values: Confederate officer with pistol in leather case, $20.

TINWARE

Painted tin plated sheet iron is rightfully known as painted tin. The more elaborately painted tin decorated with floral, landscape and other motifs is known as toleware. Japanned wares are so-called since they were made in imitation of Japanese lacquer pieces, the earliest of which were hand painted while later they were usually stenciled. By the nineteenth century painted tinware was a thriving industry and many tins were japanned and stenciled for packaging various store-bought items. Punched tin was made in America with designs that did not puncture the tin, but merely dented it. If the surface was broken it was called pierced tin. The tinsmith was well established by the 1840s and Connecticut was an important tin center. The tin most often encountered undecorated was meant primarily for kitchen use. Tin was inexpensive and in addition to it being sold in stores, peddlers roamed about the countryside selling tin and iron wares. Antique tinware should be gently cleaned to retain its pleasing luster. On painted tinware, it is always more valuable when left in the original condition. Tinware values: Deed Box,

original stenciled decoration, $135; Water Pitcher, black with floral decor, $40. Illustration on page 171.

TOBY JUGS

The name is supposedly derived from the engravings of Toby Philpot, the subject of a famous song "The Brown Jug" popular in the 1760s. The Toby Jug was a standard Staffordshire- item, made since the late eighteenth century. The general form was a seated man, usually with pipe and three cornered hat forming the pouring spout. Toby jugs were a favorite souvenir item in the Victorian era when they were sold at fairs and expositions. Washington, Napoleon, Mr. Pickwick, and Father Christmas, along with Punch and Judy, were some of the delightful mugs decorating nineteenth century jugs. The fame of the Toby jug spread to America and potters made them at Bennington, Vermont, and other areas. There are many variations found on the Toby family tree. *Tip:* The earlier the Toby, the higher the value. Toby Jug values: Jolly Fat man, majolica, $75; Napoleon, American, $265. Illustration on page 141.

TOPS

The sight of a nineteenth century top will send a collector spinning in the direction of his checkbook. Iron, wood and tin tops were made domestically and also imported from Europe in large quantities. Wooden tops were polished, gilded, striped or painted and some had simple lines while others had fancy decorations. Grips or wooden handles on a top indicate it was a more expensive type. The whistling top was of iron with a tin snap on section or was made completely of tin. Persistent seekers of tops may be rewarded by obtaining a humming, whip, or peg top, three early favorites. The Selchow and Richter firm advertised their Tip Top in the 1880s. This one tips and turns over and so will a collector if he finds one. Top values: Wooden Top, fair condition, original paint, circa 1870, $12.

TORTOISE SHELL GLASS

In their never-ending quest for new and innovative glass novelties, firms in America and Europe developed a glass imitation of true tortoise shell in the 1880s. The glass was made in very limited quantities, in tableware and ornamental items. Many items were intended for boudoir use. The colors range from shades of amber, brown, yellow and clear and

the glass is easy to recognize. Occasionally the pieces were embellished with enamel, gold or mica flecks dispersed throughout, for additional highlights. Tortoise Shell values: Perfume Bottle with stopper, $62; Tumbler, $52; Vase, 8" high, $64.

TOURAINE PATTERN

Henry Alcock of Cobridge, England, shipped this late flow-blue dinner pattern to American homemakers during the 1880s and 1890s. The dark blue border has an inset band of gold and the misty blue-floral sprays decorating the center portions blurred slightly, running into the white body. The printed mark on the underside contains the pattern name and factory trademark, with the addition of the word "England" found on pieces made after 1891. *Tip:* A distinguishing characteristic of late flow-blue patterns was the addition of gold decoration, absent on the earlier wares. Touraine values: Bone Dish, $9; Cup and Saucer, $18; Milk pitcher, $24.

TOY SOLDIERS

Soldiers of tin, wood, metal, baked clay and other materials were made in America and imported from Europe during the 1800s. Tin soldiers led the production parade when simplified methods were developed in Germany where they were produced in large quantities and exported to the United States. Wooden soldiers also ranked high as favorites and were known in England as "Biffins." Colorful paper and cardboard soldiers were made on both sides of the Atlantic, dressed in uniforms of many countries. *Tip:* Toy soldiers fought a hard battle to retain their fresh look under the rigors of heavy usage and most antique examples indicate they lost the war. Toy Soldier values: Cardboard lithographed box of 18 soldiers, all original, circa 1880, $40; German, tin, 2" high, $5.

TOY THEATRES

Printed sheets containing cutouts of famous theatrical personalities for children's model theatres were introduced in England during the early 1800s. By the middle of the century youngsters were spending many happy hours with sets consisting of an entire company of actors and actresses. For a small amount of money a printed sheet could be purchased with all the characters in a drama and printed scenery soon followed. The cut-out figures were mounted on cardboard enabling them

to stand and were available colored or uncolored if a child was inclined to want to color his own. The interest was widespread in England and also flourished in America with McLoughlin Brothers of New York and other prominent publishers making toy theatres American style. Toy Theatres value: Incomplete theatre, circa 1850, $60.

TRADE CATALOGS

Manufacturers and merchants began issuing trade catalogs with increased regularity during the 1840s. By the middle of the century, due to improvements in the printing industry, there was a tremendous expansion in the field of trade catalogs. After the Philadelphia Centennial the trade catalog mail order business gained new momentum, attributing to the increase in catalogs after this date. Trade catalogs provide the student of antiques with necessary and valuable information on craftsmen and manufacturers. The illustrations and designs found in the old catalogs are a constant and valued source of information. Most valuable are the first catalogs showing new inventions or newly created merchandise. Trade Catalog values: Art Pottery Catalog, 1894, $32; Bicycle Catalog, 1894, 28 pages, $24.

TREE OF LIFE PATTERN

The Portland Glass Company of Portland, Maine achieved prominence in the glass industry with their version of the Tree of Life pattern in the 1860s. This was a variation of the famed Craquelle glass and was made by the firm in clear and colored glass. Other American glasshouses, including George Duncan of Pittsburgh, Pennsylvania, Challinor and Taylor of Pittsburgh, Pennsylvania, and Hobbs Brocknier of Wheeling, West Virginia, among others, issued a version of the Tree of Life pattern. There are numerous interpretations of this pattern and extensive research is required to make an accurate attribution to a particular maker. Tree of Life values: Celery, $24; Creamer, $32; Tumbler, $18; Wine, $19.

TRESTLE TABLE

Country craftsmen were kept busy well into the 1800s making the American rendition of the age-old trestle table. The better tables were made with the top cut from one board, rather than two or three. They range in size up to twelve feet in length and were secured by a long board placed through the upright trestles. They were braced by two or three T-formed trestles and could easily be dismantled following a meal.

Most surviving examples are from four to six feet in length and those originating at the Shaker communities are interesting and very salable. Trestle Table value: Oak frame, maple top, six foot long, good condition, circa 1870, $250.

TRIVET

The trivet went commercial after 1850 when cast-iron trivets were made in quantities and found great public acceptance. The hand-wrought trivet, usually the work of the local blacksmith prior to this date, continued to be made but in lesser quantities. Trivets varied greatly in size, from the tall, standing fireplace types to the small under-iron varieties. Trivets in the shape of a flat iron are known as cathedral type and there were also round and rectangular shapes, all made with openwork patterns. The patterns became more intricate as the century progressed and those hitting the trivet trail will encounter such designs as heart, arrow, peacock, horseshoe, letters, insignias, emblems, portraits and hundreds of others. A trivet may often have a patent date, and many were issued as advertising devices. Iron trivets were more abundantly produced than those of brass or copper. Trivet values: Fern pattern, cast iron, $14; Horseshoe, rose center, $18; George Washington bust, brass, $39; Tree of Life, cast iron, $7. Illustration on page 131.

TRUNDLE BED

This low bed, with or without wheels, was capable of being rolled under a higher bed when not in use. The ancient trundle bed experienced a revival in England and America during the eighteenth and nineteenth centuries. They were usually made for children and due to their diminutive size could be safely tucked away without occupying storage space. They are also known as truckle beds. They are scarce and valuable, and if you stumble upon a trundle, don't fumble, buy it! Trundle Bed values: Maple, good condition, $140; Rough condition, $85.

TULIP PATTERN

The tulip motif on American pressed-glass is an early design and one consistently popular throughout the Victorian period. This motif is readily discernable on the pattern and there may be slight variations according to the individual glasshouse. Bryce McKee of Pittsburgh, Pennsylvania, listed the pattern in catalogs of the 1850s, calling it Tulip with Sawtooth. The Tulip pattern was actively produced during the

1860s in complete table ware settings. Tulip pattern glass is relatively scarce as the demand far exceeds the supply. Tulip Pattern values: Creamer, $84; Water Tumbler, $26; Wine, $30.

TURKEY RED

Yards and yards of turkey-red cotton fabrics were sold by stores across the country between the 1870s and 1900. The rich vibrant shade of red was of Near East origin, the dye being made from madder, a Eurasian herb. Where it came from really didn't matter—it was the color that appealed. Dining room tables were covered with tablecloths of turkey red made by manufacturers both here and abroad. Striking patterns, achieved by a combination of red and white in Greek key, bird, flower and medallion design could be purchased by the yard or as a completed tablecloth. Turkey Red value: Tablecloth in Turkey Red, fair condition, circa 1880, 60" x 90", $40.

TURKISH INFLUENCE

Parlors and libraries fell under the influence of overstuffed Turkish furnishings and fashions of the 1870s, 1880s and thereafter. The Near Eastern Exhibits at the Philadelphia Centennial in 1876 and the building of the Suez Canal were contributing factors in the fad for Turkish travesty. Armchairs, ottomans, sofas, side chairs, corner chairs and circular couches overstuffed and covered with upholstery and deep fringe satisfied this restless yearning for exotic faraway places. The divan found its way into the hearts and homes of Americans and only the unsophisticated resisted the urge for tantalizing Turkish furnishings. Turkish Furniture values: Arm chair, green velvet, deep fringe, good condition, circa 1880, $240; Sofa, brown velvet, deep fringe, fair condition, circa 1885, $480. Illustration on page 99.

TURK'S HEAD MOLD

The mold madness of the 1800s reached new proportions during the 1890s with this ingenious sponge cake mold-made of pottery or metal. The design of deeply molded swirls achieved a baking surprise that did indeed resemble a finely twisted turban. They pop up with the same regularity in antique shops as they did out of oven doors around the turn of the century. Turk's Head Mold values: Brown Pottery Mold, $16.

U

UNION PORCELAIN WORKS

The Charles Cartlidge ceramic factory at Greenpoint, New York, came under the ownership of Thomas C. Smith in 1861 and was renamed Union Porcelain Works. Karl Mueller was engaged by the firm in the 1870s and he proceeded to design exceptional American porcelains. The Century Vase executed for the Philadelphia Centennial in 1876 and the Finding of Moses were two of his outstanding achievements in biscuit porcelain. The firm became noted for its fine workmanship and high quality wares. During the 1890s, their attention turned to porcelain tiles. The mark, "Union Porcelain Works, Greenpoint, New York," or the initials of the firm in varying designs found on the underside denote an example from this important concern. Union Porcelain Works value: Cup and Saucer, floral, circa 1880, $28.

V

VALENTINES

Throughout the Victorian era, the word "love" was spelled v-a-l-e-n-t-i-n-e. Ladies and gentlemen labored long and lovingly over hand made Valentines, combining bits of lace and small colorful cutouts with liberal amounts of care and concern to create a lasting love token for February 14th. There were special "Valentine Writers" containing suitable verses to be hand written on a completed Valentine when the maker became too overcome with anticipation to conceive a verse of his own. Commercial Valentines appeared during the 1840s and enterprising Esther Howland, a young lady from New England, imported paper lace from England and was soon grossing one hundred thousand dollars annually on her assembly-line-pasted Valentine venture. Her cards were often marked with a small "h" stamped in red on the back. During the 1890s, the three-dimensional type Valentine, intricately die-cut and trimmed with honeycomb tissue, was imported from Germany. Valentine values:

Embossed paper lace, hand-written verse, 5" x 7", $14; Large three-dimensional type, Germany ship and flowers, $18.

VASELINE GLASS

The distinctive color of this late Victorian glass has resulted in its being referred to as Vaseline glass. The glass had a slightly oily look and the light yellow color with a tint of blue closely resembled the color of petroleum jelly. All pieces of nineteenth century Vaseline glass, also known as canary glass, are collectible. Vaseline was combined with clear glass on some pieces and was produced in both clear and opaque yellow in a number of attractive patterns. Valuable is the word for Vaseline, as this particular glass has acquired a legion of admirers over the years. Vaseline Glass values: Daisy and Button Ornament Tumbler, $21; Finger Bowl, $30; Square Dot pattern Celery, $22.

VELOCIPEDES

Picture a cart with two back wheels and a horse head attached to a small front wheel and you have visualized a version of the velocipede. Sticks connected to the back wheel propelled the earlier models, while later styles had pedals. The Crandalls produced some of the first velocipedes during the 1840s. Fancier versions followed including the "American Trotter" with a horse head of wood and a sulky seat. The "Cantering Tricycle" moved forward while rocking up and down in horselike fashion. The velocipede was a forerunner of the tricycle and moving vehicles such as these became a favorite outdoor pastime in the post Civil War era. Velocipede values: Sulky seat, original condition, circa 1870, $210.

VICTORIAN EMPIRE

The decade between 1840 and 1850 is known as the Victorian Empire period. The furniture of the period was in the American Empire style, but with added Victorian details, including wavy molding, medallions and applied carving in leaf and floral motifs. There were also interpretations of the eclectic styles such as the Elizabethan, Gothic, Baroque, and Rococo noted in the furniture forms. Certain techniques requiring less skill were introduced as early furniture factories achieved simplified production methods with the combining of machine work and hand work. The ottoman and lazy Susan table were two new furniture forms and the bookcase and wardrobe both became better known. Marble tops also sprang into fashion. The Classical and Revival styles of the

Federal and Empire periods were gradually supplanted during the Early Victorian period, 1840–1850. Victorian Empire values: Sideboard, mahogany, circa 1840, $650.

VILLEROY AND BOCH

Mettlach steins from the Villeroy and Boch factory of Germany were imported in quantity to the United States from about 1860 onward. They are easy to recognize by the superior stoneware workmanship and by the famous castle mark, factory name, monogram VB and numbers denoting date of production, stock number and decoration number found on the base. Two separate families, Villeroy and Boch, merged in 1841 to form this still existing firm. The well-known castle mark represents the Abbey of Mettlach, which was purchased and converted into the pottery by Jean-Francois Boch in the early 1800s. Villeroy and Boch values: Stein 1898, Cavalier, $340; Thirsty Rider, $420.

VINAIGRETTES

Small vinaigrettes to ward off unpleasant odors were an eighteenth century innovation, still performing their pleasant duty throughout the Victorian era. The vinaigrette remained basically the same, except it was subject to minor Victorian elaboration. They were made of gold, silver, enamel, pinchbeck metal, porcelain and glass. The design varied slightly but usually consisted of a box with a lid, and pierced inner lid through which the perfume escaped from the enclosed aromatic sponge. The portable vinaigrette was small enough to tuck into a pocket or handbag and there was also a larger size developed for passing around in a warm overcrowded room. Vinaigrette value: Cut glass with aromatic insert, $30.

W

WAFFLE PATTERN

The Boston and Sandwich Glass Factory and other American glasshouses made this enduringly popular pressed-glass pattern. The vertical groups of blocks, separated into four sections, form the distinctive waffle motif. The earlier glass was of fine quality with a sharp resonance. Milk glass waffle appeared during the 1870s and quart size and half gallon

pitchers in clear and colored glass were also made. Among the variants are Waffle and Thumbprint, Waffle and Fine Cut, Waffle and Star Band and Waffle with Points. Waffle Pattern values: Butter Dish, $55; Champagne, $37; Goblet, $18; Tumbler, $26; Wine, $24.

WAGON SEAT

The wagon seat was a dual purpose seat which was used in a wagon during a ride and could be removed as an auxiliary seat for the home or at a meeting place. Wagon seats date from the eighteenth century, but were still proving functional in the rural areas during the 1800s. Typically made with short legs and splat back to fit securely into the wagon, these wooden settee-type seats were sturdy and durable. They were made of available woods in prevailing contemporary styles to suit regional tastes. *Tip:* A smaller, shorter version may be a trifle baffling unless you remember they were also made for children. Wagon Seat value: Original paint, good condition, circa 1850, $130.

WAG ON WALL

A wall clock where the weights and pendulum are not enclosed within a case was known as a wag on wall. They were sold without a case, ready to be hung on a wall until a time when a case could be provided. Eli Terry was a forerunner in the development of the wag-on-wall clock and other clockmakers joined Terry in supplying them to the masses. The wag-on-wall clock proved timely, and with or without a case, remained fashionable for the entire century. A number were fitted with a small hood as protection from harmful accumulations of dust which might interfere with the clock mechanism. Wag on Wall values: American made, circa 1840, $190.

WALL POCKETS

The wall pocket was almost as heavily used as the clothing pocket during the Victorian era. The wall pocket hung on the wall as a catch-all for a thousand and one household trifles and treasures. They were generally hand crafted at home by gentlemen skilled at jigsaw work and were then handed over to the lady of the house for some nifty needlework or beaded design to enrich the front panel. A very elegant wall pocket was hand painted and they were created in many sizes and shapes and hung on walls throughout the house. The wall pocket was actually a complete lost and found department but with added Victorian details provided by

those in the craft corner. Wall Pocket values: Hand painted front tin section, red velvet interior, $60; Needlepoint front, fretwork, good condition, $57. Illustration on page 221.

WARDIAN CASE

A flower box protected with a glass bell, the original idea was developed as a method for safely transferring plants home from foreign countries. Dr. Nathaniel Ward perfected this indoor horticultural wonder and plant-loving Victorians were forever grateful. Plants and fragile ferns were planted in a flower box, properly watered and then encased in a bell-like dome. The condensation on the inside of the Wardian case provided the necessary humidity for the plants to flourish. They are frequently spotted on antiquing ventures and called a flower box, terrarium, or window garden by those who never heard of Dr. Ward and his Wardian case. Wardian Case values: Large size, original glass, $470.

WARDROBE

The wardrobe was first made around the 1850s at the time of the Rococo Revival period in the United States. There were practically no built-in closets and the wardrobe solved the problem of storing heavy and bulky clothing such as the voluminous hooped skirt. They were greeted with immediate approval, and due to their practicality remained in favor through the 1880s. They ranged up to six feet or more in height and had either a single or double door, depending on their width. The better quality wardrobes were distinguishable by their mirrored panel doors and drawer base. They were principally made by furniture factories and were simply constructed and easy to dismantle, despite their rather awesome size. Wardrobe values: 7' tall, full size mirror panels, good condition, $500.

WASHSTAND

Every Victorian bedroom had a washstand of either the open or closed-base variety. The simplest type resembled a bedside night table with towel bars and a low shelf beneath. Open washstands of the 1840s were often made by cabinetmakers and small furniture factories. Later they were all factory produced and were sold separately rather than being a part of a bedroom set. The enclosed version, also known as a commode, often had a marble top. Country washstands were made of wood, without a marble top, but often with a splash rail also of wood. Some

washstands had the raised gallery continued at the sides projecting into towel bar ends. Washstand values: Open washstand, maple, circa 1870, refinished $100; Washstand, hole top for basin, shelf beneath, pine, refinished, $90.

WASHSTAND SETS

Antique bowl and pitcher sets, matching, and in excellent condition, represent a standout find. They were essential bedroom items of the Victorian era and three piece sets were sold consisting of a bowl, pitcher, and chamber pot with a cover which was stored in the commode. The larger sets had a matching soap dish, hot water jug, toothbrush holder, slop bucket, and complete sets sell at premium prices. Potters made them in a never-ending variety, including flow-blue, tea leaf ironstone, plain white ironstone, moss rose and numerous other china patterns as well as floral motifs galore. They were also made in glass and metal throughout the nineteenth century. The age, condition, quality and maker's mark are important factors in determining value. Washstand Set values: Copeland and Garret, bowl and pitcher, grape leaves, burgundy, circa 1845, $175; White ironstone, 7-piece set, circa 1890, $160.

WATER BENCH

The water bench was a nineteenth century country kitchen piece frequently of Pennsylvania origin. The water bench was so named as it held pails of water on its broad counter shelf and milk pails and other containers were stored in the cupboard space below the shelf. A form of dresser, it had a full-width cupboard in the portion under the counter extending to the floor. Above the counter shelf, there was an upper narrow shelf with a small compartment to house dippers, mugs and other small utensils. Water benches can be easily converted into a buffet and were generally made of pine or other available soft woods by cabinetmakers or a home craftsman. Water Bench values: Good condition, $170; Rough condition, $100.

WAX DOLLS

Dimpled darlings of the Victorian era loved their cuddly wax dolls, much to the delight of their European makers. The wax head actually had a papier-mâché base that was treated to either a thin or thick coating of wax. Germany, France and England competed for the healthy American market, and most wax dolls had arms and legs of wood and

bodies of cloth stuffed with sawdust. Wax dolls from the first part of the nineteenth century were fondly referred to as Pumpkin or Squash heads. Their hair was arranged in pompadour style and was molded on the head. Their dark glass eyes had no pupils. *Tip:* Wax dolls will melt or crack under extremes of heat or cold. Wax Doll values: Lady Doll, original dress, circa 1860, 19″, $210. Illustration on page 161.

WAX PORTRAITS

Exercise your art expertise by differentiating between the true wax portraits of the 1800s and the recent flood of forgeries. Wax portraits won acclaim in France and England during the eighteenth century and remained in favor in America well into the Victorian age. Portraits of Presidents also won great favor in America and after they were molded or cast into the desired subject they were mounted on dark backgrounds and framed. Don't allow an antique frame or a date mislead you into thinking you have uncovered a masterpiece, as the forgeries are neatly fitted into antique frames and falsely dated. Wax Portrait values: Gentleman, framed, circa 1850, $175.

WAX WORK

The eye of the beholder was temporarily confused by the realistic wax work accomplished by ladies devoted to this art form. The wax work fad spread quickly following the London Exhibition in 1851 and required skills in modeling, painting and sculpture. The artist endeavored to create wax flower and fruit arrangements that were true to nature. Those possessing a talent for wax work transcended into the commercial arena, selling their wax wonders for handsome prices. The finished piece was encased under a glass dome, and proudly displayed on a pier table, mantel, sideboard or other visually effective setting. Wax work is closely associated with Victoriana and is worthy of its present museum status. Wax Work values: Three-tier Fruit Centerpiece, wire basket, wooden base, under dome 24″ high, $165. Illustration on page 221.

WEATHER VANES

Farming spread across rural America during the 1800s and with it the fame of the weather vane. The first weather vanes were simple outline shapes in wood, iron or tin, replaced by larger and more elegant weather tellers as the century progressed. The high-relief work gave the later produced weather vanes a three-dimensional effect and the subject

matter was quite varied ranging from roosters to fancy dragons. Wood, copper, zinc, tin, iron or other metal weather vanes were designed by carvers and blacksmiths. Forecasting the weather were such revolving wonders as a horse, cow, fish, ship, steamboat or locomotive among others. Weather Vane values: Copper Cow, $2,200; Copper Eagle, $1,800. Illustration on page 151.

WELLER

Samuel Weller operated a pottery in Zanesville, Ohio during the 1880s, entering the art pottery field in the 1890s. He made lines similar to the renowned Rookwood factory. The Louwelsa line, with underglaze decoration on dark grounds with motifs such as animal, fruit, flower and Indian portraits among others, earned the firm immediate recognition. Louwelsa wares bear the factory name, artist's signature and the word "Louwelsa." The Weller earthenware line developed by J. Sicard, resembling the glass of Tiffany, was developed in 1903 and is known as "Sicard Weller." The firm remained active marketing numerous art pottery lines until the business terminated in the late 1940s. Weller values: Mug, handled, Indian portrait, 5" high, $45; Vase, floral decor, Louwelsa, 10" high, $105; Umbrella Stand, floral decor, marked "Weller" circa 1900, $100.

WEST STATUARY

"Making Up," "Playing Grandma" and "Red Riding Hood" are just three of the captivating parlor statuary groups from the West firm of Chicago, Illinois. J. J. West marketed primarily through his mail-order catalogs a complete line of plaster parlor statuary resembling the important Rogers groups. The West firm engaged talented artists to create their subjects and it was not their intention to copy the work of John Rogers. Children were popular subjects on the West statuary and they sold the country over. The name of the particular subject appears on the front of the base and the firm's mark "West Statuary" can be found stamped upon the base. West Statuary values: "Playing Grandma," $130; "Red Riding Hood," $140.

WESTWARD HO PATTERN

Pressed-glass tableware services were used more widely in America during the late 1800s than in any other country in the world. Competition was keen and Gillinder and Sons of Philadelphia, Pennsylvania

scored a minor sensation with their Westward Ho pattern which combined clear and frosted glass in the late 1870s. They referred to the pattern as Pioneer, aptly named as the pattern featured a frosted band with scenes of running deer, bison, log cabins, mountains and trees. The covered pieces had a well-molded, frosted kneeling Indian figure crouching on a pad as decorative finials. *Tip:* The reproductions are from the original mold; however, by placing an antique piece of Westward Ho alongside a new piece, the slight differences become more noticeable. Westward Ho values: Celery, $90; Sugar Bowl, $100; Wine, $80.

WHALE OIL LAMPS

The whale oil lamp was designed in the 1780s to burn inexpensive whale oil and continued being produced until after the Civil War. The lamps were fitted with one or two round wicks and were made of pewter, tin, brass, pressed glass and other materials. The large amount of whale oil used for these lighting devices created a thriving whale oil business in America. The whale oil lamp was clean and economical and frequently called the "common lamp." There were several variations and following the introduction of pressed glass in the 1820s, those with pressed glass bases were heavily produced. The pressed glass designs followed the techniques and patterns of the glass industry and various changes occurred in whale oil lamp patterns throughout the year. Whale Oil Lamp values: Clear-glass Lamp, cut and etched, $55; American Pewter single wick, $85; Hand Whale-oil Lamp, twin burner, $32. Illustration on page 11.

WHAT-NOT

The what-not was a standard furniture piece in every Victorian home. They were rapidly converted by bric-a-brac lovers into miniature museums. They were usually factory made, except for some finer examples which were the work of cabinetmakers. There were flat-wall and corner what-nots, generally with five shelves graduated in size and becoming smaller toward the top. Spool-turned posts in various patterns or machine-cut brackets joined and supported the shelves which frequently had low gallery pieces in the rear and fancy openwork. The flat wall what-not was either square or rectangular and on finer examples incorporated a desk or cupboard base. Walnut, rosewood and mahogany were favorite woods for finer what-nots while less expensive woods were

stained to resemble walnut. What-not values: Corner What-not, five shelves, good condition, $195; Eastlake What-not, walnut, circa 1875, $220.

WHEAT PATTERN

White ironstone dinner services decorated with the Wheat design embossed or raised around the border ranks as one of the best-loved patterns ever conceived. The Wheat design proved very popular with home-makers of the second half of the nineteenth century and numerous potters met the demand for this design. It was made in numerous shapes and pieces. A few factories made the Wheat pattern with luster decoration. American and English firms found the Wheat design yielded a harvest of profits, and most pieces were marked with a factory trademark. *Tip:* A complete set of Wheat pattern ironstone may be accumulated by means of the mix or match method. Wheat Pattern values: Plate, $15; Pitcher, large, $35; Platter, $28.

WICKER

Spectacular wicker chairs, tables, lamps, planters and other decorative accessories gave gardens and porchs a face lift during the 1880s. Wicker woven from willow twigs was made in the United States from the 1850s, but failed to become fashionable until after the Civil War. A number of pieces were painted with gold paint, usually worn with the passing of time. Wicker faded from favor after the turn of the century and staged a come back in simplified version around the 1930s. *Tip:* An estate auction sale may be a bargain spot for antique wicker, if you act quicker than the town picker! Wicker values: Round table, good condition, circa 1885, $55; Side chair, $52. Illustration on page 61.

WILDFLOWER PATTERN

Adams and Company of Pennsylvania, along with other glass-houses, made this popular pressed-glass pattern in the 1870s and thereafter. The design consists of a flower, clusters of berries and foliage on a stiff spray in low relief, all heavily stippled. The wide band of fine-cut stars in high relief with pointed tops is another distinguishing feature. There was a reissue of the pattern during the 1890s. Wildflower was available in complete tableware settings and numerous other tableware pieces in clear, yellow, amber, blue, green and amethyst. *Tip:* Current reproductions are less detailed and have sparser foliage than on the orig-

inal Wildflower pattern. Wildflower Pattern values: Celery, clear, $24; Cordial, amber, $30; Sauce, flat green, $19. Sugar Bowl, green, $56.

WILLETS WARE

American Beleek reached new heights of public favor when the Willets Manufacturing Company of Trenton, New Jersey concentrated on this ware in the 1880s. Shell and coral forms were made in America to rival the Irish Beleek and most of the firms' pieces are clearly marked. Beleek bearing a snake curled to form a W with "Willets" below and "Beleek" above is your assurance that you have a piece of Beleek from this prominent American company. Willets Beleek values: Bowl, floral decor, marked, 10″ diameter, $85; Cup and Saucer, serpent handle, $43; Mug, factory mark, circa 1890, $35; Vase, oriental decor, marked, 10″ high, $68.

WILLOW PATTERN

Thomas Turner of the Caughley Pottery Works, England, first made the famed Willow pattern in 1780 and by the 1840s hundreds of other English potters were busy supplying the design to customers around the world. This beloved blue and white pattern with an Oriental scene varied only slightly over the years and changes are noted only upon close examination. Perhaps its enduring popularity can be credited to the story surrounding the design. It supposedly depicts two lovers fleeing from an irate father who does not want them to marry. They drown in their attempted escape and the doves flying overhead represent the souls of the two departed lovers. The tender tale was concocted after the pattern was in production for a number of years and the harsh truth is that early Willow had no people on the bridge, but who are we to tamper with a legend! *Tip:* The earlier the Willow the higher the value. Factory trademarks will provide a dating clue and solve the dilemma surrounding old and new Willow ware. Willow Pattern values: Tureen, large, covered, with tray marked Ridgway, $120; Plate 8″ diameter, $10.

WINDSOR CHAIRS

There were numerous chairs made by furniture factories between 1840 and 1900 with typical Windsor characteristics. Furniture makers employed the solid wooden seat, along with the open spindle back and splayed legs. In the 1870s the low-back Windsor, best known as a Captain's chair, was revived. Inexpensive U-back kitchen chairs were often

a version of the loop-back Windsor. Commercial establishments and private homes were furnished with Windsor variations of the fan-back, comb-back, arch-back, bow-back and others. They were usually painted green, red or black and made of assorted woods. Some chairs sold for the grand sum of fifty cents each. Windsor Chair values: Fan-back type, painted black, good condition, $87; Splat-back Windsor, painted and striped, good condition, $64; U-Back Kitchen Chair, maple, refinished, $52; Rough condition, $24.

WING CHAIR

The Victorian version of this extremely popular chair of the seventeenth century had several distinguishing features. Those of the nineteenth century usually had one-piece sides shaped so that the wing and arm were a single unit. The arms were very low, in fact only slightly higher than the seat cushion, while the turned front legs taper noticeably on these later chairs. Deep fringe hanging from the front and side rails was another Victorian characteristic. This upholstered easy chair with wing-shaped sidings that jut forward at the head level from the back of the chair was originally designed to reduce drafts. Black walnut, mahogany or rosewood legs were favored while the concealed frame was of assorted hard and soft woods. Wing Chair value: Mahogany legs, upholstered body, deep fringe, velvet, good condition, circa 1850, $330.

WITCH BALL

The witch ball hung in windows and over doors to ward off evil spirits. These glass balls of color, as well as gold and silver, were popular between the 1820s and the 1860s. The earlier witch balls date from the late 1700s and the balls were made in sizes from that of a marble to a foot or more in diameter. Later versions were also known as watch balls, and when hung in the corner of a room, the complete room would be mirrored in the ball. There are very few of these highly fragile witch balls available today that are free of blemishes. Witch Ball values: Brilliant crystal, 2″ in diameter, $35; Mercury glass, 5″ in diameter, $36.

WOOTEN PATENT DESK

The Wooten desk was an effort on the part of W. S. Wooten to capsule a complete office into a single piece of furniture. This massive desk was patented in 1874 and when closed gave the outward appearance of a large cupboard. The cylinder-front six-foot desk came with a

cupboard base and had hinged-over sections that opened from the middle in either direction. They opened to reveal a miniature office, with innumerable pigeon holes, shelves, over forty small filing sections and a full front writing surface. There was even a letter box for a busy executive and each desk had a name plate reading "Wooten Patent Desk, Manf. Co. Indianapolis, Ind. W.S. Wooten's Patent Oct. 4, 1874." Wooten Patent Desk value: Good original condition, $1800.

WORLD PATTERN

This brown transfer-printed pattern was a geographical wonder, patented by Wallis, Grimson and Company of England in 1883. Each piece in the dinner service pictures buildings and scenes from numerous countries around the world. Pictured on the various table items were interiors from the Crystal Palace Exhibition, King Edward's Sandringham House, The Traitor's Gate, St. Paul's Cathedral, The Tower of London, Rhine Bridge and Palace and other architectural achievements. World Pattern values: Butter Pat, $5; Cup and Saucer, $18; Platter, medium, $42.

WRITING BOXES

Practically every Victorian lady had a writing box to accomplish her almost daily writing chores. These portable boxes of rosewood, walnut or mahogany were smaller than lap desks. The standard size was twelve inches long, seven inches wide and about four inches deep. The interior contained a slanted wood writing surface and sections to hold needed writing materials with a space for an inkwell, and a trough for pens and pencils across the front. The lids had a concealed compartment with a tight-fitting inside cover to hide personal letters. The interior of the box was frequently lined with fancy papers. Decoration consisted of bands of inlay or shallow carving. Almost all writing boxes were fitted with lock and key. Writing Box values: Mahogany inlay work, good condition, circa 1855, $95.

WRITING TABLE

The writing table was designed for either home or office use and met with the immediate approval of letter-writing Victorians. Small writing tables in light wood or papier-mâché were suitable for a lady's boudoir. The styles varied in a manner to complement existing furniture designs. Most writing tables were rectangular in shape, on cabriole legs,

and finer examples were ornamented with ormulu, mother of pearl or brass trim. They had one or more drawers to hold writing paraphernalia, and leather tops. The writing table designated for library or office use was less elaborate and usually made of black walnut. Writing Table values: Papier-mâché, mother-of-pearl inlay, circa 1865, $275; Turned-leg Writing Table, library type, walnut, circa 1870, $350.

<p style="text-align:center">Ü</p>

YELLOW WARE

The potters of America, particularly those centered in the area of East Liverpool, Ohio, made quantities of Yellow ware between 1830 and 1900. The ware was similar to the body of Rockingham wares, except the transparent glaze tended to bring out the yellow color in the body and it became known as Yellow ware. The term was used in the same manner as the articles covered with a brown glaze, generally referred to as Brown ware. The production of Yellow ware was primarily limited to simple table items and utilitarian kitchen items. Yellow Ware values: Pie Plate, circa 1850, $14.

<p style="text-align:center">Z</p>

ZOLSNAY WARE

Bold and beautiful Zolsnay ceramics from the Hungarian factory founded in the middle 1800s are being acquired by aware antiquers. This illustrious factory strived to create new and exciting ceramics and their Art Nouveau designs, expressed in vivid colors and unique shapes, brought them highest honors. Around the turn of the century the famous Hungarian painter, Joseph Rippi-Ronai, designed wares for this progressive firm with notable success. Prized are their various articles enameled in bright colors with a strong glaze and the factory trademark on the base, incorporating the words "Zolsnay, Pecs," provides accurate identification. Zolsnay Ware values: Jug, large, Persian flowers, signed $110; Teapot, enameled florals, signed, $84.